How to draw the
Human Figure
Victor Ambrus

How to draw the
Human Figure
Victor Ambrus

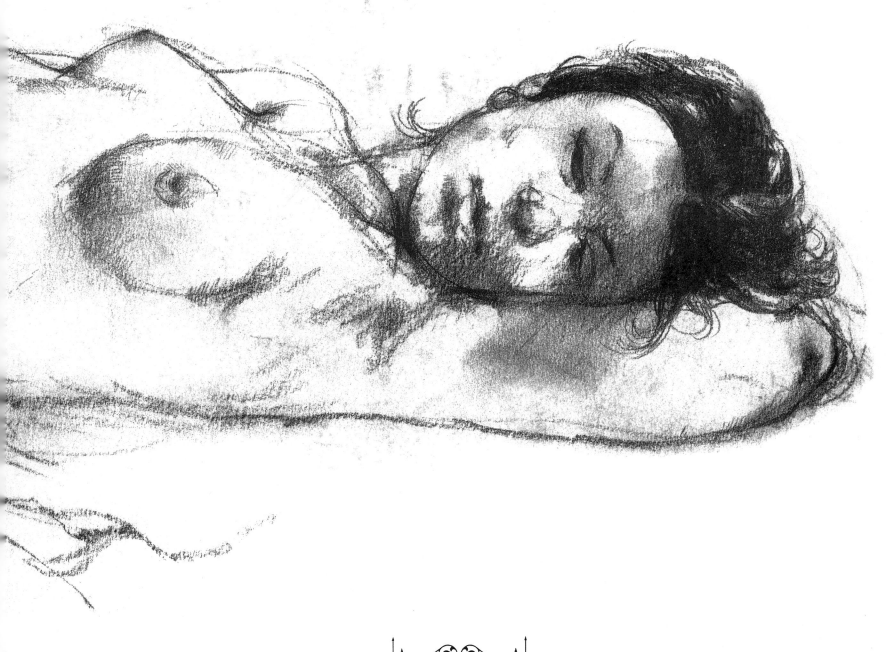

Grange
BOOKS

Published in 2000 by
Grange Books
An imprint of Grange Books PLC
The Grange, Units 1-6
Kingsnorth Industrial Estate
Hoo, Nr Rochester
Kent ME3 9ND

ISBN 1 85627 386 7

Printed in Singapore

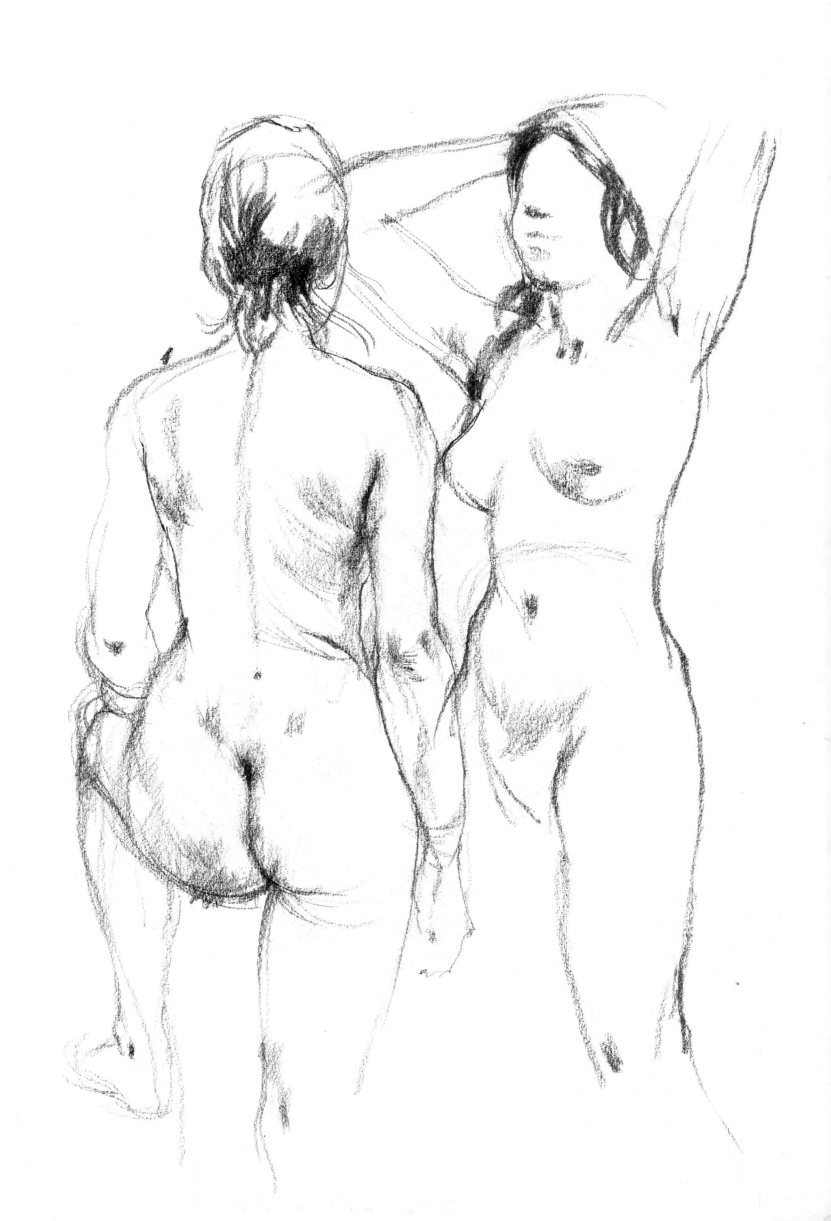

Contents

Introduction ... 8
Starting to Draw the Figure ... 10
Short Pose Sketches ... 12
Foreshortening and Shadows ... 14
The Recumbent Figure .. 16
Reclining and Sitting Poses .. 18
The Male Figure .. 20
The Back View ... 22
Sitting Down ... 24
Using a Soft Tone ... 26
Line and Rich Tone Drawing .. 28
Head and Hands in Focus ... 30
Back View in Strong Light .. 32

Reclining Pose in Full Light.........................35
Arm Muscles on the Male Figure.....................36
Two Sitting Poses.................................38
Drawing Older Models..............................40
Heads and Hands in Life Drawing...................42
Standing and Sitting..............................44
Drawing Hair......................................46
Finding the Right Pose............................49
A Work Sheet of Quick Drawings....................50
Standing and Resting..............................52
Short Sketches....................................54
Two Similar Back Views............................56
Looking Down......................................60
A Different Medium................................62
The Head..64
The Female Head...................................66
Male and Female Heads.............................68
Two Girls...70
Contrast in Faces.................................72
Quick Drawings of Heads...........................74
Sketching...76
Heads and Hands...................................78
Two Interesting Heads.............................80
Drawing a Head with Tone..........................84
Drawing Hair......................................86
Drawing Hands.....................................90
Drawings in Line..................................92
The Costumed Figure...............................94
From Life Drawing to Costume......................96
Drawing Feet......................................99
Dark Hair, Light Hair............................100
Different Clothes and Hairstyles.................102
Ballet Dancers...................................104
Standing Poses...................................108
The End of a Tiring Day..........................110
The Life Class...................................116

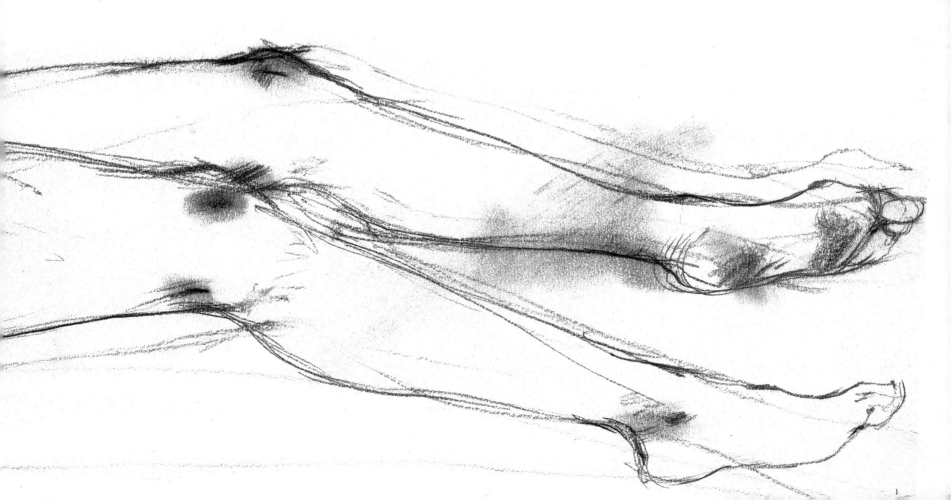

Introduction

This book contains a set of drawings produced over the past five years, mostly in life drawing studios with a class of adult students. The length of poses varied from five minutes or less to one hour on a longer study for the more advanced student. I have not attempted to give diagrams or sectioned figures to begin with. There are many books which do just that but I would much rather draw instinctively, by taking a long hard look at the subject, getting it down on paper and checking the proportions in the usual way.

Right: Dark tone used on the hair to give focal point.

Above right: The clearly visible texture of the rougher side of paper.

Below right: Head drawn with softer lines.

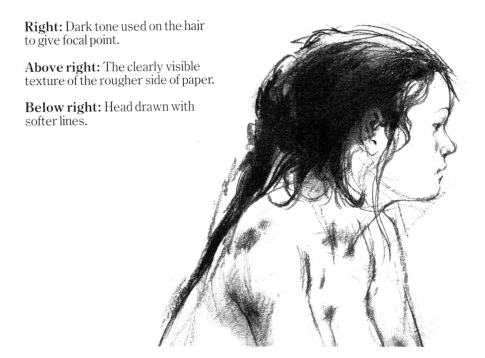

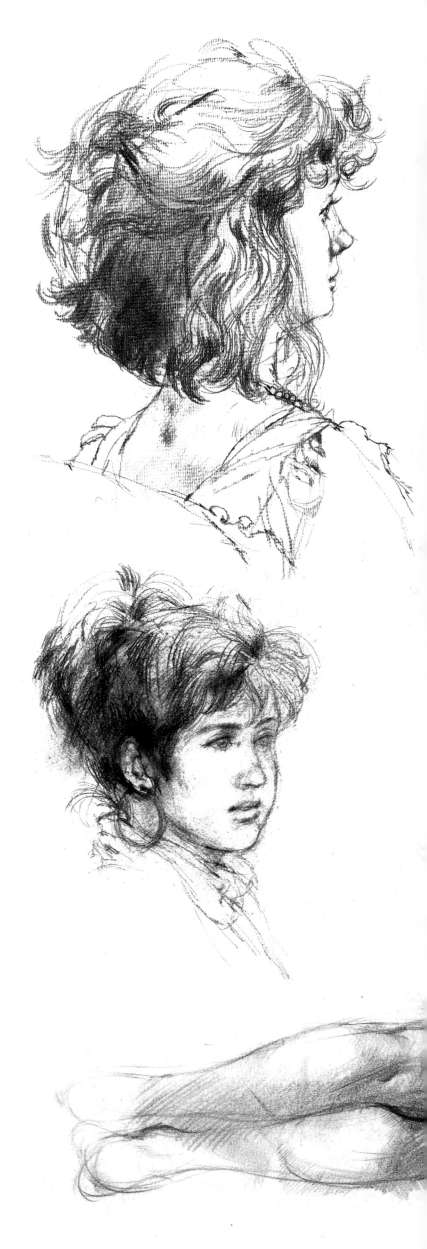

This is not an anatomy book either, because the subject would need a book all of its own. However, I was very fortunate to have had an excellent grounding in anatomy at my old college and this has remained with me always as an invaluable basis to my own drawing. It is something which should always be at the back of your mind when you are working, and should be 'under the skin' of all your drawing. Whenever you draw an arm or a leg you should ask yourself what is going on under the surface. If you try and follow the muscles in your mind, it will help enormously. In the same way, do not look at the figure or the face as something with an outline. It is a three-dimensional object. Try to draw around it in your imagination. That will explain the shapes that you see. Tone should never stop at the outline but move in and out of the background and should be used to describe and bring out the forms of the body.

Nearly all the drawings were produced with carbon pencil, charcoal pencil or charcoal. I find carbon pencil a more definite medium than ordinary graphite lead pencils. It draws a rich black line instead of the more silvery tone of graphite and can be used to apply tone ranging from subtle pale flesh tones to very rich black-brown. It also mixes very well with charcoal or black conté crayon. It is a purely personal choice: some people find it too harsh a line because it draws very dark unless held very lightly and used with care. I also like it because it reproduces well and is therefore ideal for this book.

The papers used for the drawings range from white cartridge to a variety of tinted papers, shades of grey, light brown and ochre. Some have very smooth textures.

In the main I have used Ingres paper, as a rule used for pastel, which has excellent texture and a choice of two sides, one slightly rougher and the other smooth. In general, any paper suitable for pastel is ideal and should always have fine texture. Never use a very smooth surface.

During the page by page comment I have described the way I use crayons on the sketches but basically there are two ways in which you would hold a pencil. Firstly, you would use the point for the more precise description of, say, the features of the face, or to describe strong lines in and around the figure, or to concentrate on intricate detail of form such as a foreshortened arm. Secondly, you would use the pencil for quick sketching, or for drawing the outline of a figure or face by holding the pencil on its side to apply a softer but much bolder line. It is also the way in which you should apply general tone, ranging from lightly held shading to very hard pressure to produce rich black concentration of shadow or, for instance, dark hair. It is a very versatile way of working and is particularly useful on starting a drawing when strong lines are not required but you are searching for the right line to describe the figure. On the following pages you will see numerous 'search lines' left in to show how many mistakes you can make before arriving at the correct decision.

A drawing should be carefully composed. Composition starts with your selection of the angle from which you are going to work, which is not necessarily the obvious 'best' place. For instance, a model facing you full on may be more interesting in half profile or, if it is a nude, a back view could be very much more striking than the more usual face on view. The next step is to place the figure on the paper. Is it best landscape or upright? Should you draw the whole figure or just down to the hands? Should you concentrate on the head or should you just sketch it in lightly? These are all decisions to make before you start. Then there is the tone. All drawings should have a concentrated graphic focal point. They should have a 'punch' somewhere. It could be a particularly carefully drawn arm or leg or just the dark black tone of a girl's hair.

I hope that this book will inspire you to examine new ways of looking at the problems of life drawing. The human face and body are the most fascinating subjects that you are ever likely to attempt to capture.

Above: A combination of charcoal undertone and carbon pencil.

Below: A graphite pencil drawing using cross-hatching to indicate forms. This is the technique that some of the great masters used, such as Michelangelo.

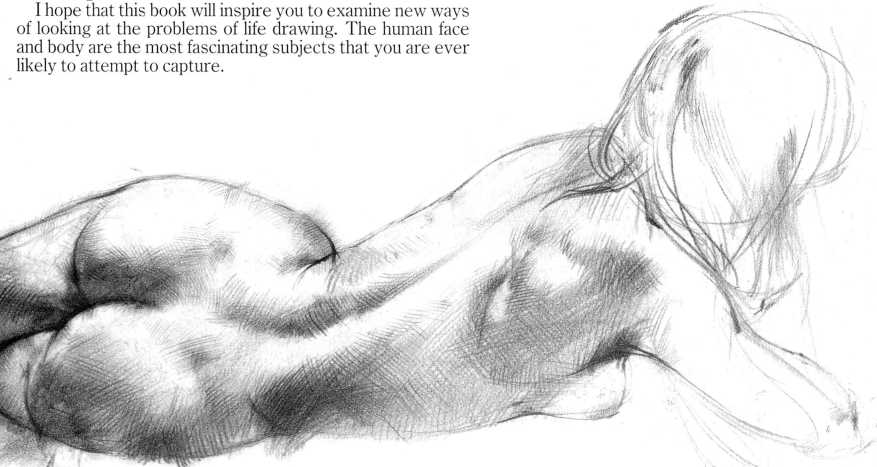

Starting to Draw the Figure

You would normally start off your day's drawing with very quick poses, sometimes as short as 3 minutes, so there is no time to become bogged down with detail. You have to put down the essential movement. This is best done with soft pencil or crayon turned on its side which gives a flowing line and the opportunity to lighten tones where necessary. It will really make you concentrate on capturing the form of the entire figure.

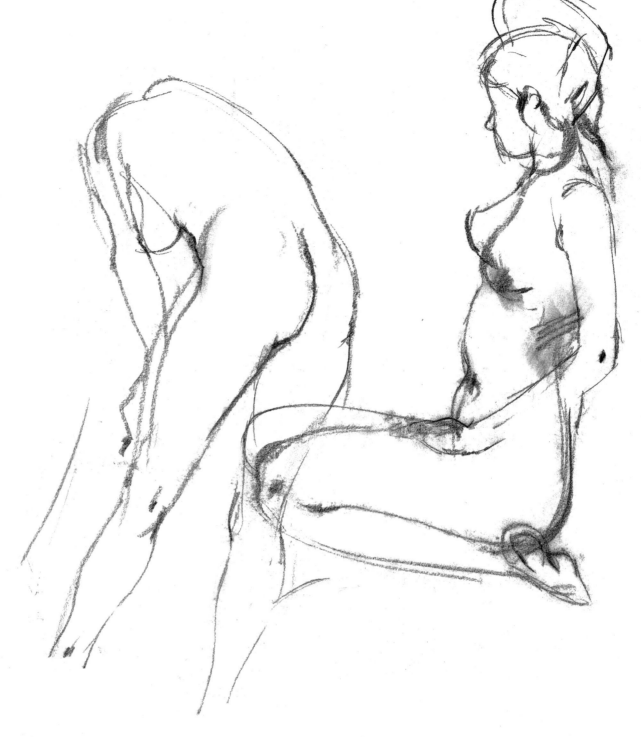

In the drawing left soft crayon, held on its side again, gave fine lines and soft tone at the same time. I used just enough tone to give form to this back view, making use of the nice shadows produced by the sharp light coming from the right of the model.

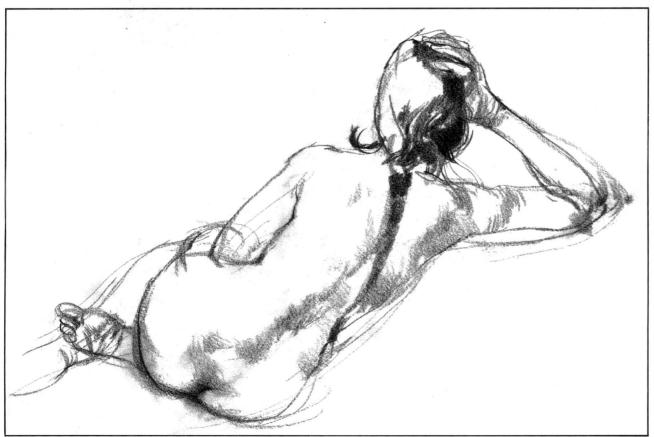

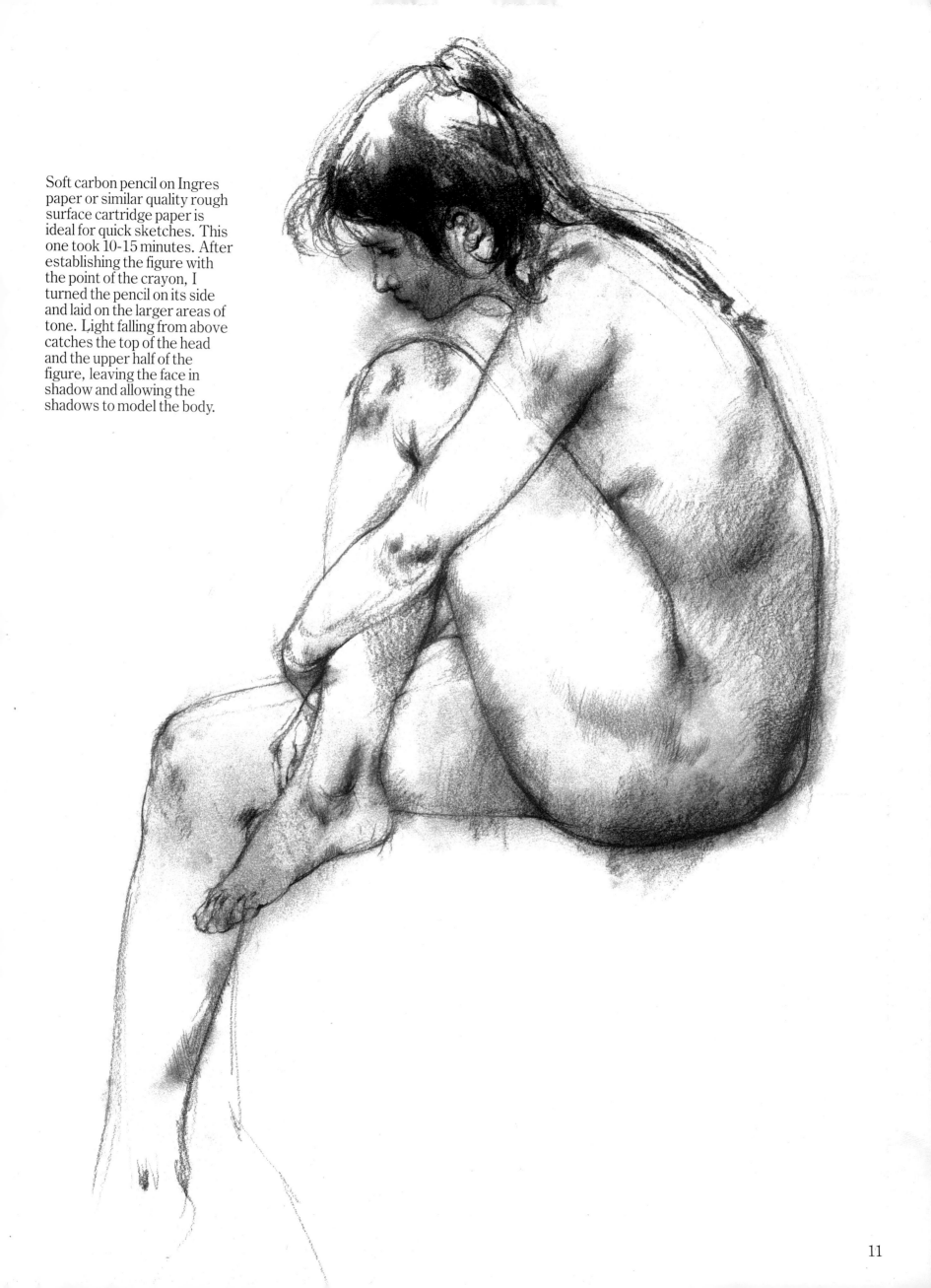

Soft carbon pencil on Ingres paper or similar quality rough surface cartridge paper is ideal for quick sketches. This one took 10-15 minutes. After establishing the figure with the point of the crayon, I turned the pencil on its side and laid on the larger areas of tone. Light falling from above catches the top of the head and the upper half of the figure, leaving the face in shadow and allowing the shadows to model the body.

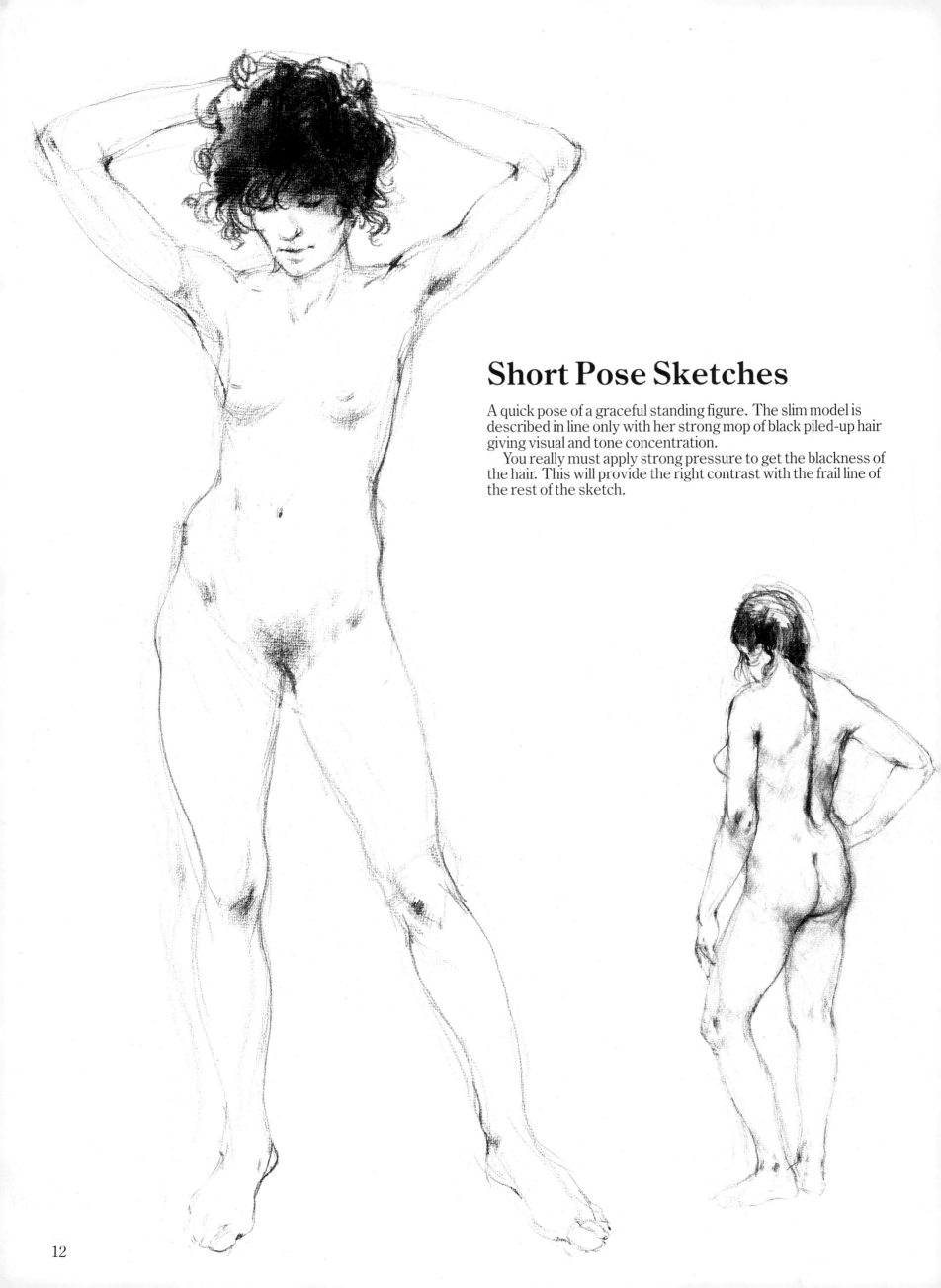

Short Pose Sketches

A quick pose of a graceful standing figure. The slim model is described in line only with her strong mop of black piled-up hair giving visual and tone concentration.

You really must apply strong pressure to get the blackness of the hair. This will provide the right contrast with the frail line of the rest of the sketch.

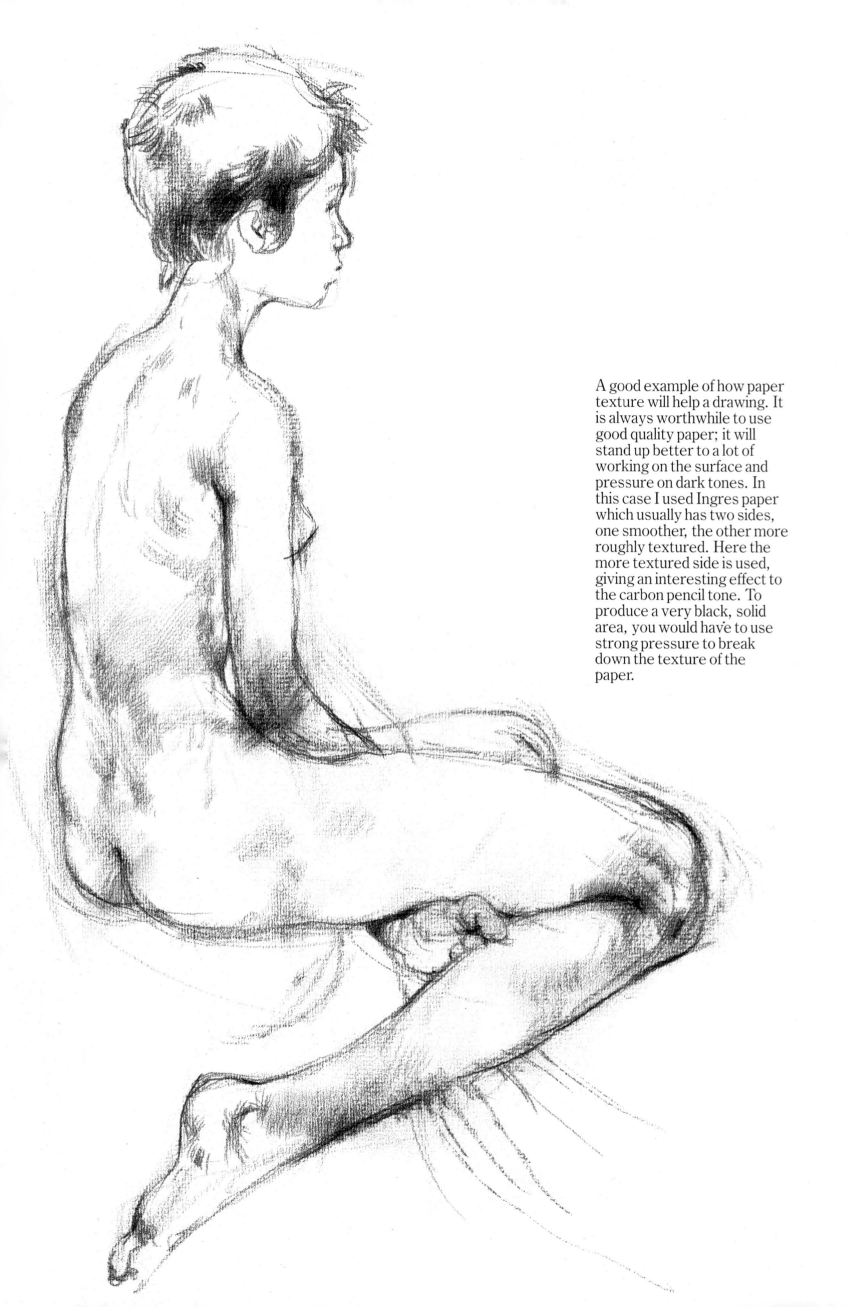

A good example of how paper texture will help a drawing. It is always worthwhile to use good quality paper; it will stand up better to a lot of working on the surface and pressure on dark tones. In this case I used Ingres paper which usually has two sides, one smoother, the other more roughly textured. Here the more textured side is used, giving an interesting effect to the carbon pencil tone. To produce a very black, solid area, you would have to use strong pressure to break down the texture of the paper.

13

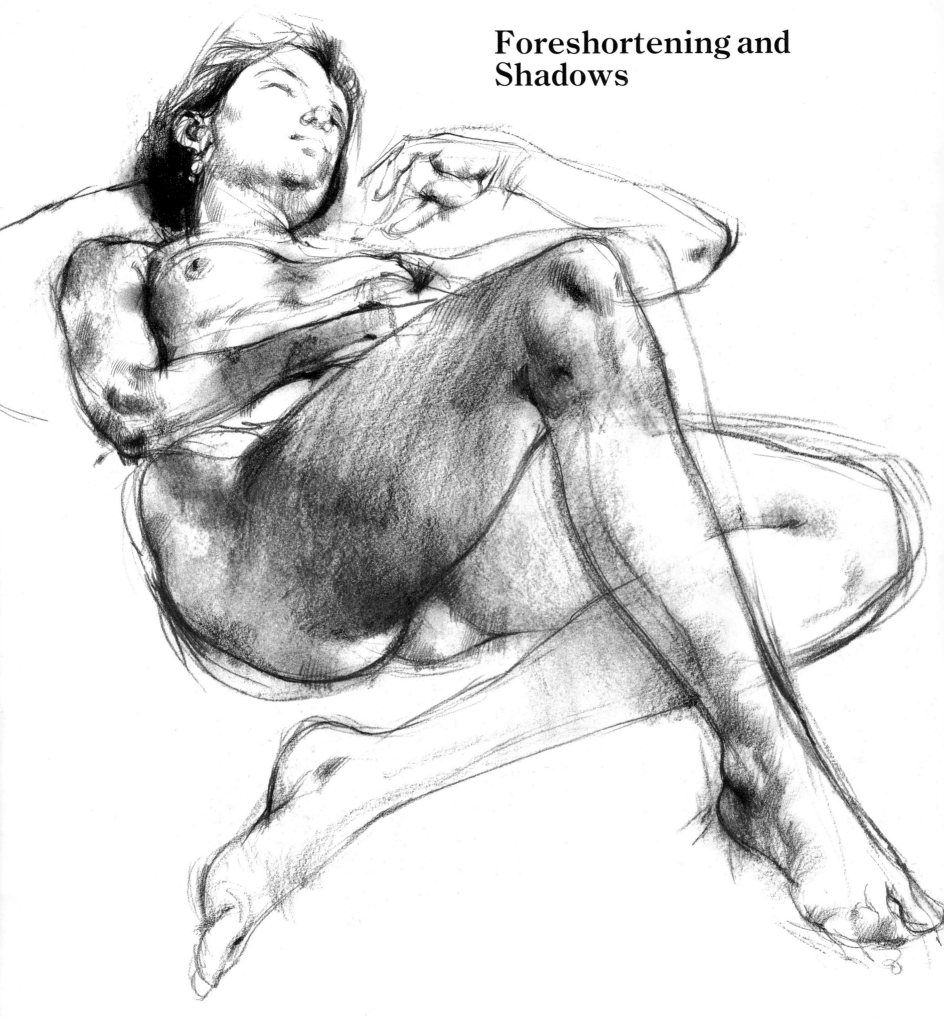

Foreshortening and Shadows

Another foreshortening in reverse to that on the right-hand page. The light falls from above producing very dramatic shadows on the thigh. A difficult pose to draw, as seen by the numerous search lines. I tried to avoid getting the legs too large; they zoom towards you when you try to draw them, the head and shoulders receding towards the background. The tone in this case is essential to bring the leg and knee forward, so I did not hesitate to use a strong burst of carbon crayon to get strong contrast and powerful modelling of the muscles.

Shortage of time precluded more detail on the hands and feet. This is an example of strong light enabling you to cope with a foreshortened figure.

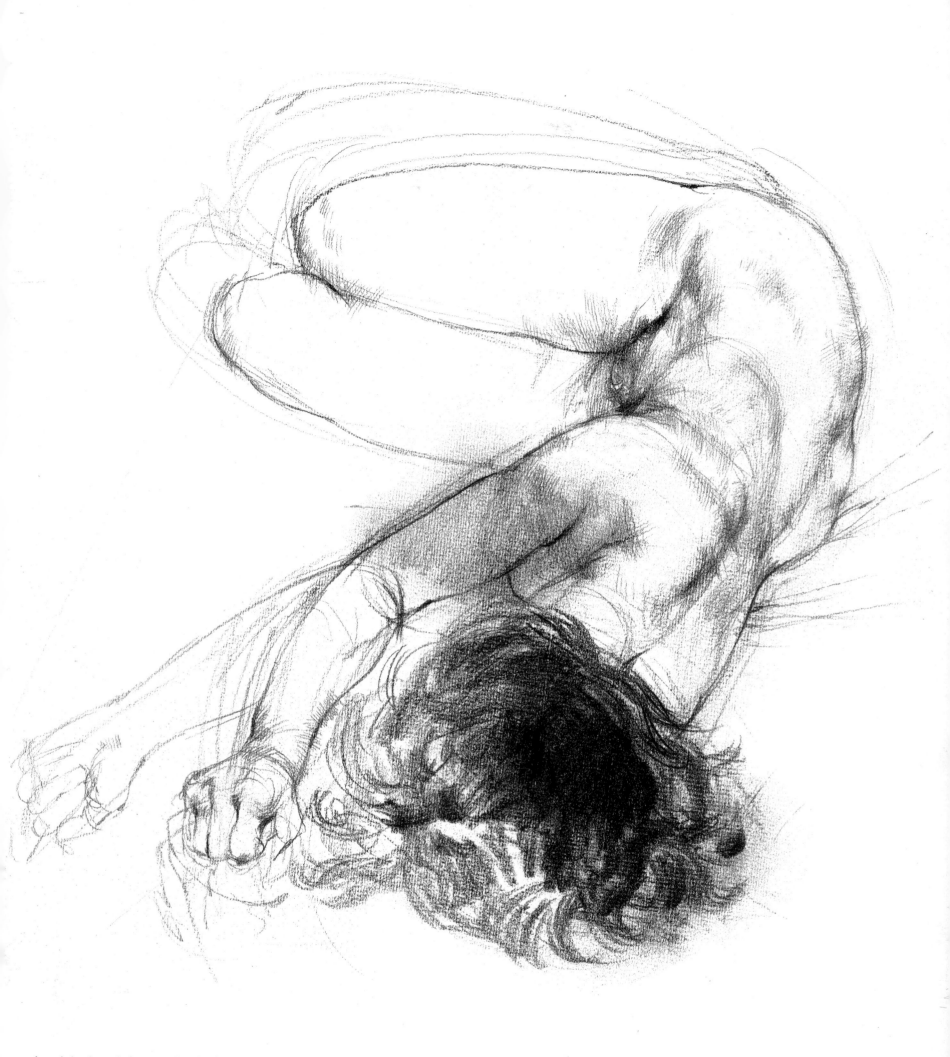

A quick sketch for an oil painting; the model lying on the floor with drastic foreshortening of the body, the head covered by loose red hair. Because of the flood of light coming from above left, the figure is almost entirely illuminated, therefore very little tone is used, just sufficient to round out the body. The line drawing was crucial for fixing the correct perspective of the body, with the hips and the back bearing a little shadow drawn in by a flatly held pencil. The white skin contrasts strongly with the tone of the rich red hair which also presents a focal point to the drawing. The tone of the hair also helps to bring the head and shoulders right forward, with the hand seen in more detail in the immediate foreground.

The Recumbent Figure

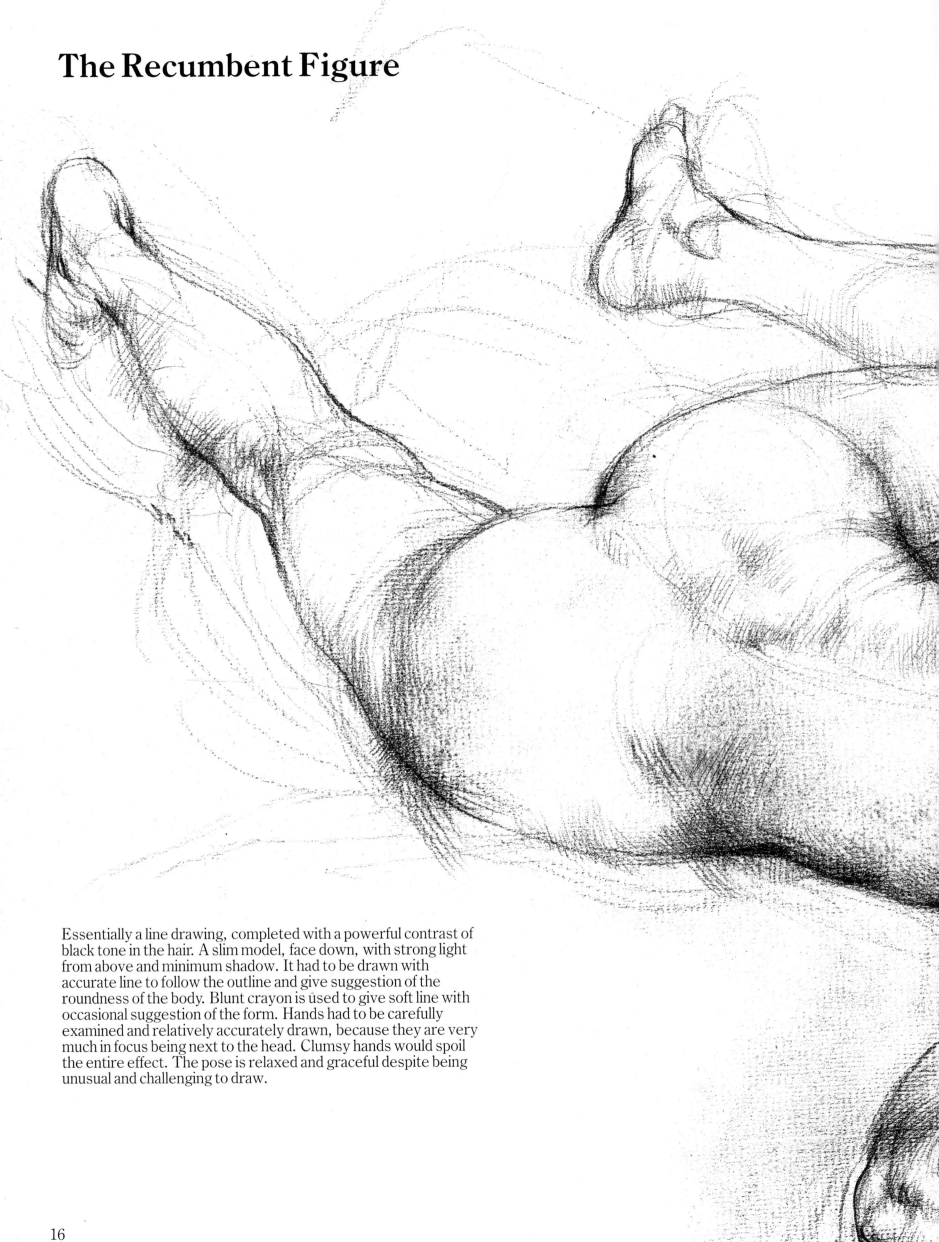

Essentially a line drawing, completed with a powerful contrast of black tone in the hair. A slim model, face down, with strong light from above and minimum shadow. It had to be drawn with accurate line to follow the outline and give suggestion of the roundness of the body. Blunt crayon is used to give soft line with occasional suggestion of the form. Hands had to be carefully examined and relatively accurately drawn, because they are very much in focus being next to the head. Clumsy hands would spoil the entire effect. The pose is relaxed and graceful despite being unusual and challenging to draw.

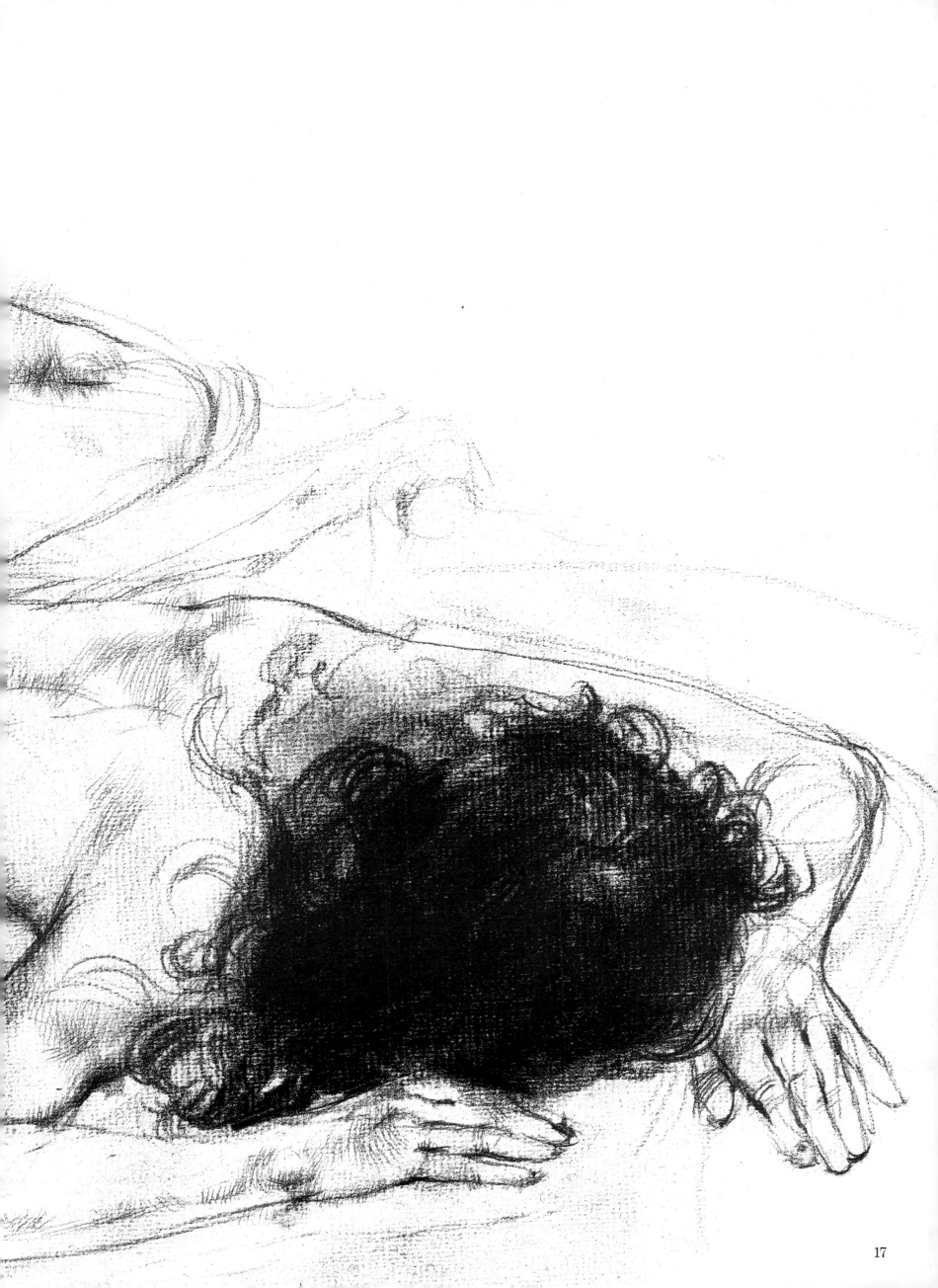

Reclining and Sitting Poses

Some people are naturally more graceful in movement than others and this girl is a striking example in point. An interesting pose, slightly looking down on a foreshortening figure and drawn in about 30 minutes. The composition of the legs is balanced accidentally but very effectively by her pigtail.

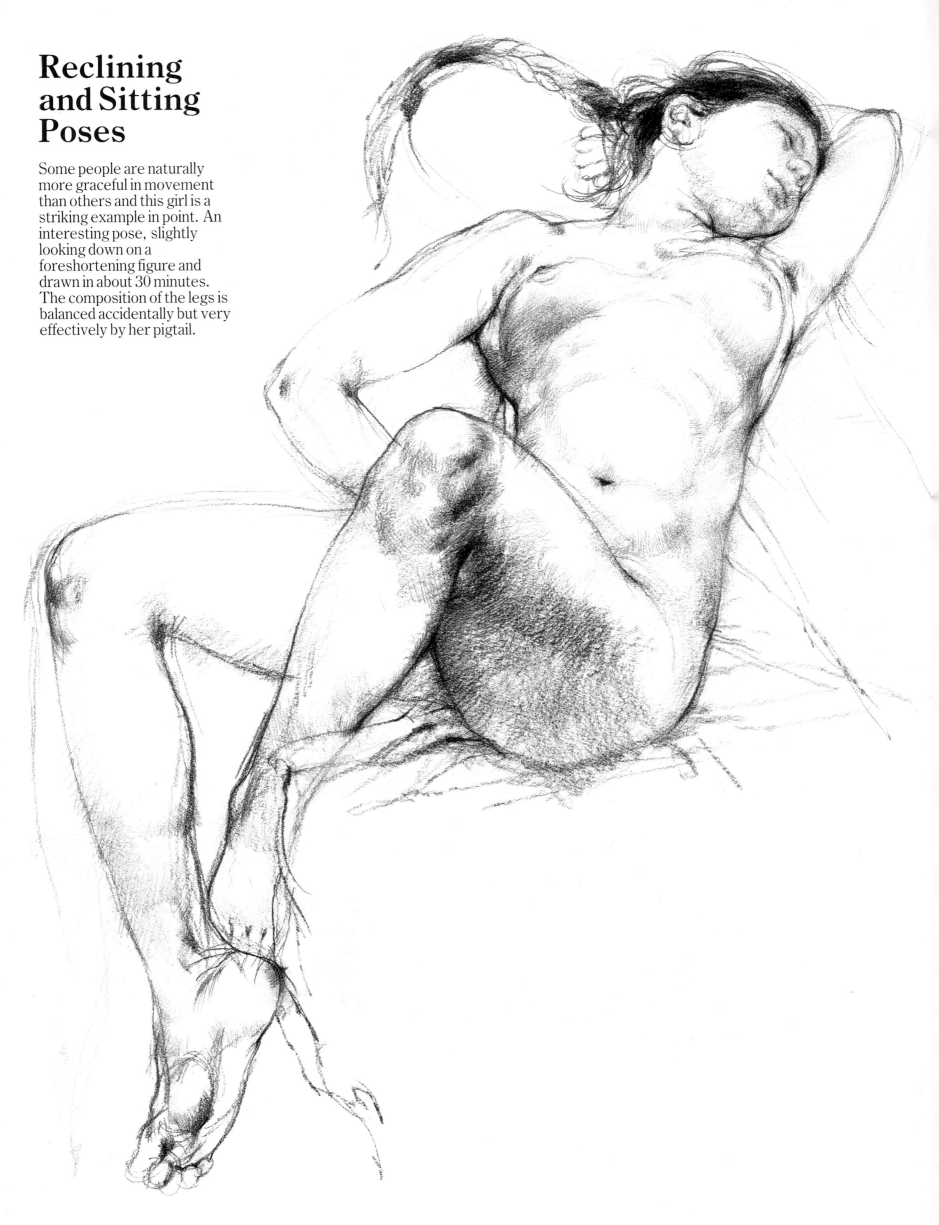

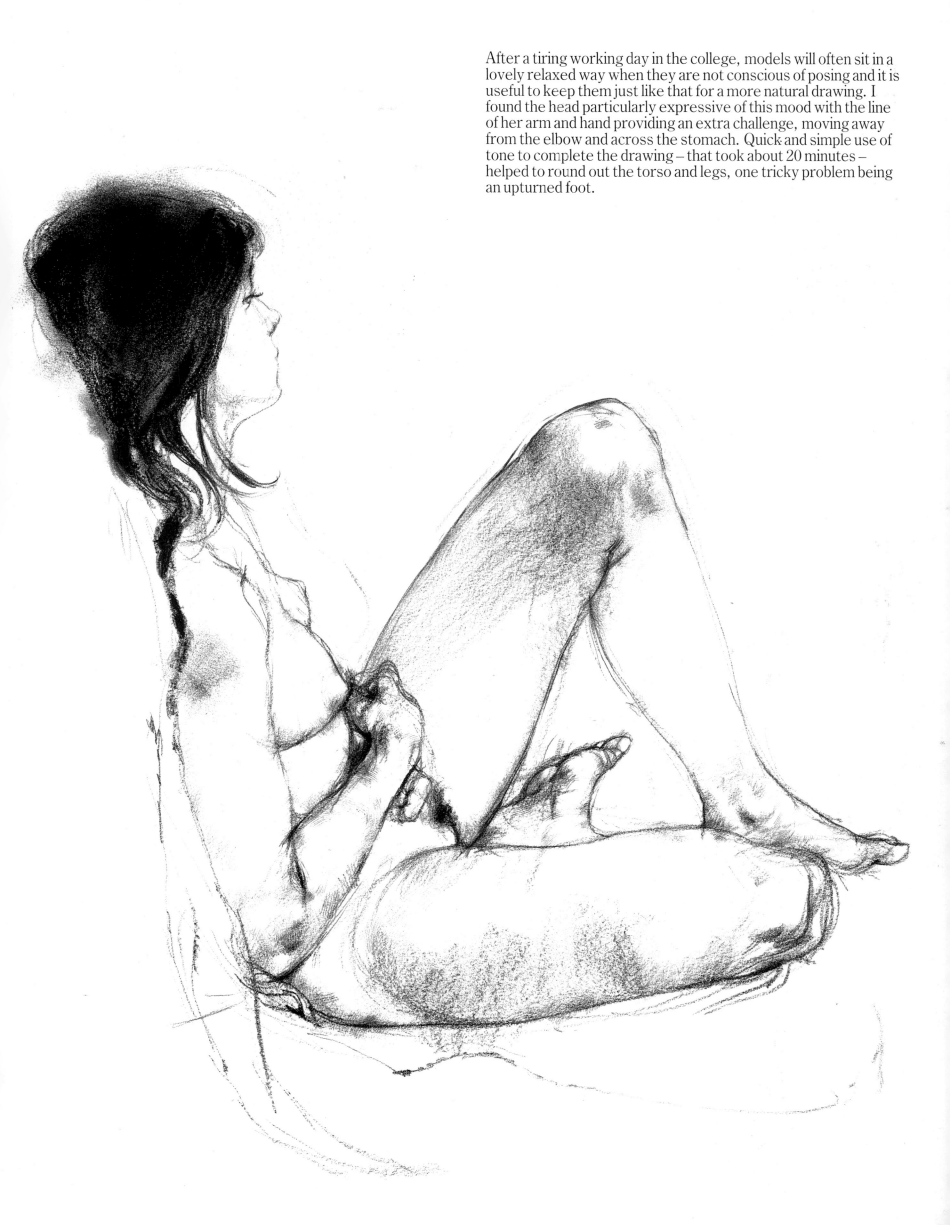

After a tiring working day in the college, models will often sit in a lovely relaxed way when they are not conscious of posing and it is useful to keep them just like that for a more natural drawing. I found the head particularly expressive of this mood with the line of her arm and hand providing an extra challenge, moving away from the elbow and across the stomach. Quick and simple use of tone to complete the drawing – that took about 20 minutes – helped to round out the torso and legs, one tricky problem being an upturned foot.

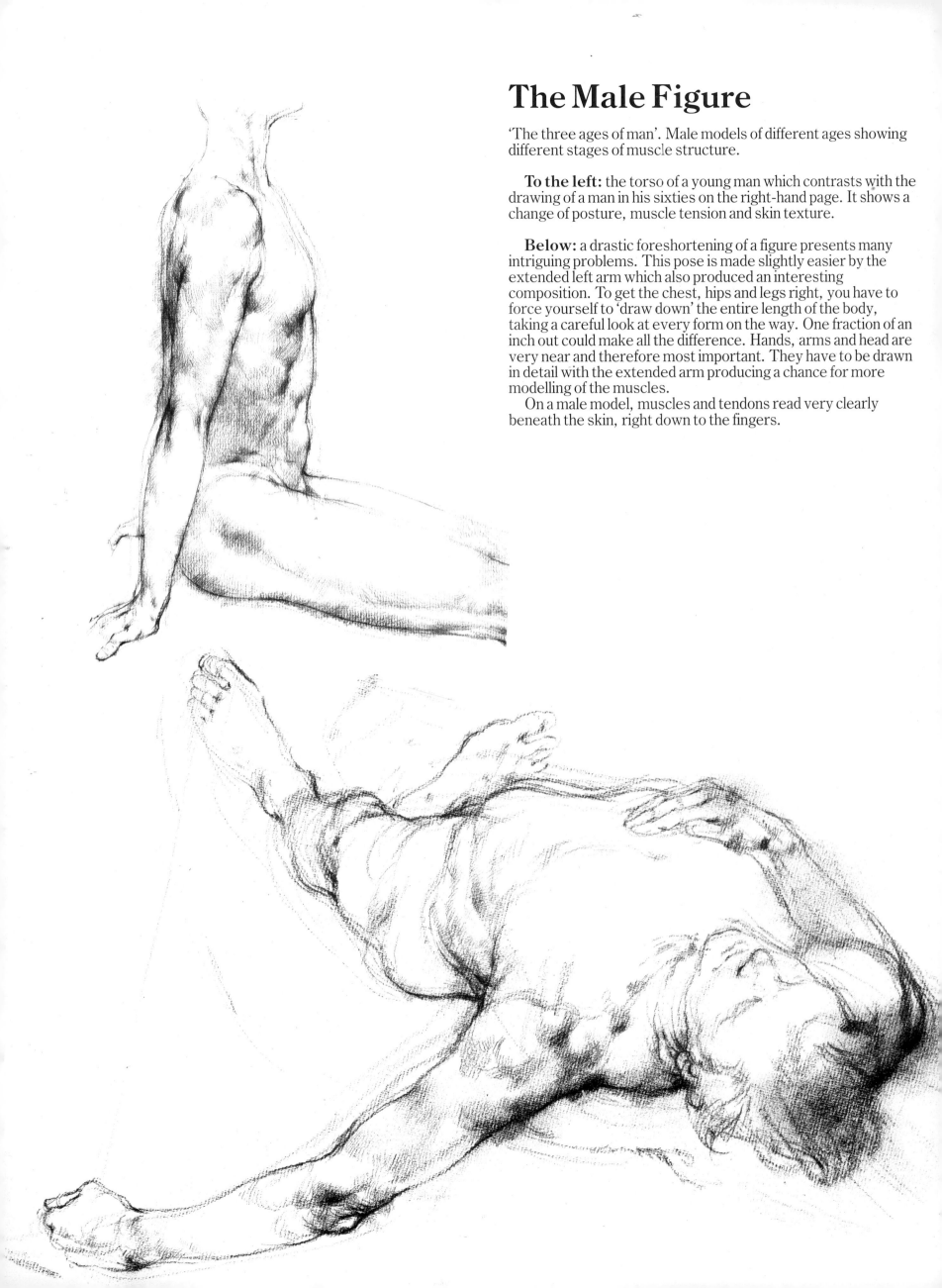

The Male Figure

'The three ages of man'. Male models of different ages showing different stages of muscle structure.

To the left: the torso of a young man which contrasts with the drawing of a man in his sixties on the right-hand page. It shows a change of posture, muscle tension and skin texture.

Below: a drastic foreshortening of a figure presents many intriguing problems. This pose is made slightly easier by the extended left arm which also produced an interesting composition. To get the chest, hips and legs right, you have to force yourself to 'draw down' the entire length of the body, taking a careful look at every form on the way. One fraction of an inch out could make all the difference. Hands, arms and head are very near and therefore most important. They have to be drawn in detail with the extended arm producing a chance for more modelling of the muscles.

On a male model, muscles and tendons read very clearly beneath the skin, right down to the fingers.

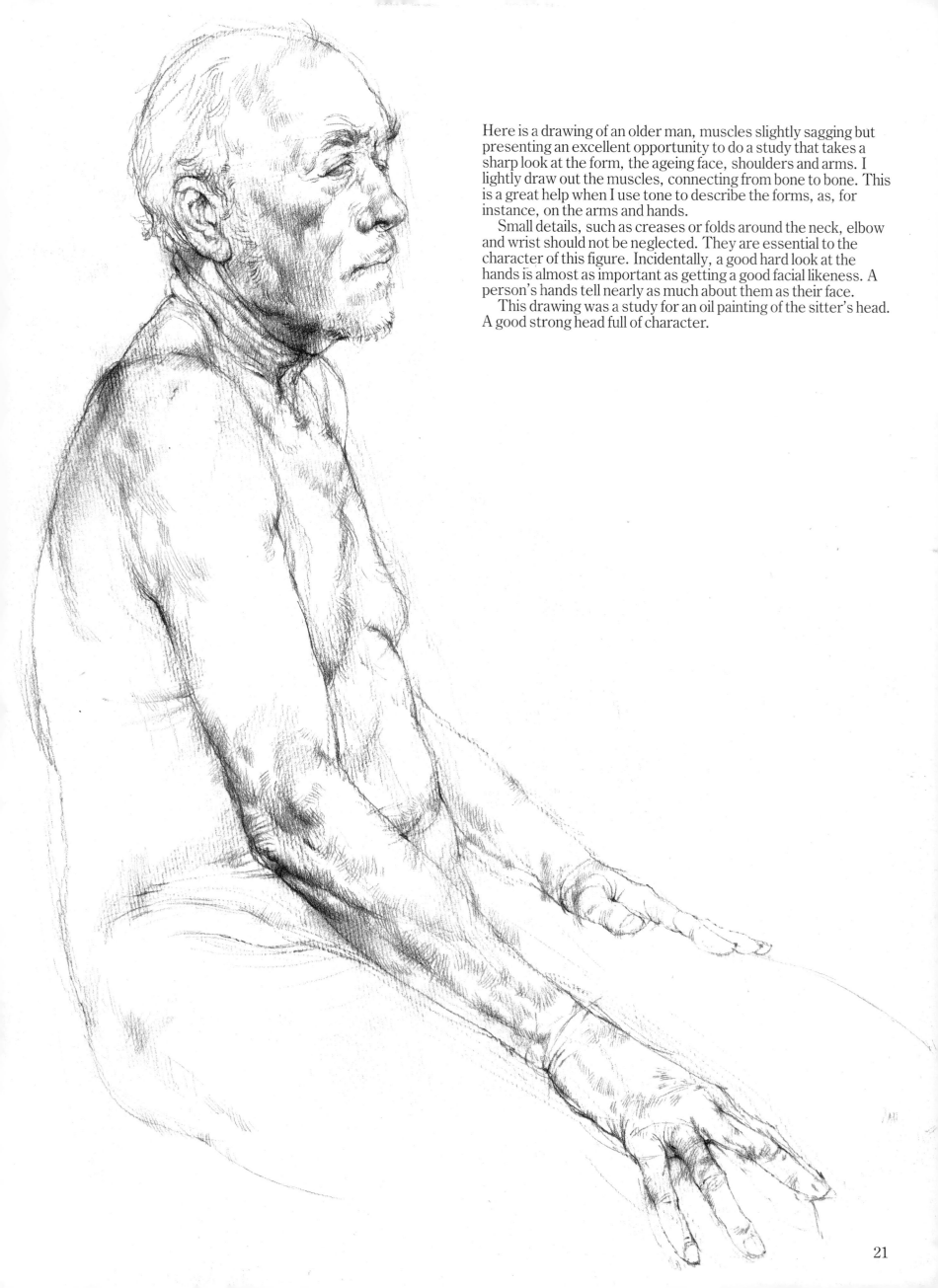

Here is a drawing of an older man, muscles slightly sagging but presenting an excellent opportunity to do a study that takes a sharp look at the form, the ageing face, shoulders and arms. I lightly draw out the muscles, connecting from bone to bone. This is a great help when I use tone to describe the forms, as, for instance, on the arms and hands.

Small details, such as creases or folds around the neck, elbow and wrist should not be neglected. They are essential to the character of this figure. Incidentally, a good hard look at the hands is almost as important as getting a good facial likeness. A person's hands tell nearly as much about them as their face.

This drawing was a study for an oil painting of the sitter's head. A good strong head full of character.

The Back View

Back views may seem lacking in form at first glance, but they are a challenge of line and of simplicity. It is essential to get a sound line drawing, in this case using a soft point carbon pencil, with economical use of tone to describe the lovely shapes of the back and hips. The tone was applied in the combination of a flatly held pencil, used almost like a brush, on its side, and the point of the pencil to describe more accurate detail where necessary, such as around the spine.

You should always draw a figure as if you could see all around it. Never stop at the contour. It is not a 'wire frame' surrounding the figure, it is merely the visible outline of the form which carries on existing out of sight. The tone is there to help carry the form around to the other side. The back view of the model lying down would be anaemic without the contrast of the soft dark hair. Here carbon pencil is applied hard to show some detail, but basically kept in one strong shape.

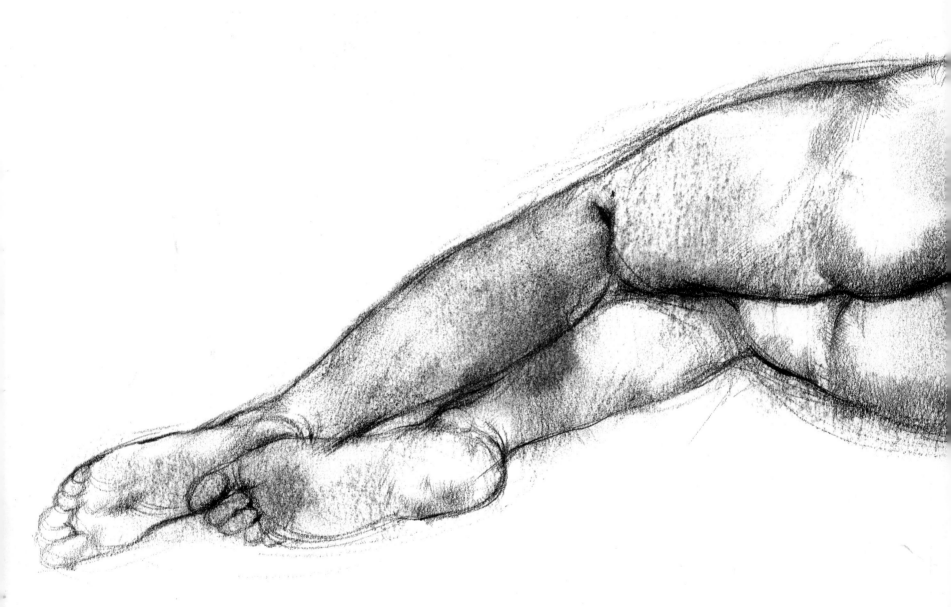

A slightly different method of using tone, produced by harder use of lines and fine hatching in combination with soft texture charcoal laid on its side.

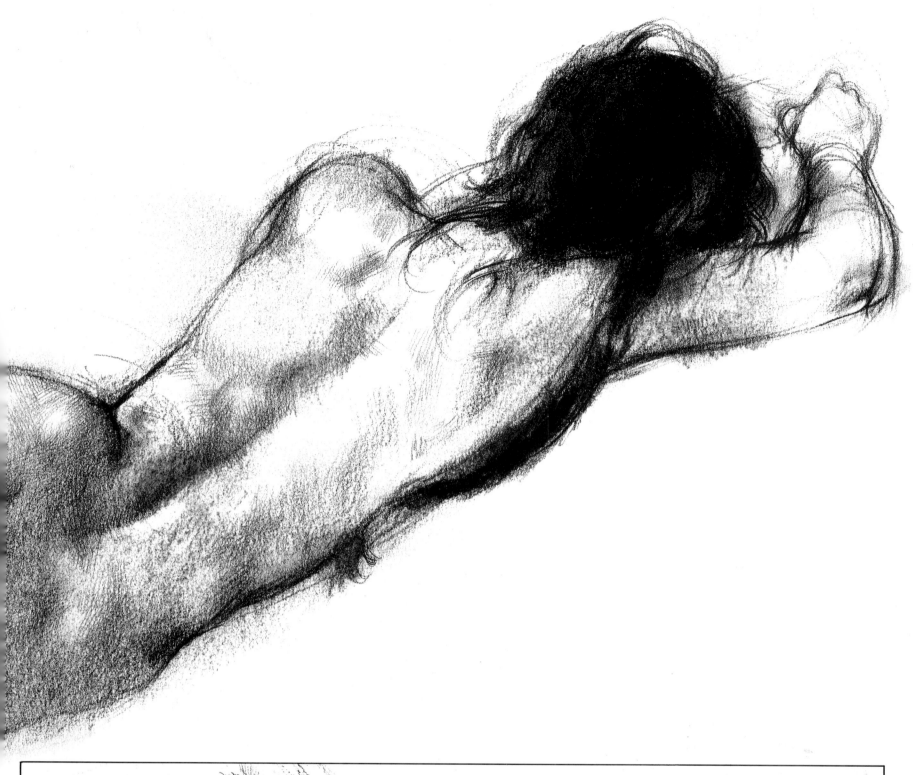

Sitting Down

A quick but accurate drawing on the rough surface of Ingres paper, making use of the natural texture of the paper and using a very soft crayon. Make sure that the line not only describes a contour, but goes all around the body. For instance, the head and neck go in front of the shoulders by means of lines, legs move away and forward from the hips, arms move forward from the shoulder. The forms have to be looked at very carefully even in a line stage.

All tone and shadows fall around the hips. This gives a concentration of weight to the drawing as well as a chance for some strong modelling of the forms around the back and hips. Note the different strength of lines. These are strongest at the nearest points, fading away as the legs move forward to help foreshortening.

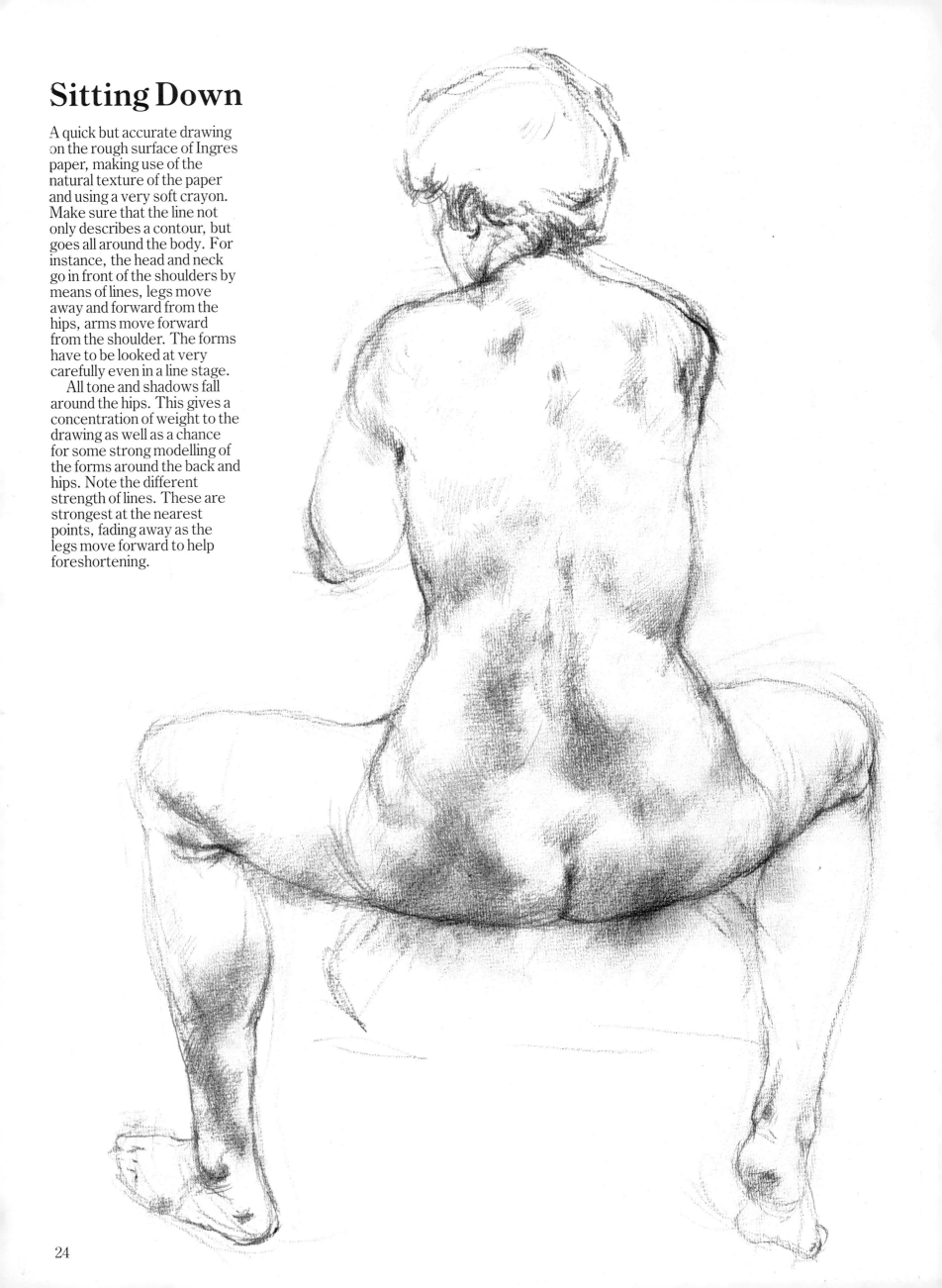

24

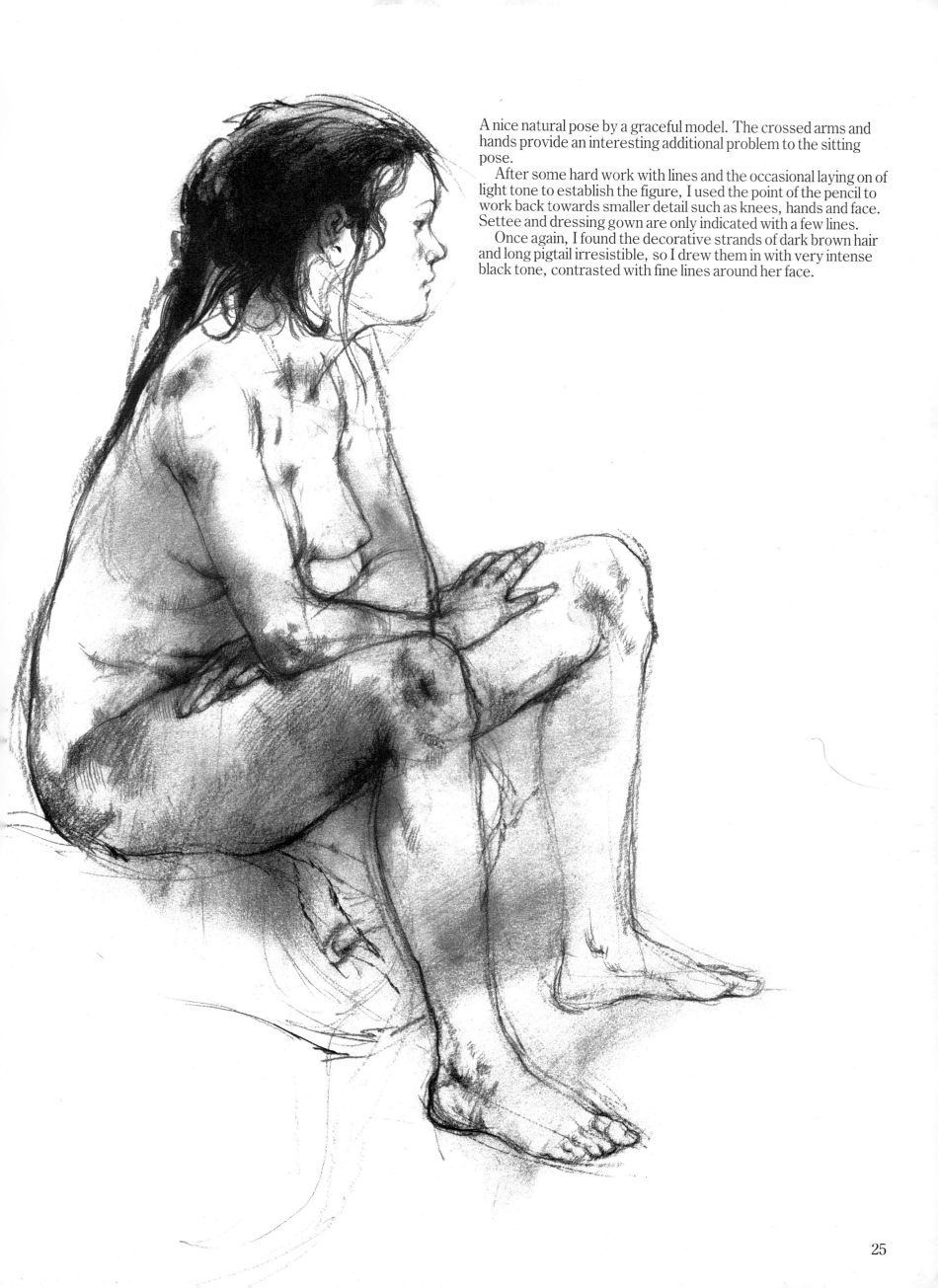

A nice natural pose by a graceful model. The crossed arms and hands provide an interesting additional problem to the sitting pose.

After some hard work with lines and the occasional laying on of light tone to establish the figure, I used the point of the pencil to work back towards smaller detail such as knees, hands and face. Settee and dressing gown are only indicated with a few lines.

Once again, I found the decorative strands of dark brown hair and long pigtail irresistible, so I drew them in with very intense black tone, contrasted with fine lines around her face.

Using a Soft Tone

One of a series of 10-15 minute poses drawn lightly with soft crayon.

A quick pose means you have to work hard and concentrate hard. This drawing is nearly all in soft line and tone, produced with carbon pencil held flat on its side. This enables you to draw line and use tone very quickly.

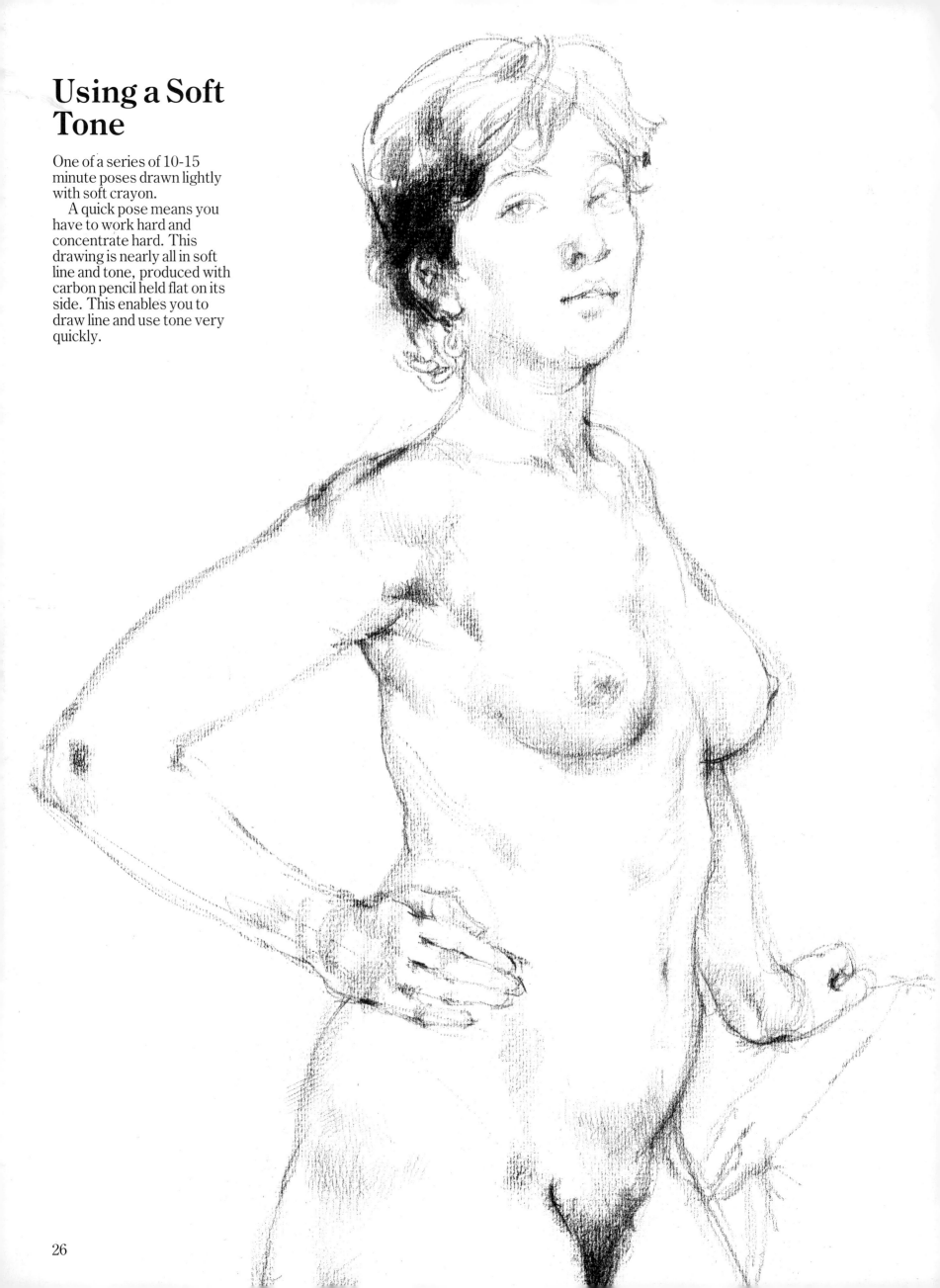

A pose lasting about 30 minutes. A flowing relaxed figure of a German girl, drawn directly from the front. Her head had a classical look, and the pose, with hands resting on the couch and legs moving together to the right, presents a calm and elegant line.

The length of the pose gave me time to model the face, arms, torso and knees a little more in detail, but the main problem lay in drawing a sitting figure face on, and making the legs move forward. I believe I more or less succeeded.

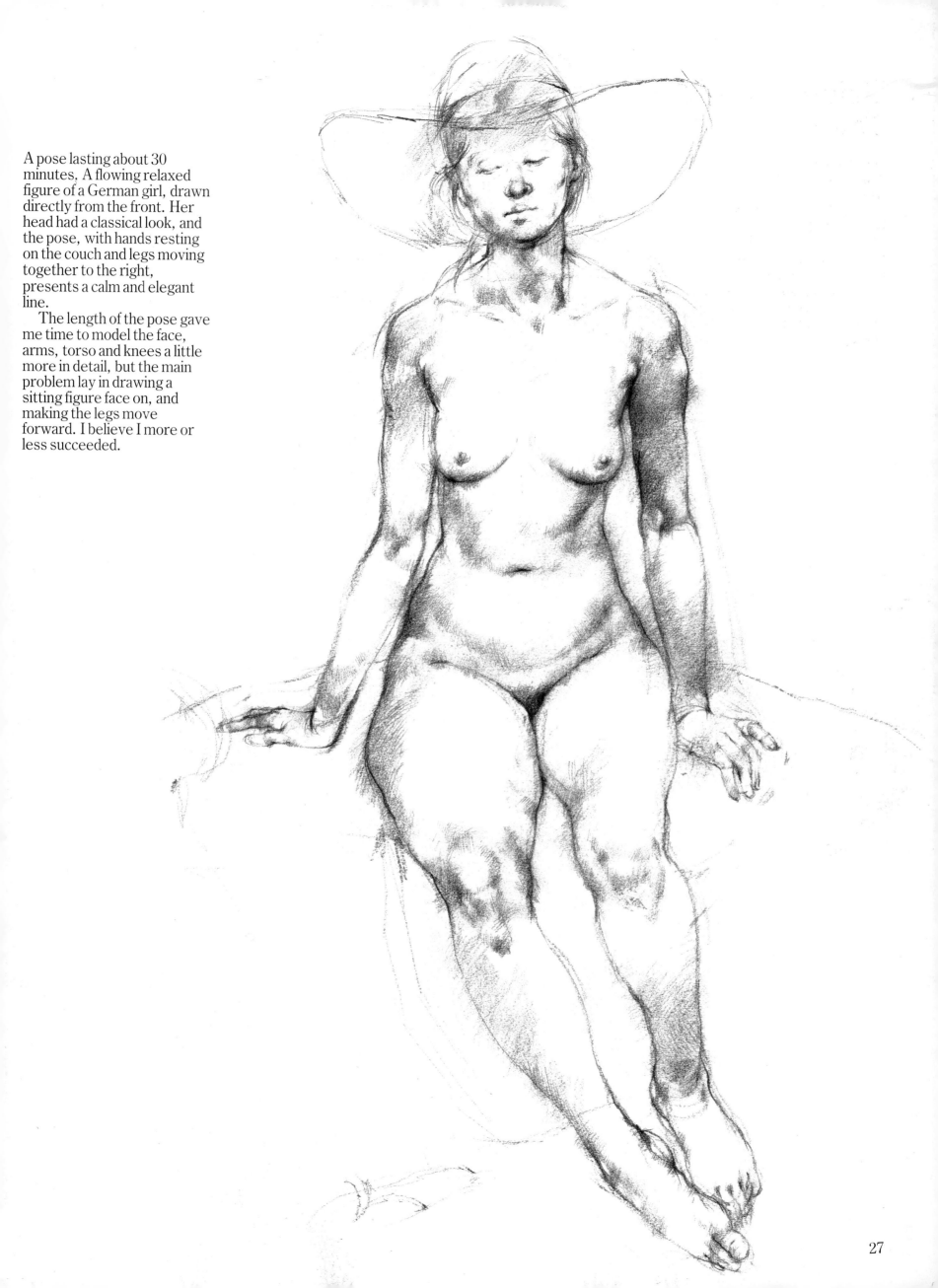

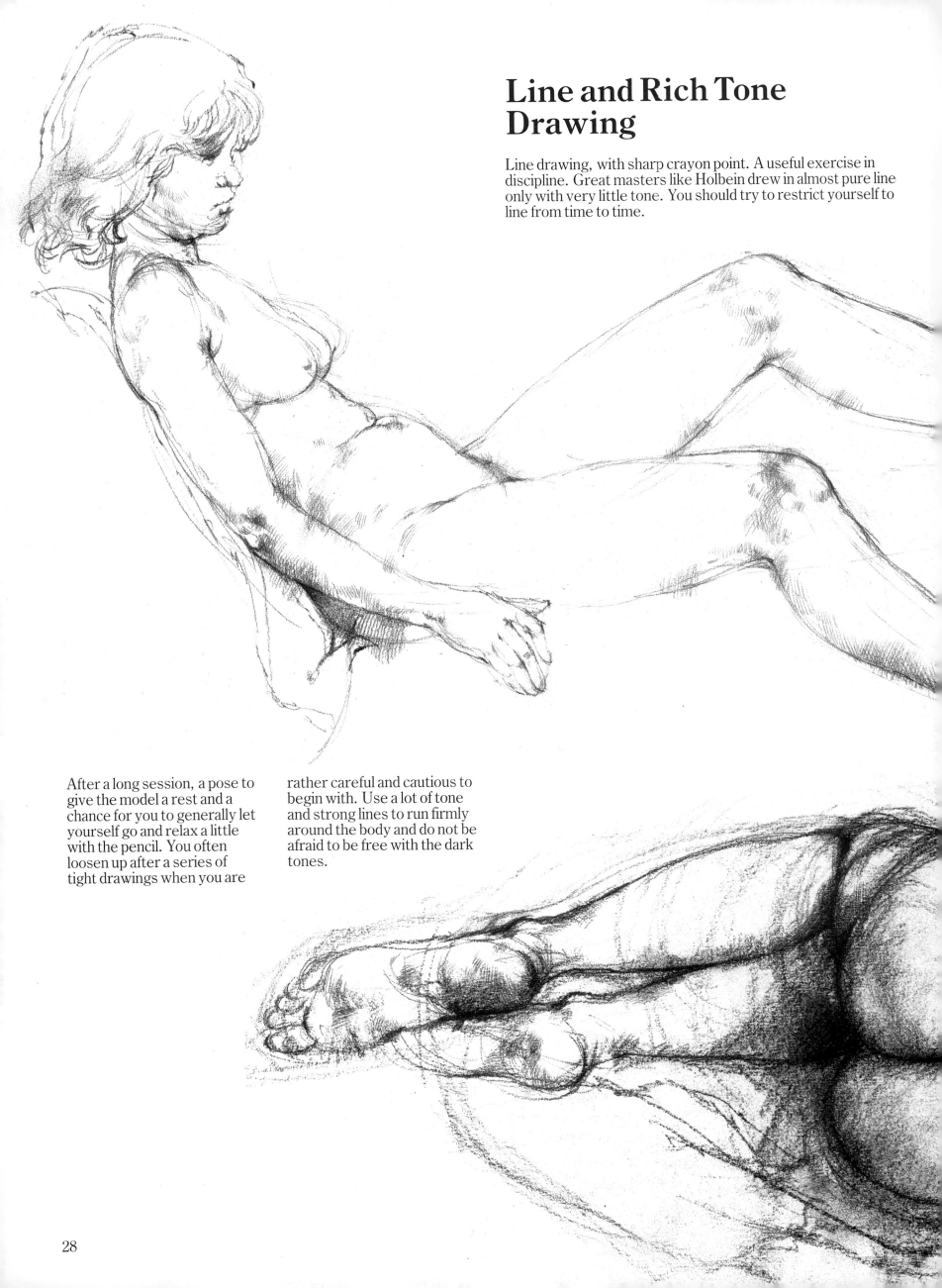

Line and Rich Tone Drawing

Line drawing, with sharp crayon point. A useful exercise in discipline. Great masters like Holbein drew in almost pure line only with very little tone. You should try to restrict yourself to line from time to time.

After a long session, a pose to give the model a rest and a chance for you to generally let yourself go and relax a little with the pencil. You often loosen up after a series of tight drawings when you are rather careful and cautious to begin with. Use a lot of tone and strong lines to run firmly around the body and do not be afraid to be free with the dark tones.

In this drawing I had to move original search lines several times to get the feet in the right position. Once having established how the maximum weight of the figure is distributed, the feet in relation to the head could then be correctly positioned.

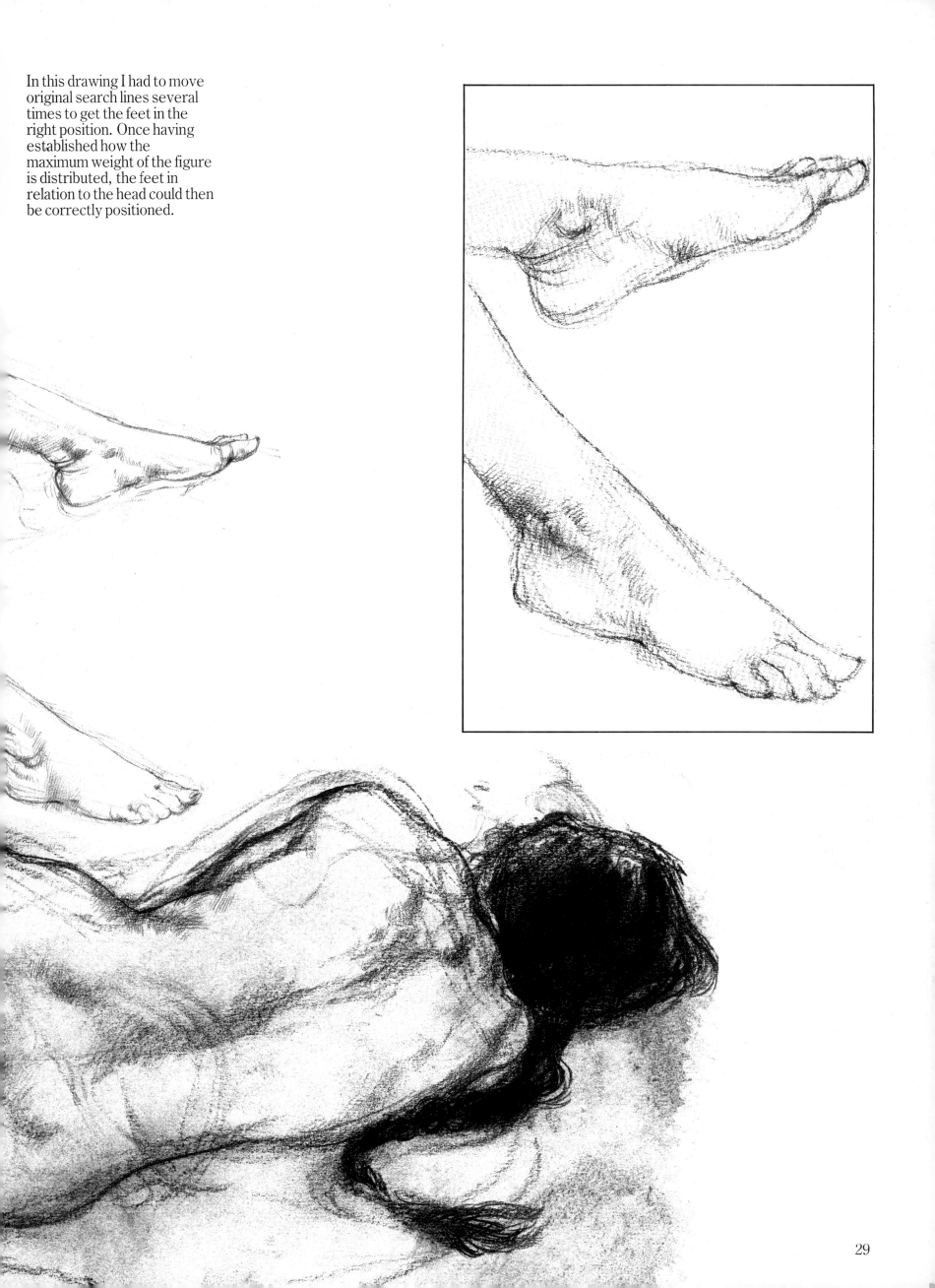

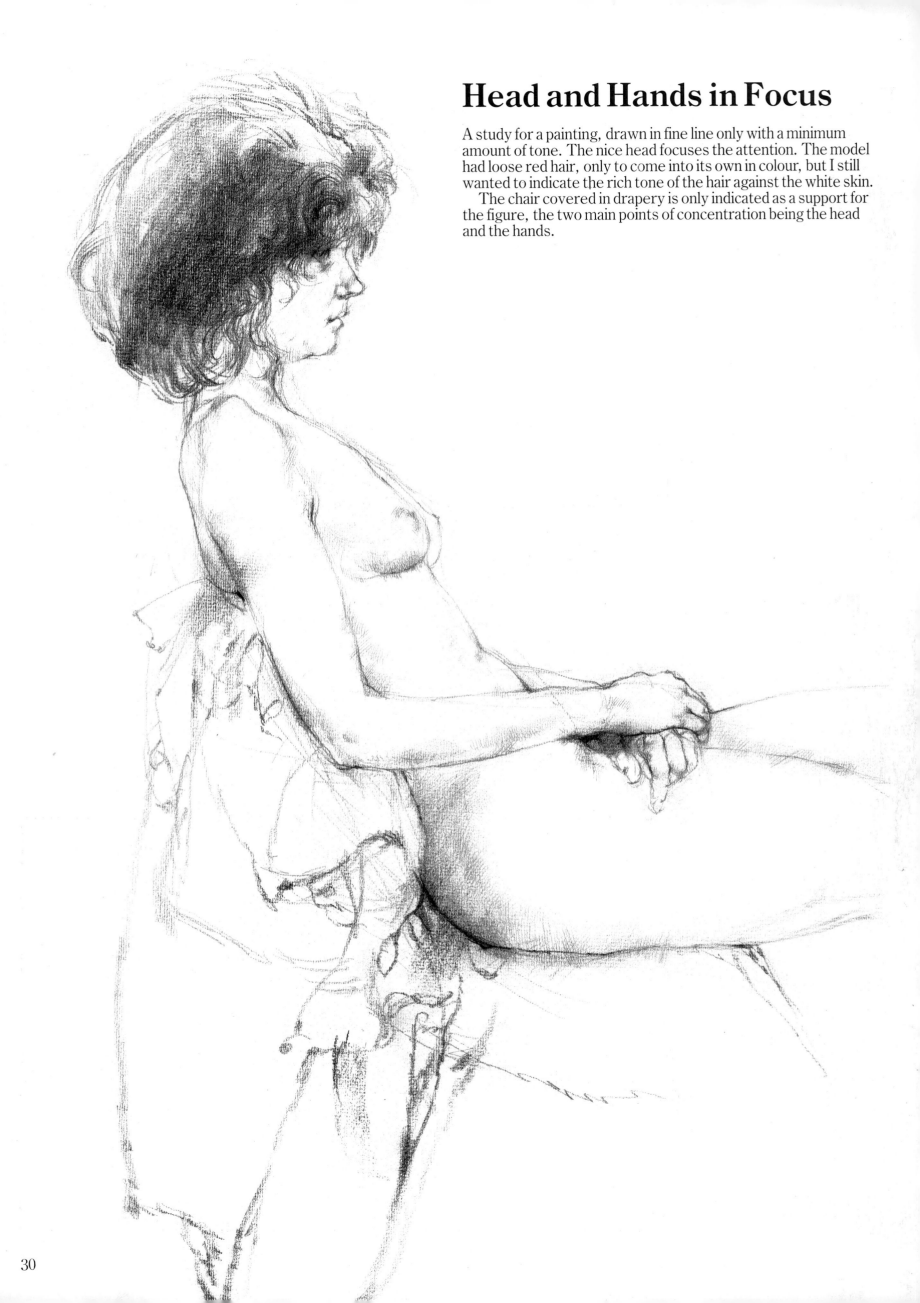

Head and Hands in Focus

A study for a painting, drawn in fine line only with a minimum amount of tone. The nice head focuses the attention. The model had loose red hair, only to come into its own in colour, but I still wanted to indicate the rich tone of the hair against the white skin.

The chair covered in drapery is only indicated as a support for the figure, the two main points of concentration being the head and the hands.

Detail of the head. The textured paper generally softens the carbon pencil lines, and allows the use of more diffused line and tone.

The eye, partially hidden under the loose locks of hair, still has to be carefully suggested.

The hair is drawn in outline at first to give the general shape and then broken up into smaller detail.

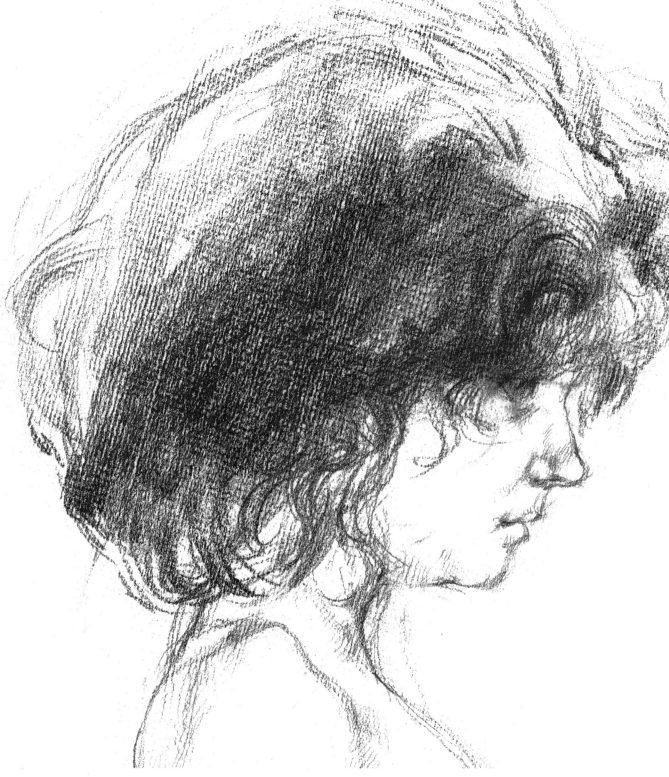

An enlarged detail of the hands. The top hand works reasonably well, but the one underneath needs more attention.

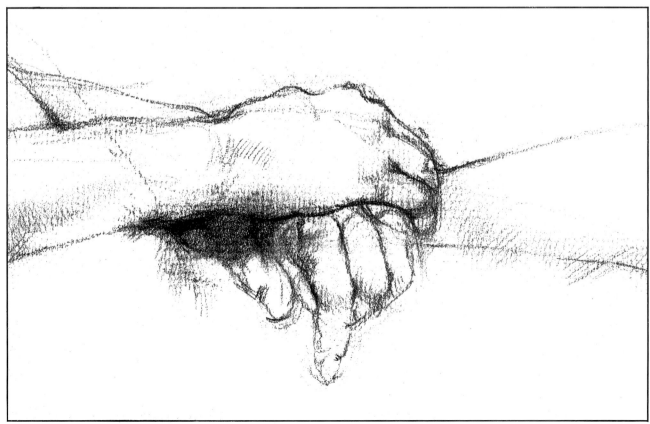

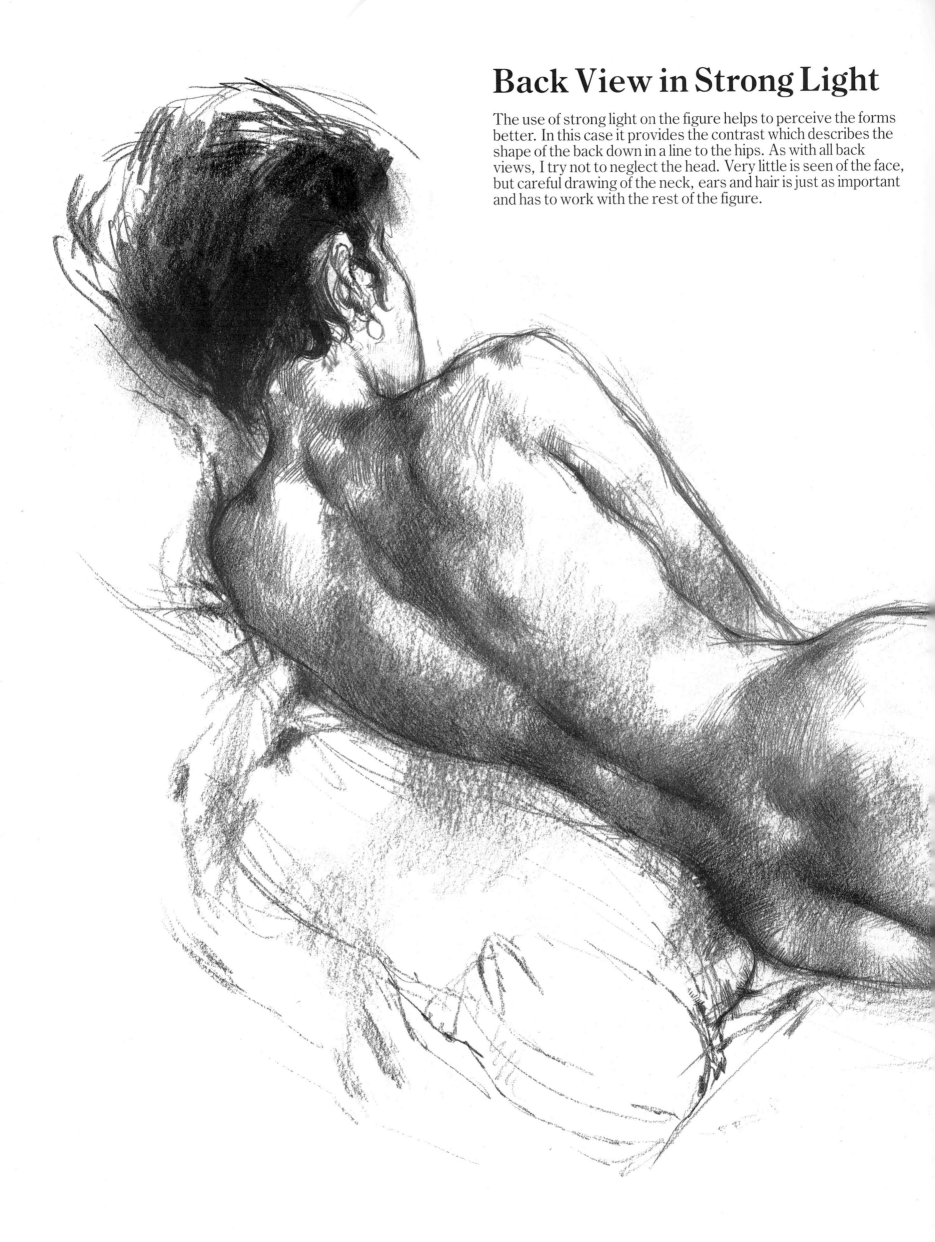

Back View in Strong Light

The use of strong light on the figure helps to perceive the forms better. In this case it provides the contrast which describes the shape of the back down in a line to the hips. As with all back views, I try not to neglect the head. Very little is seen of the face, but careful drawing of the neck, ears and hair is just as important and has to work with the rest of the figure.

An enlargement which shows
how the light falls across the
sole of the foot.

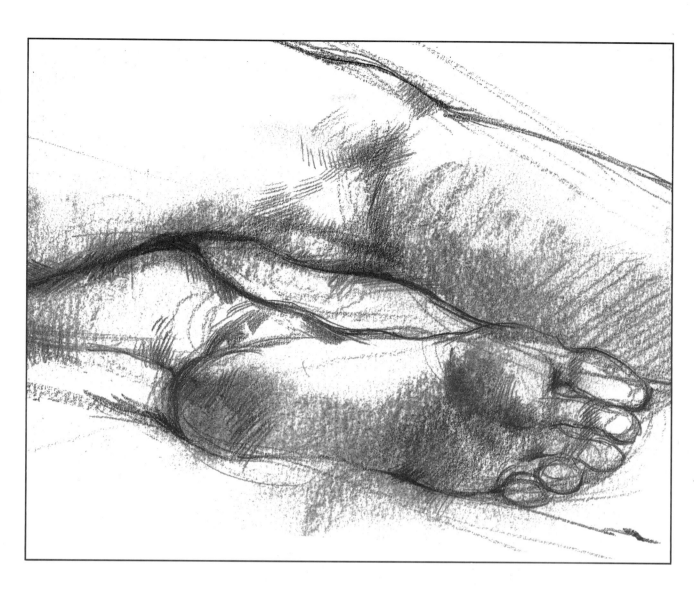

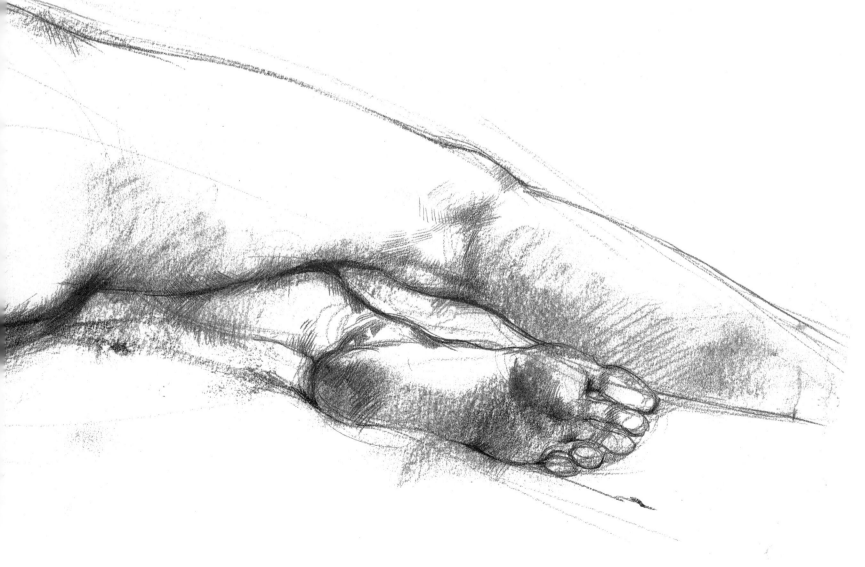

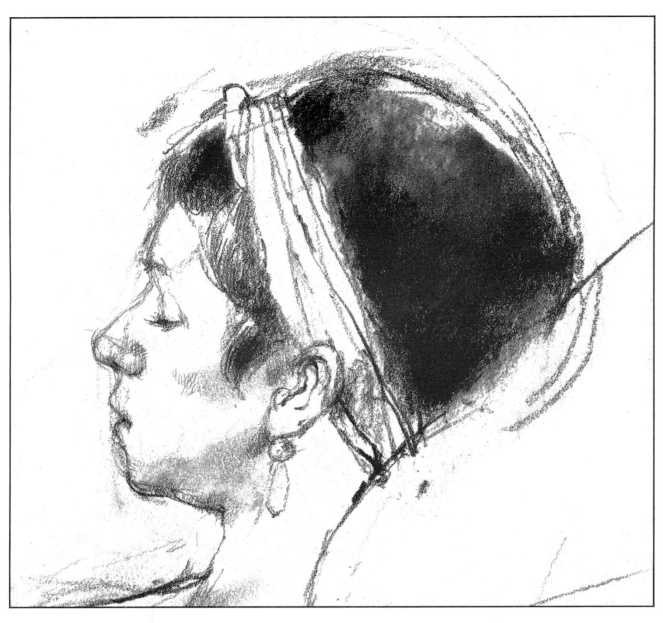

The shape of the head is suggested by the line which is only used in any strength where there is shadow.

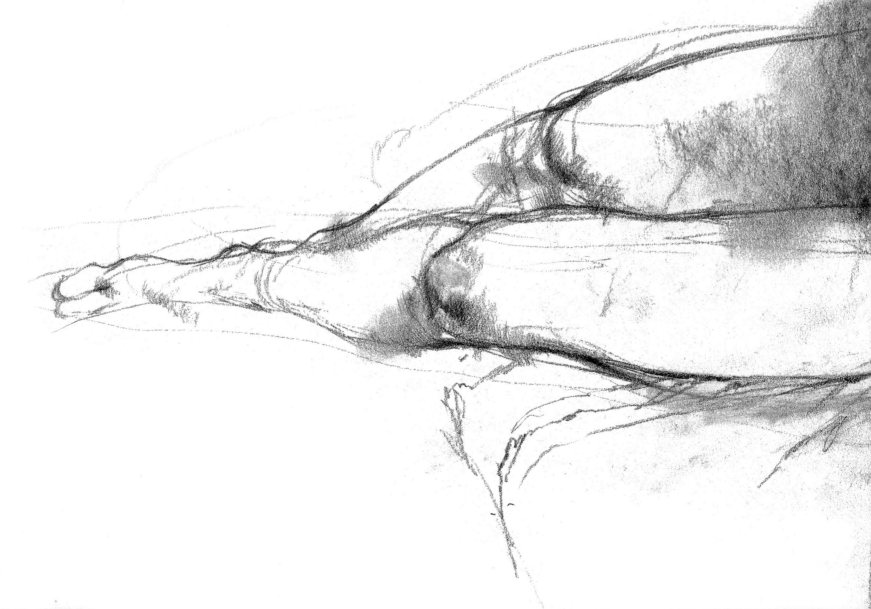

Reclining Pose in Full Light

One of several short poses. A very slim but elegant young girl seen mostly in line resting in strong light with hardly any shadows on the body. I tried to catch the flowing movements of the arms and legs and to focus on the sleeping face framed by a small band of scarf. Profiles have to be very softly drawn to stop them becoming a 'wire frame' around the face.

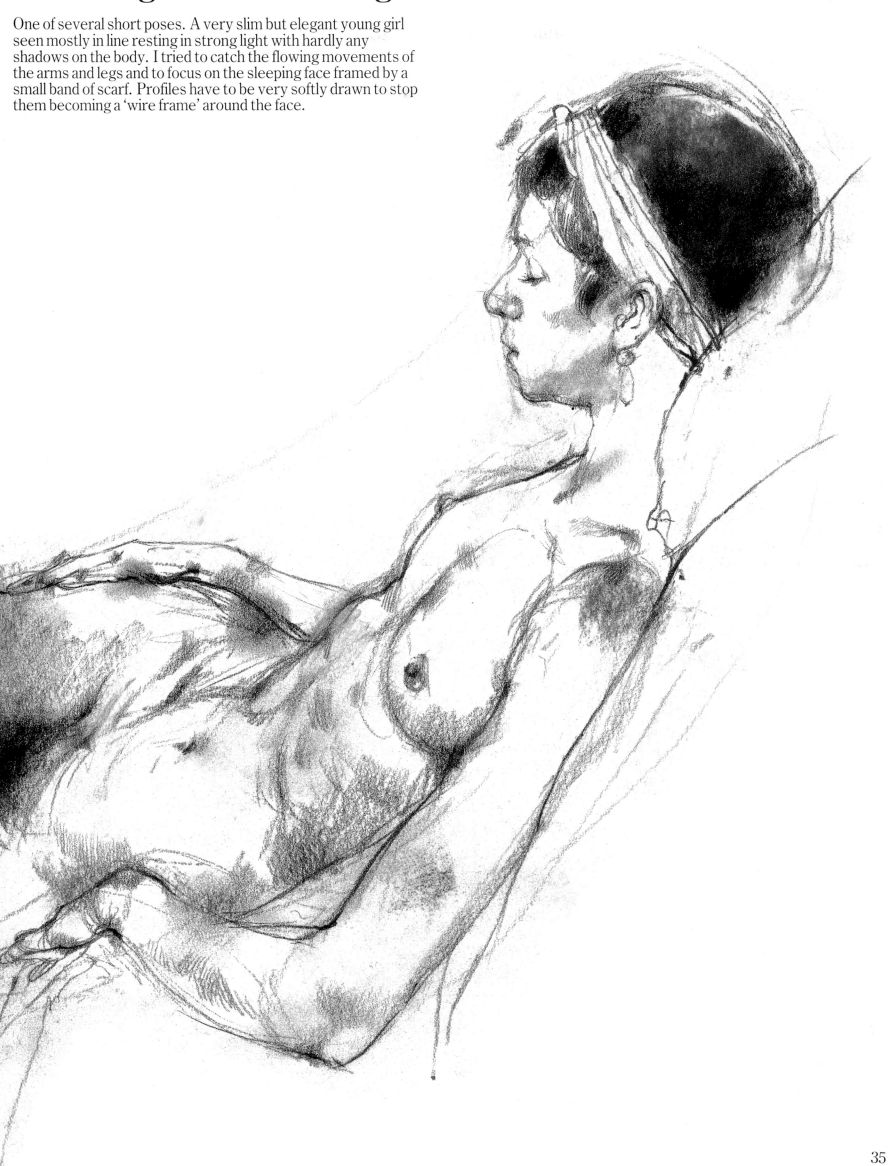

Arm Muscles on the Male Figure

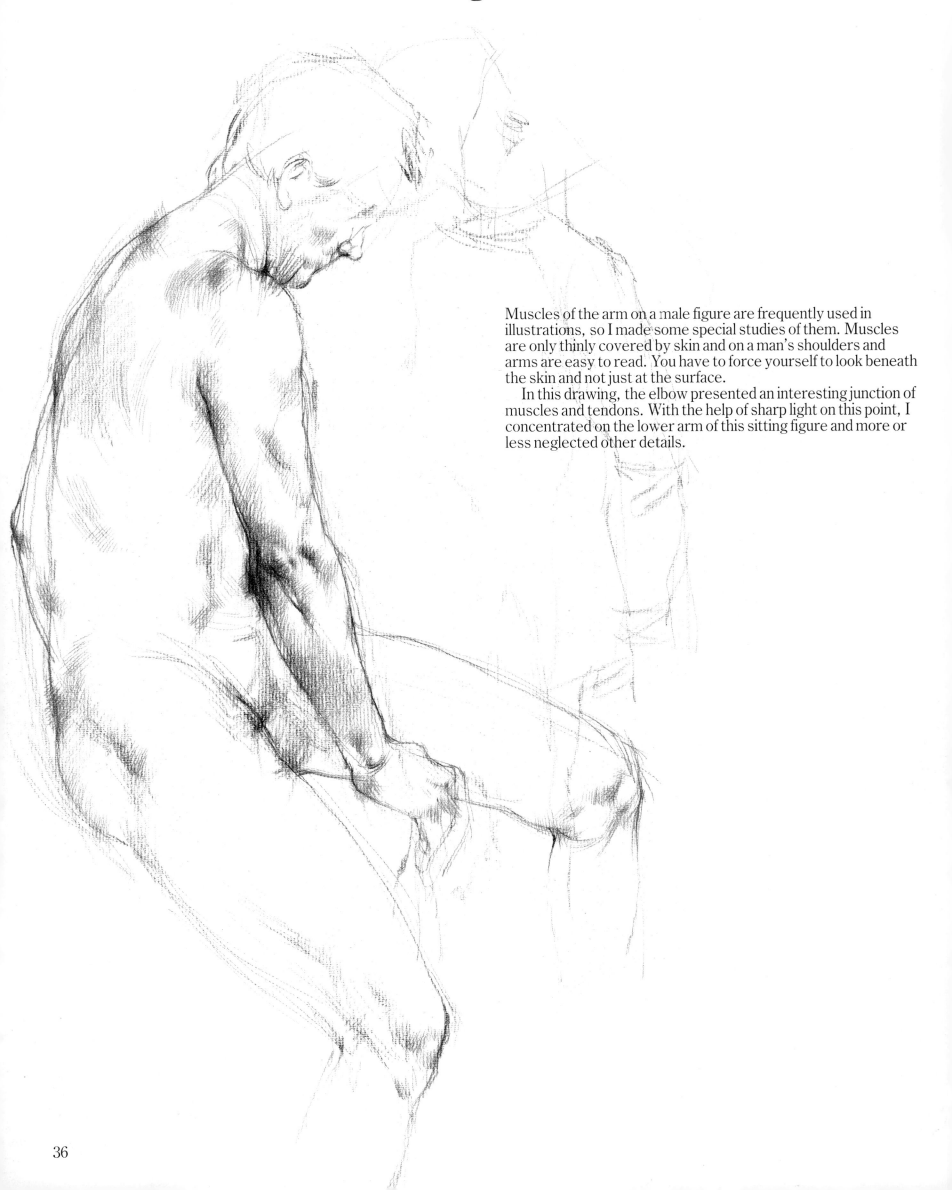

Muscles of the arm on a male figure are frequently used in illustrations, so I made some special studies of them. Muscles are only thinly covered by skin and on a man's shoulders and arms are easy to read. You have to force yourself to look beneath the skin and not just at the surface.

In this drawing, the elbow presented an interesting junction of muscles and tendons. With the help of sharp light on this point, I concentrated on the lower arm of this sitting figure and more or less neglected other details.

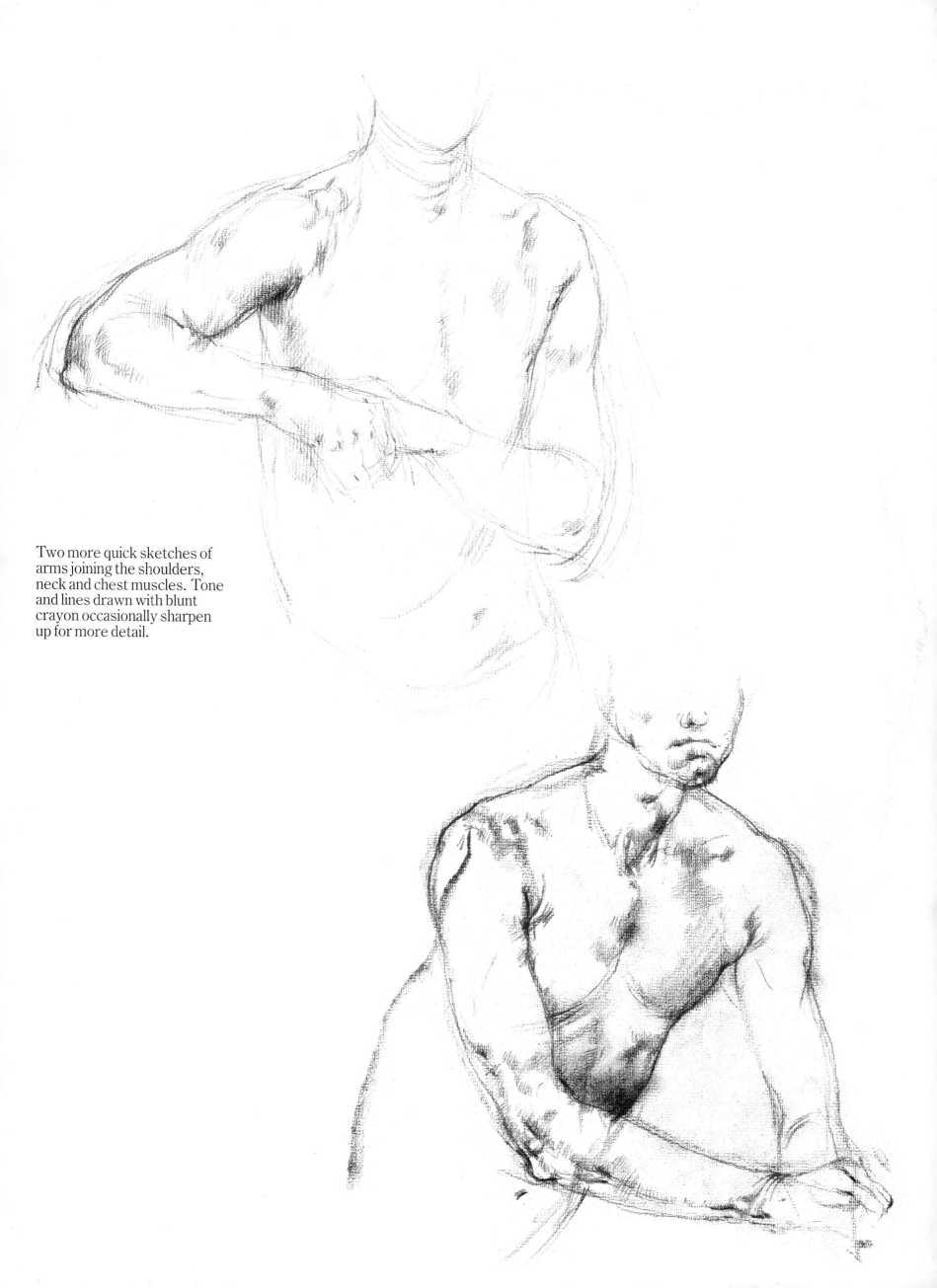

Two more quick sketches of
arms joining the shoulders,
neck and chest muscles. Tone
and lines drawn with blunt
crayon occasionally sharpen
up for more detail.

Two Sitting Poses

A 5–10 minute pose drawn with quick lines, basically to capture the pose and movement of the head to the left, with tone used to accentuate it.

With quick sketching it is the movement of the body which matters, but it is nice to indicate the mood of the face in a few lines.

No time was left for more detail on the feet, etc.

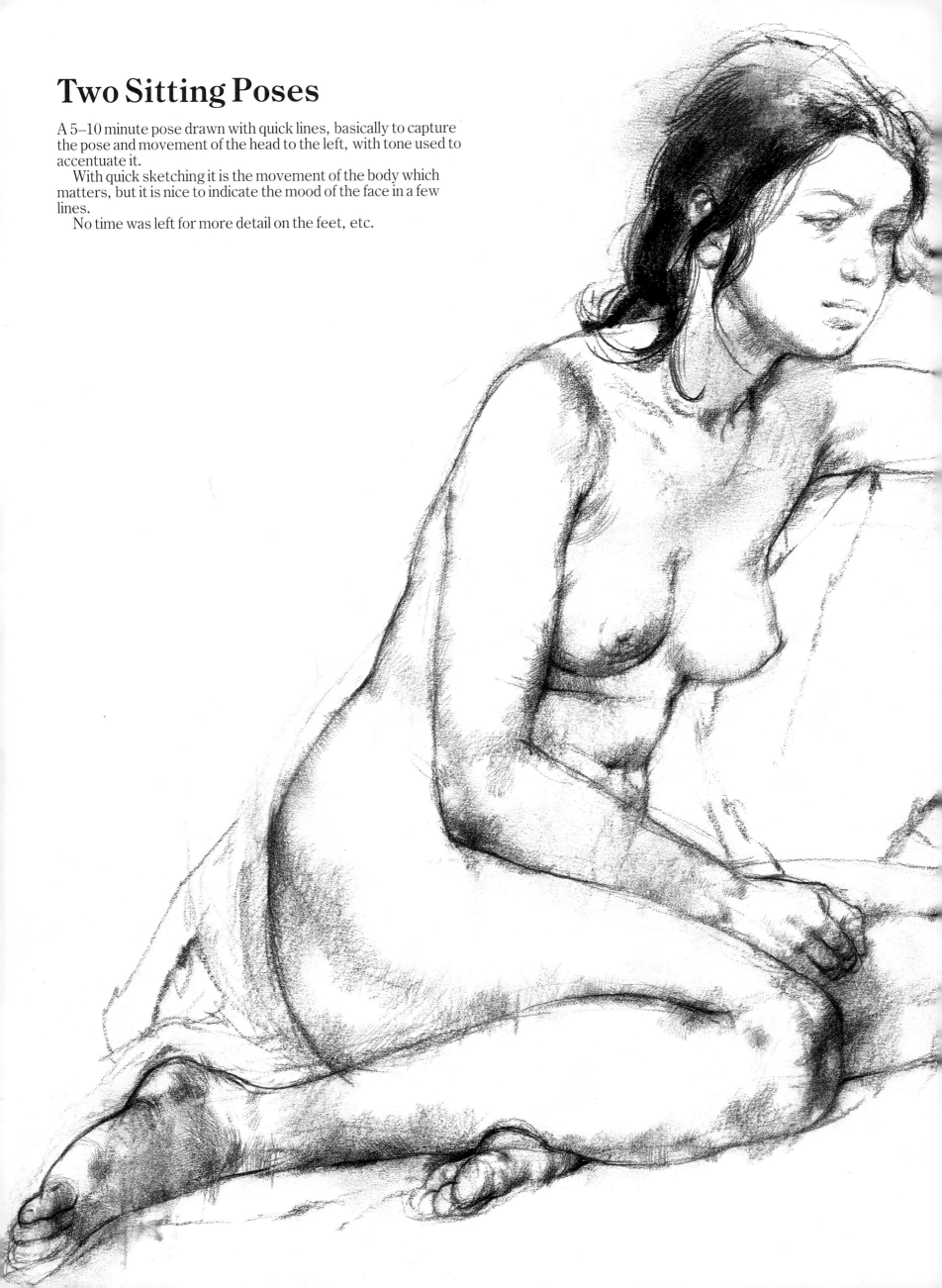

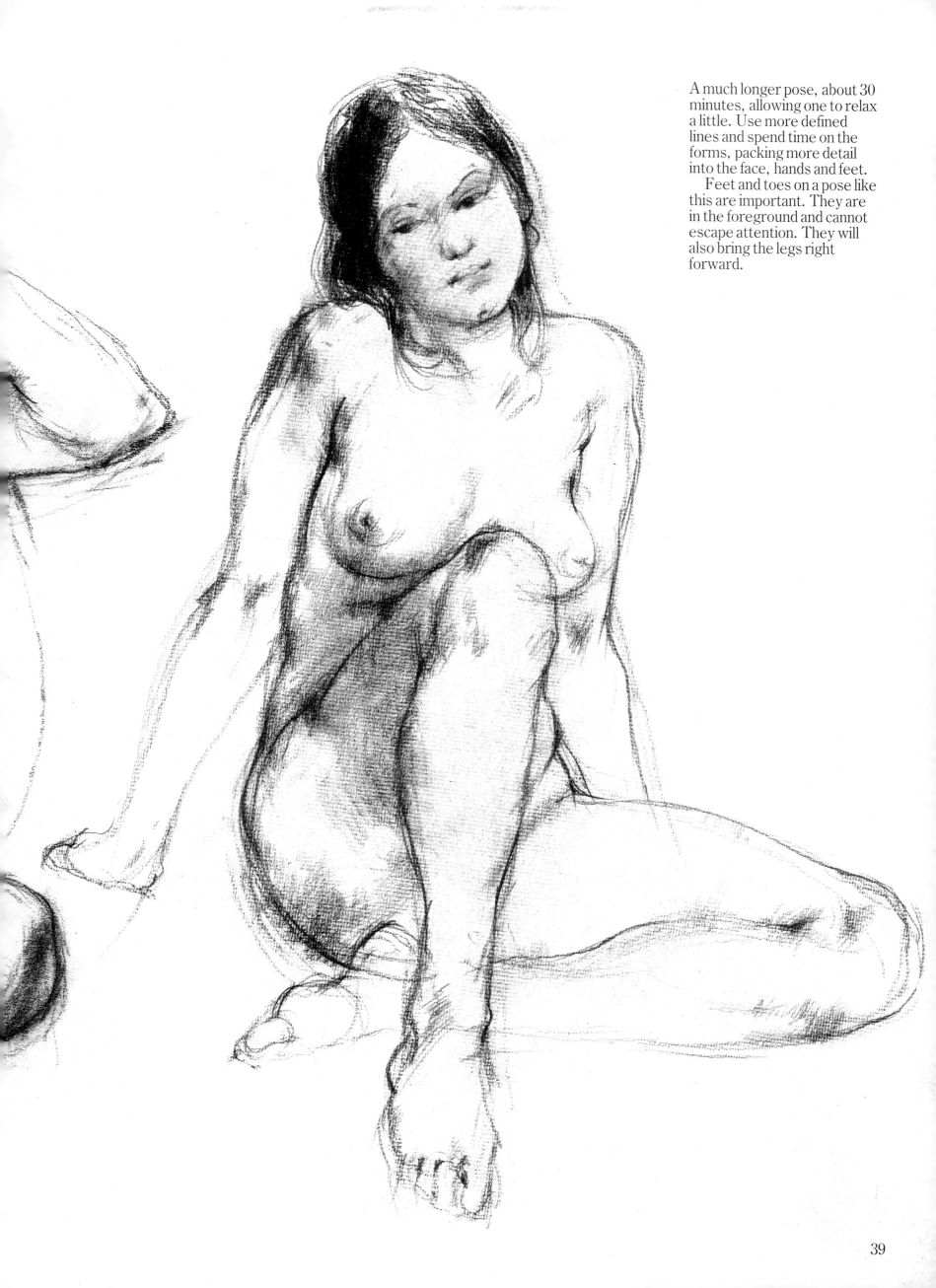

A much longer pose, about 30 minutes, allowing one to relax a little. Use more defined lines and spend time on the forms, packing more detail into the face, hands and feet.

Feet and toes on a pose like this are important. They are in the foreground and cannot escape attention. They will also bring the legs right forward.

39

Drawing Older Models

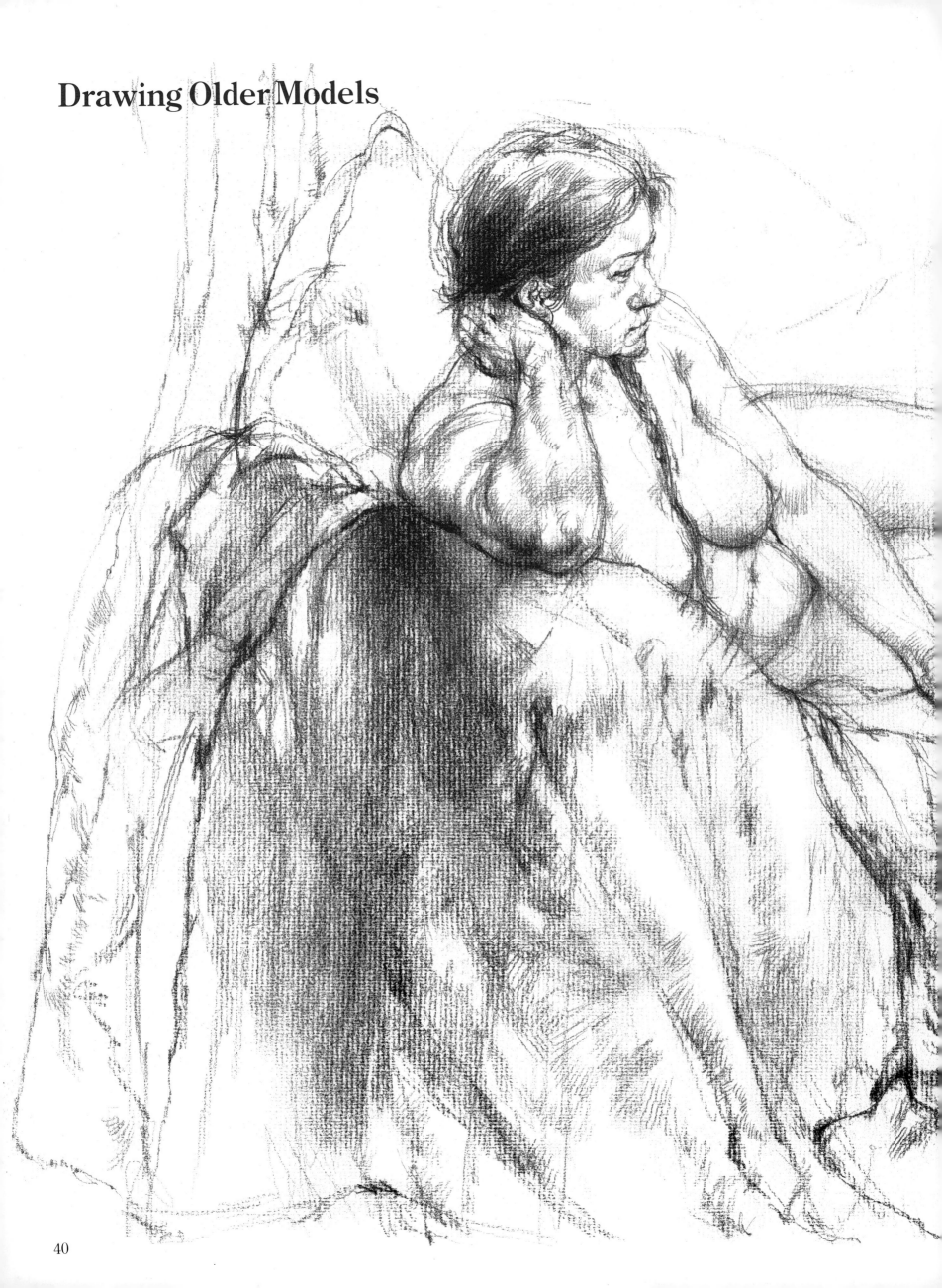

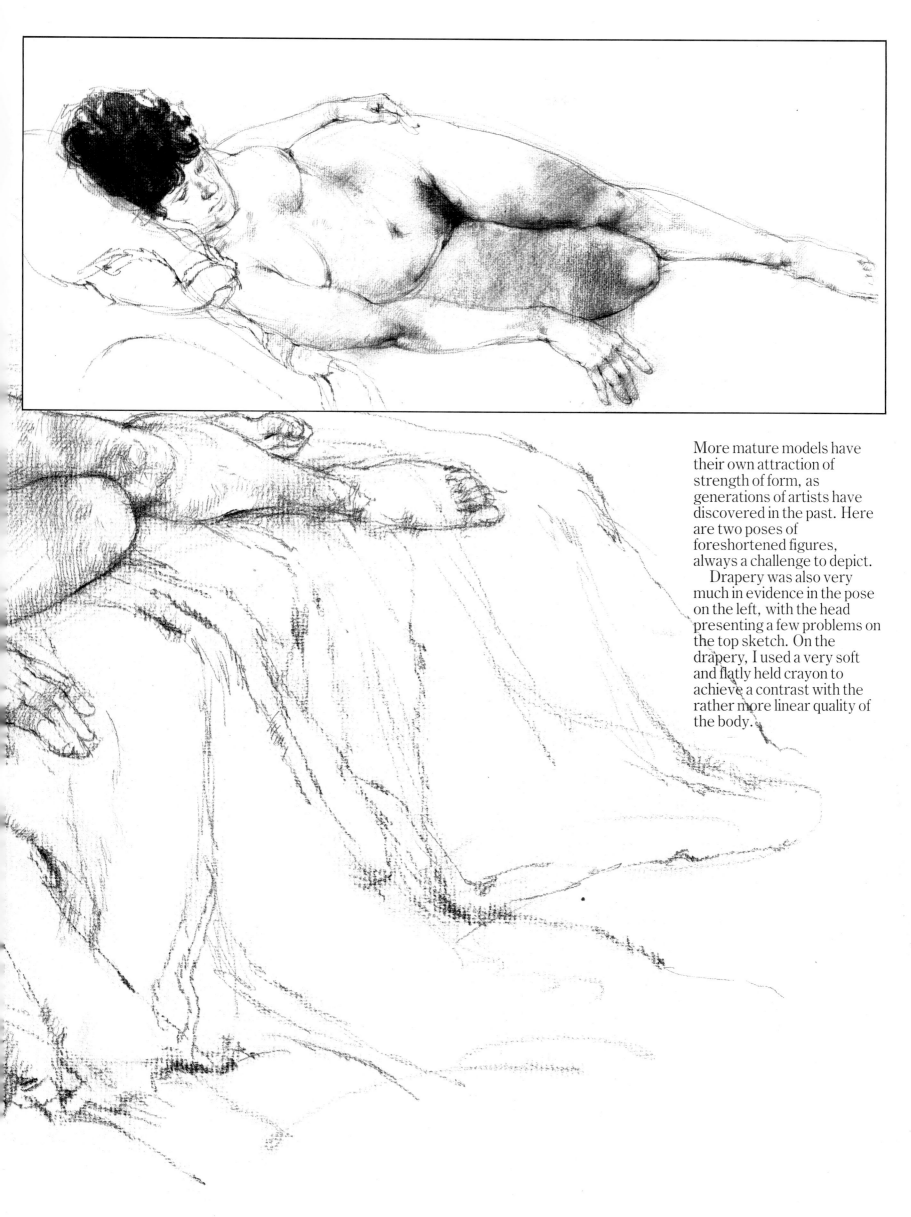

More mature models have their own attraction of strength of form, as generations of artists have discovered in the past. Here are two poses of foreshortened figures, always a challenge to depict.

Drapery was also very much in evidence in the pose on the left, with the head presenting a few problems on the top sketch. On the drapery, I used a very soft and flatly held crayon to achieve a contrast with the rather more linear quality of the body.

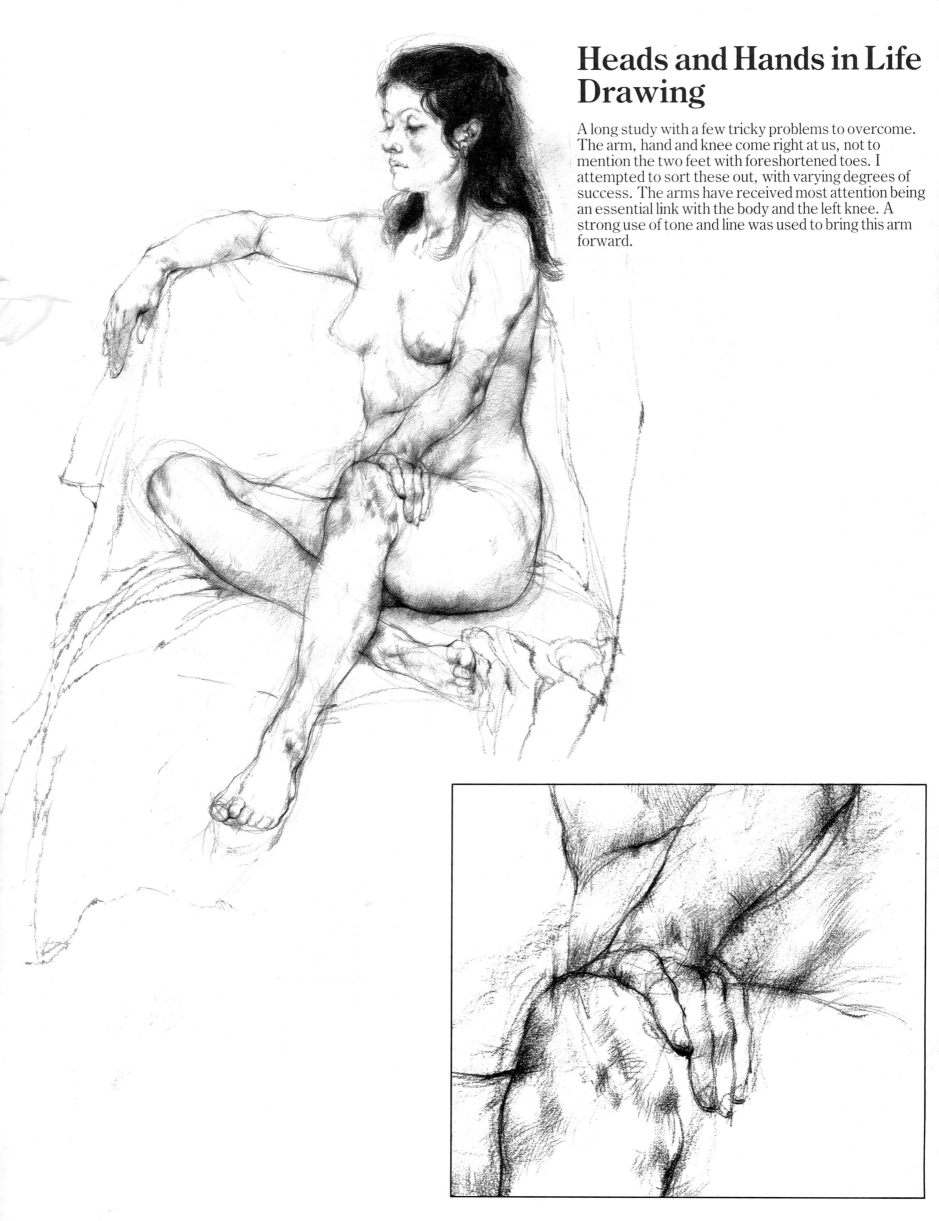

Heads and Hands in Life Drawing

A long study with a few tricky problems to overcome. The arm, hand and knee come right at us, not to mention the two feet with foreshortened toes. I attempted to sort these out, with varying degrees of success. The arms have received most attention being an essential link with the body and the left knee. A strong use of tone and line was used to bring this arm forward.

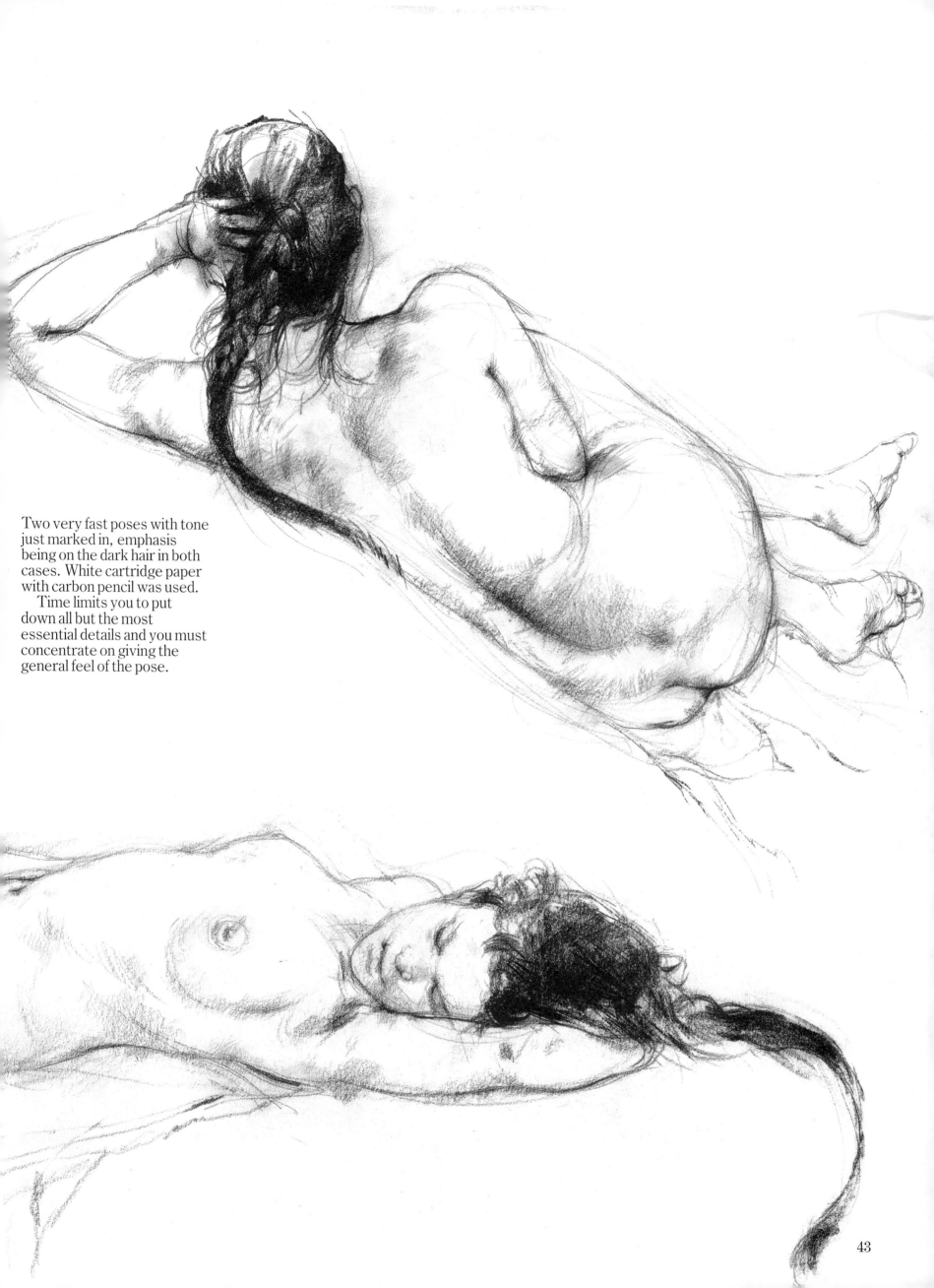

Two very fast poses with tone just marked in, emphasis being on the dark hair in both cases. White cartridge paper with carbon pencil was used.

Time limits you to put down all but the most essential details and you must concentrate on giving the general feel of the pose.

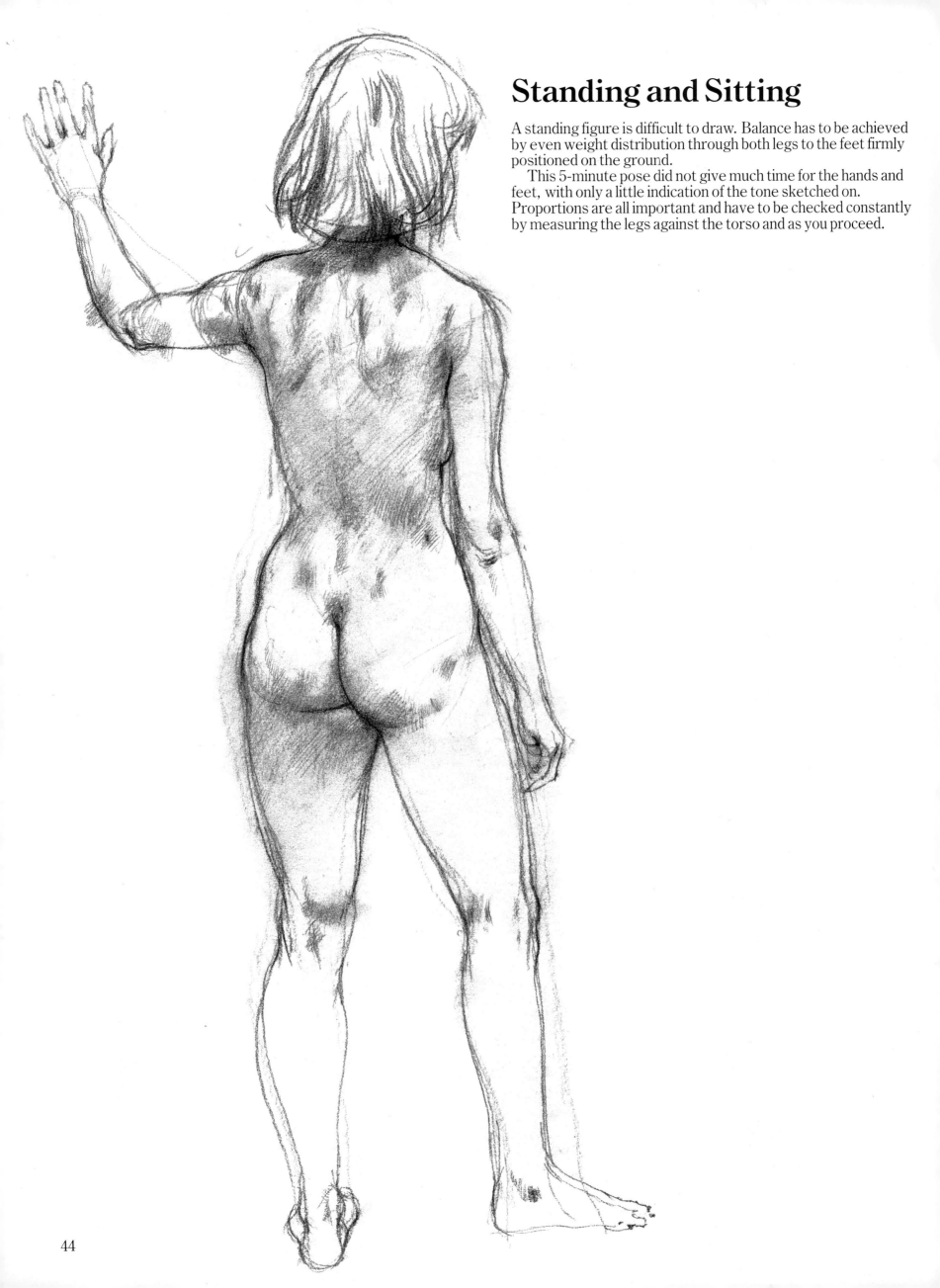

Standing and Sitting

A standing figure is difficult to draw. Balance has to be achieved by even weight distribution through both legs to the feet firmly positioned on the ground.

This 5-minute pose did not give much time for the hands and feet, with only a little indication of the tone sketched on. Proportions are all important and have to be checked constantly by measuring the legs against the torso and as you proceed.

This simple line drawing is only broken up by the long pigtail and rich dark hair of the model, with an attractive little half profile of the face. The strong triangular composition exaggerates the weight of the figure. The moderate use of tone contrasts the white of the body against the black of the hair.

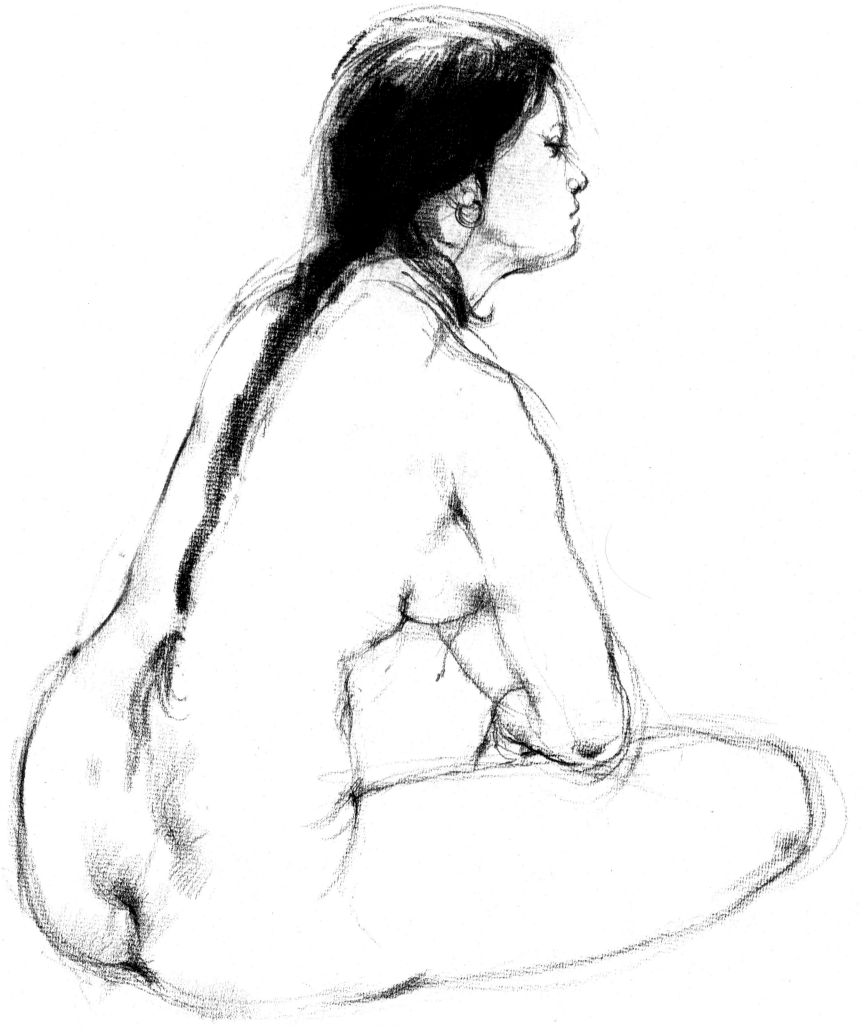

Drawing Hair

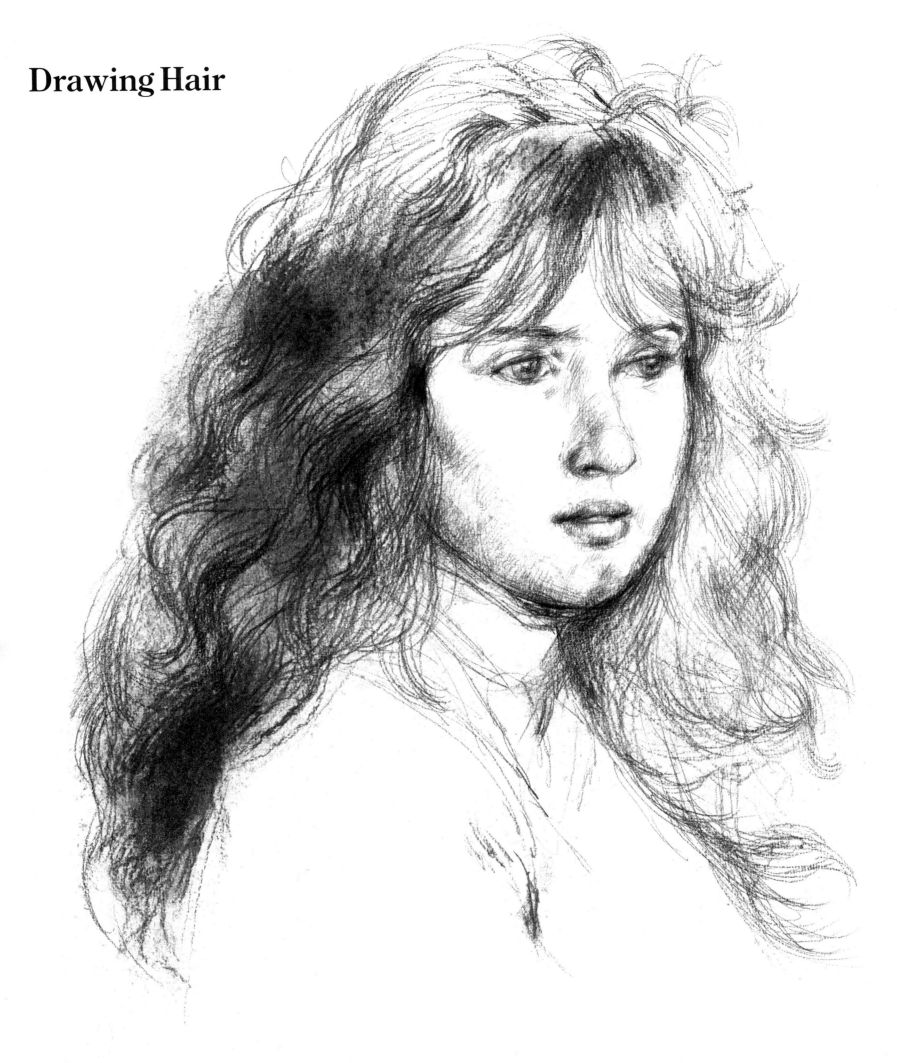

The drawing is a combination of charcoal and carbon pencil with the charcoal providing a soft background tone in contrast to the smoothness of the face. Once the bulk of the head and the facial features were accurately drawn in, I used the charcoal to lay down the general tone, then the point of the carbon pencil to finish it and to draw in the strands of fine hair as well as the details of the eyes, nose and mouth. You must look at the hair carefully and follow its direction with the pencil. It is no use giving a general impression; hair will not look convincing or have the correct texture and feel about it unless drawn with the utmost care.

Another head of a young girl with much stronger shadows on the face, which allows more modelling of the mouth and nose. The fringe throws a shadow over the eyes; this is laid down first with charcoal, then the eyes are drawn in with carbon pencil. In contrast to the girl opposite, this model has dark brown, heavy hair which is drawn in sweeping heavy lines. The sections of the fringe and the longer hair down the sides can be clearly delineated beforehand, so that detail can be added without losing sight of the large, general shapes.

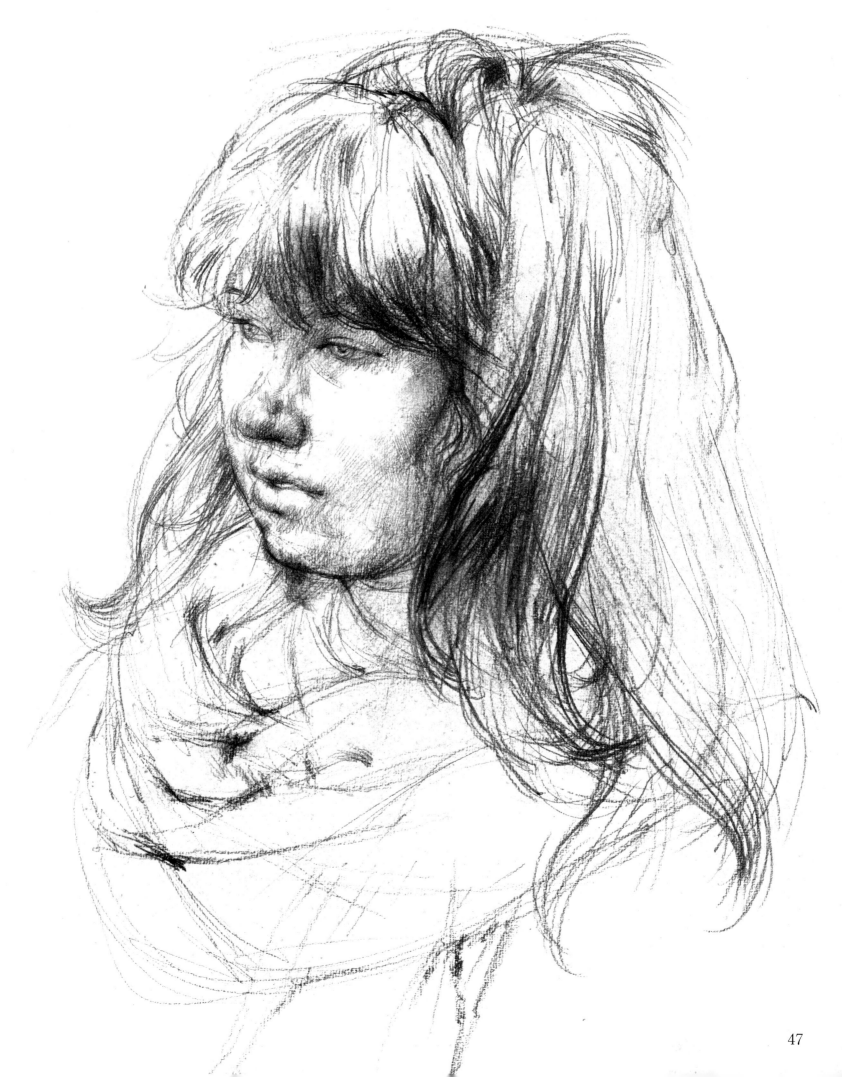

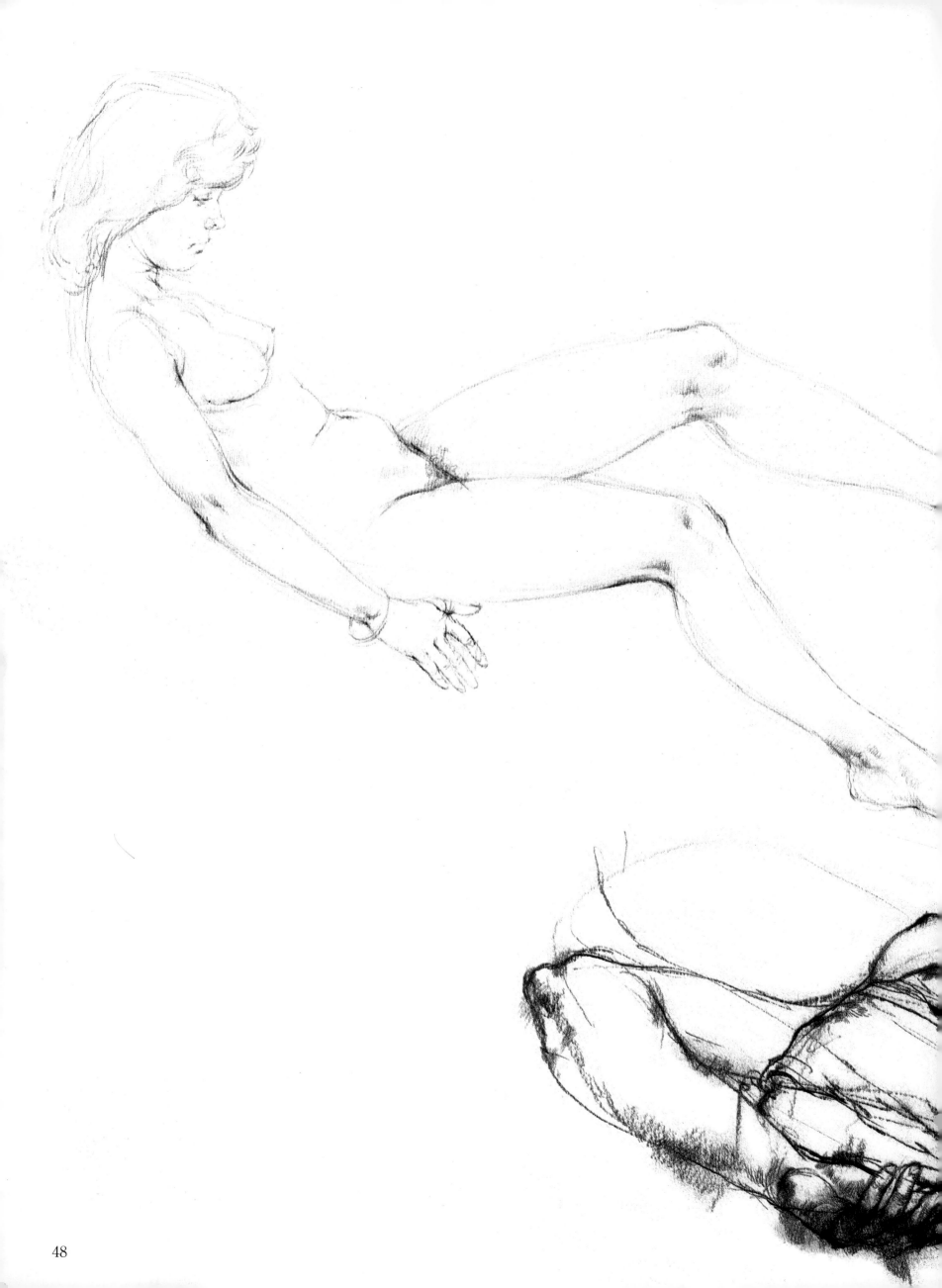

Finding the Right Pose

A drawing in very light line and tone. The lack of shadows and contrasts made this pose suitable for a clear-cut line study with just enough tone to make the forms three-dimensional.

The fine point of the pencil was used to accurately describe detail in the hands, feet and face.

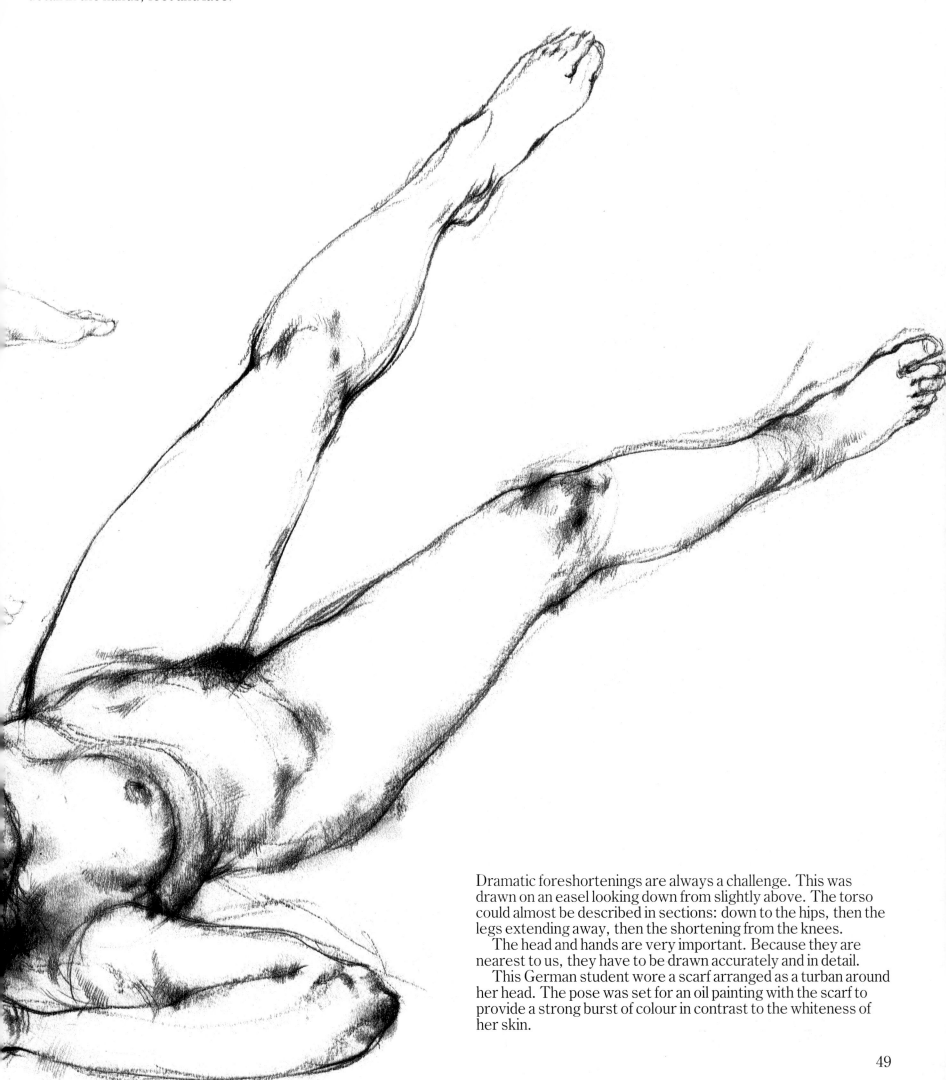

Dramatic foreshortenings are always a challenge. This was drawn on an easel looking down from slightly above. The torso could almost be described in sections: down to the hips, then the legs extending away, then the shortening from the knees.

The head and hands are very important. Because they are nearest to us, they have to be drawn accurately and in detail.

This German student wore a scarf arranged as a turban around her head. The pose was set for an oil painting with the scarf to provide a strong burst of colour in contrast to the whiteness of her skin.

49

A Work Sheet of Quick Drawings

You may wish to move around and draw some quick sketches of the same pose from different angles. Alternatively, you could concentrate on legs, feet or shoulders, neglecting the head.

Here are two very similar sitting poses, experiments for a painting. Before deciding on a pose for an oil painting it is always useful to make a series of quick sketches of different poses, and then decide which one of these you like best. First thing in the morning, at the beginning of the day's work, the model may not be very relaxed and may not move in the most natural way. A few different poses and some figure drawings will help both you and your model to find the right pose for a painting.

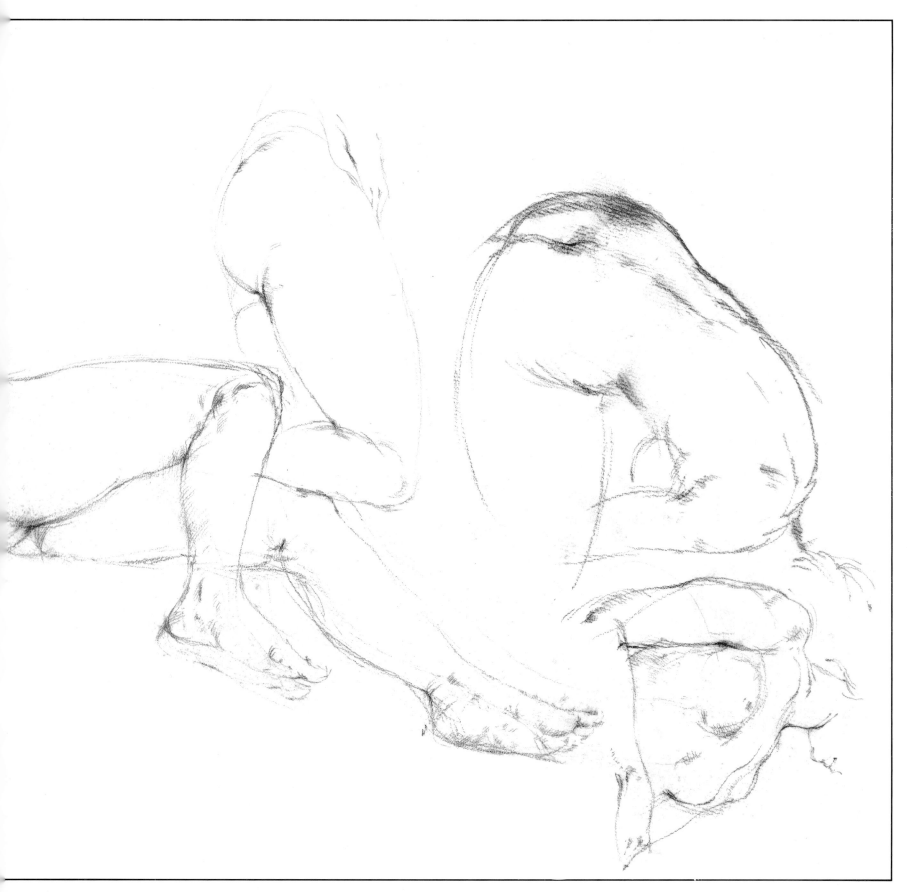

Your drawing sheet may look like a jumble of legs, hips and arms, but each sketch is a useful exercise. It gives you a chance to concentrate on a tricky arm, the turn of a neck, or upturned feet which would normally be just part of a whole figure. It can also produce some very interesting 'abstract' compositions and save you a lot of paper.

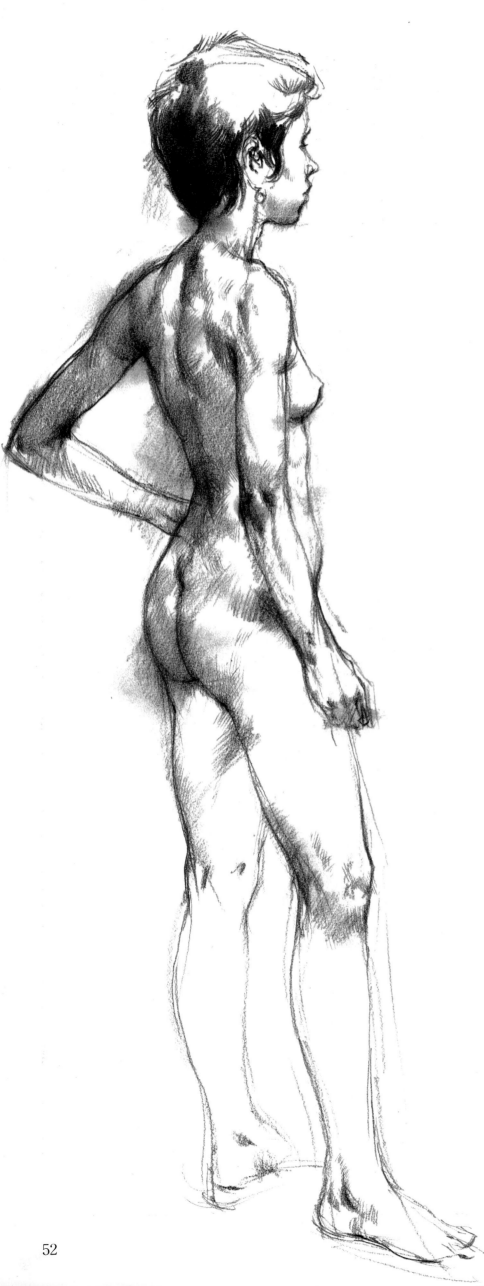

Standing and Resting

Standing figures have to be well balanced. Here, no time was left for the feet, which should have been drawn in better. However, the top half of the model created the more interesting subject with the richer tone.

Tone does not just stop at the edge of the figure, but overlaps into the background.

Superimposed sketches done during quick poses owing to shortage of paper! They do make interesting drawings, in this case, one in line and one in much richer tone. The weight of the body, all to one side, is brought out with the use of charcoal and soft carbon pencil, with just an indication of the features of the face.

It is often said that 'what you leave out' is just as important as 'what you put in' to a drawing. Do not hesitate to concentrate on one part of the body, in this case leaving in the torso with just a line description for the head.

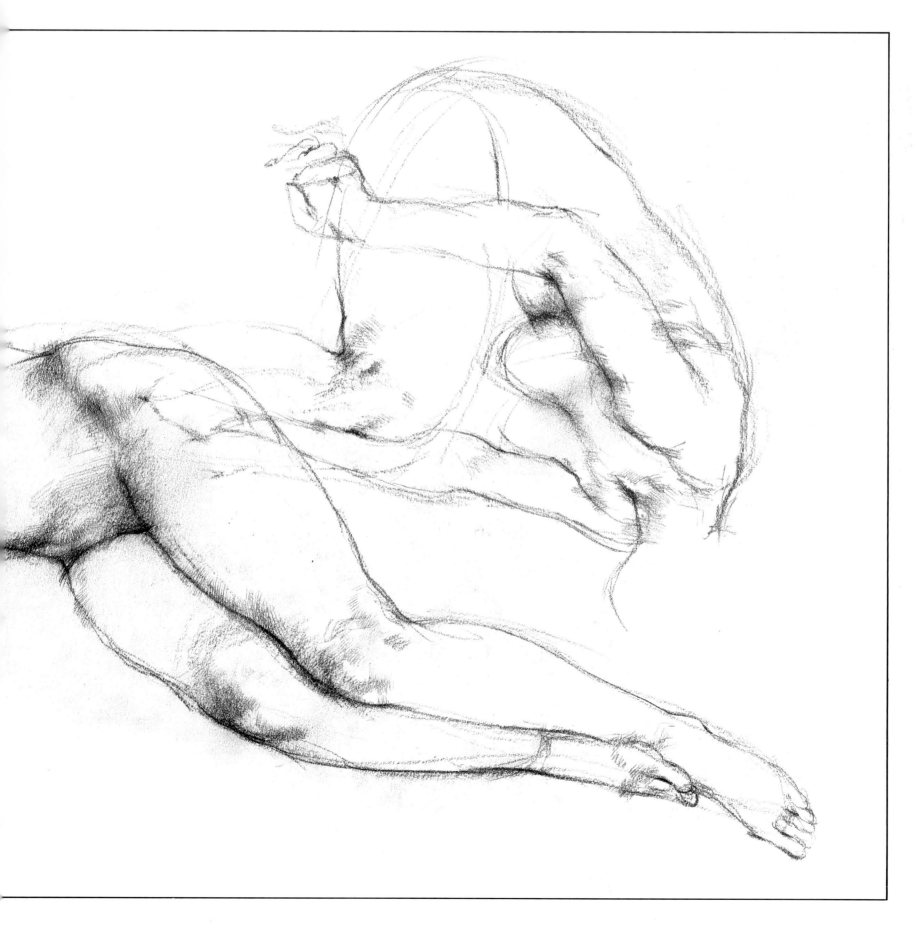

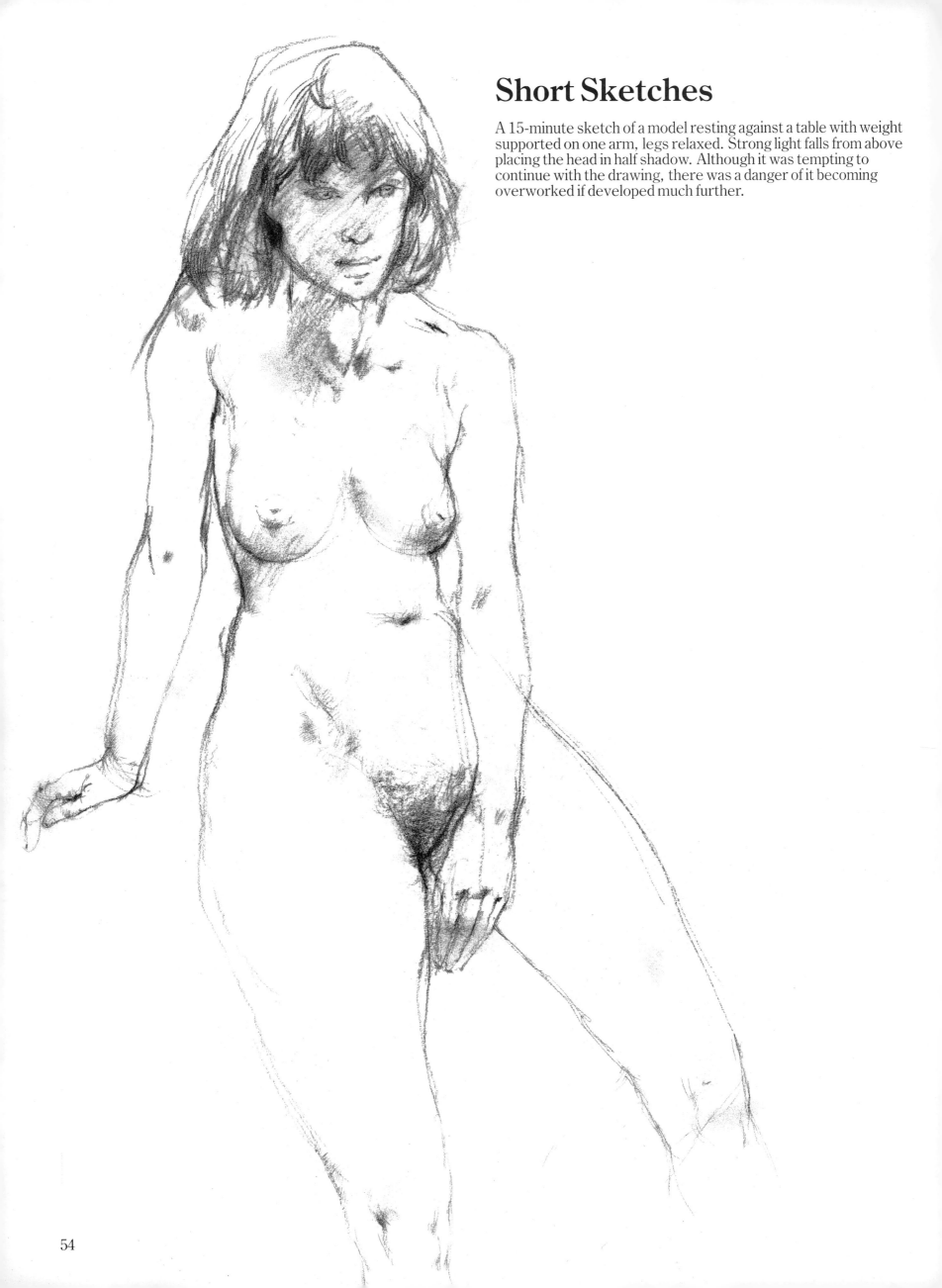

Short Sketches

A 15-minute sketch of a model resting against a table with weight supported on one arm, legs relaxed. Strong light falls from above placing the head in half shadow. Although it was tempting to continue with the drawing, there was a danger of it becoming overworked if developed much further.

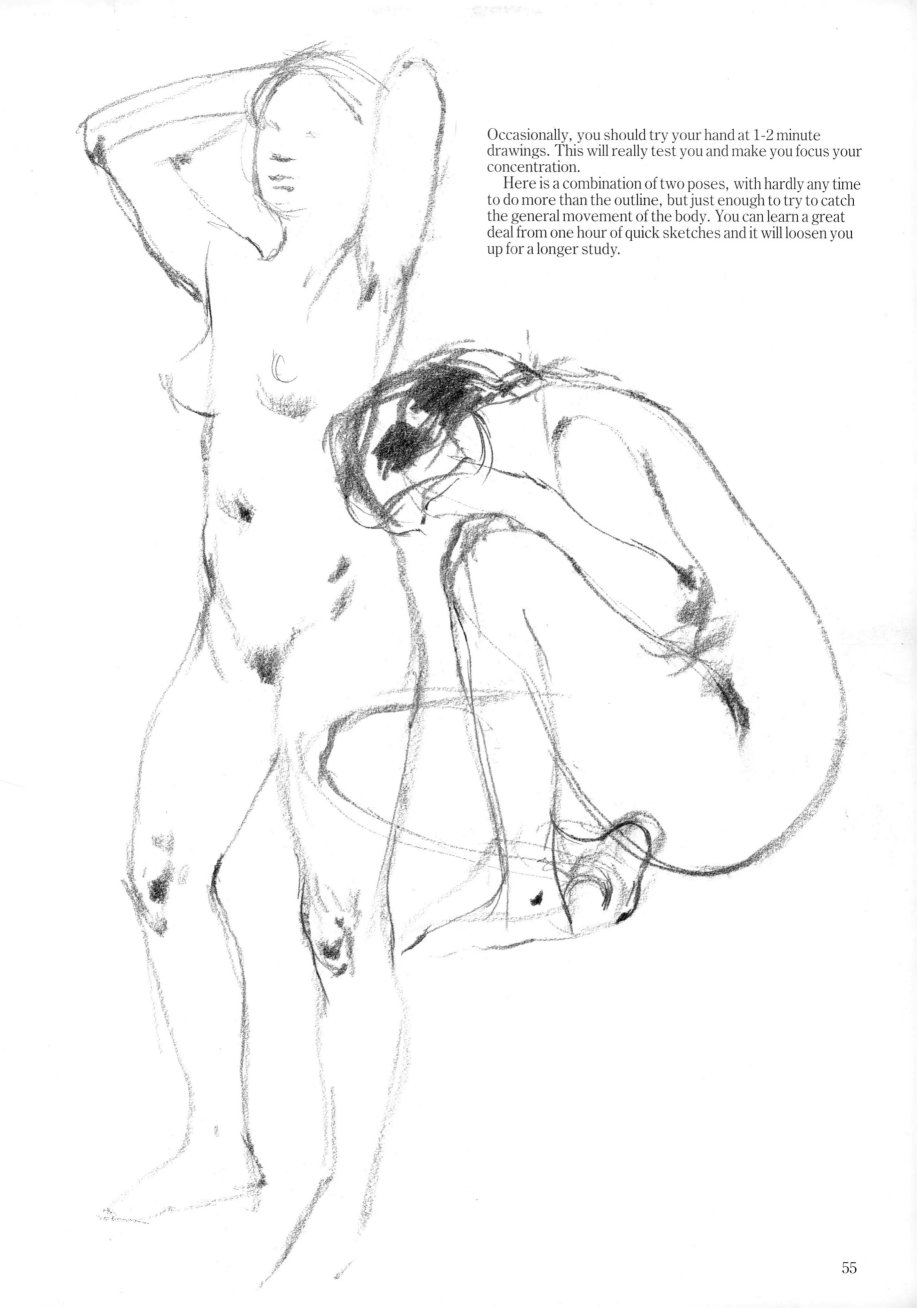

Occasionally, you should try your hand at 1-2 minute drawings. This will really test you and make you focus your concentration.

Here is a combination of two poses, with hardly any time to do more than the outline, but just enough to try to catch the general movement of the body. You can learn a great deal from one hour of quick sketches and it will loosen you up for a longer study.

Two Similar Back Views

Contrasting models
An interesting head with lots of strong forms and very short hair. The lack of hair on the back of the head presents the opportunity to draw more clearly the turning of the head, with the arms supporting the slightly curved back.

Strong light from above made the head fascinating to draw.

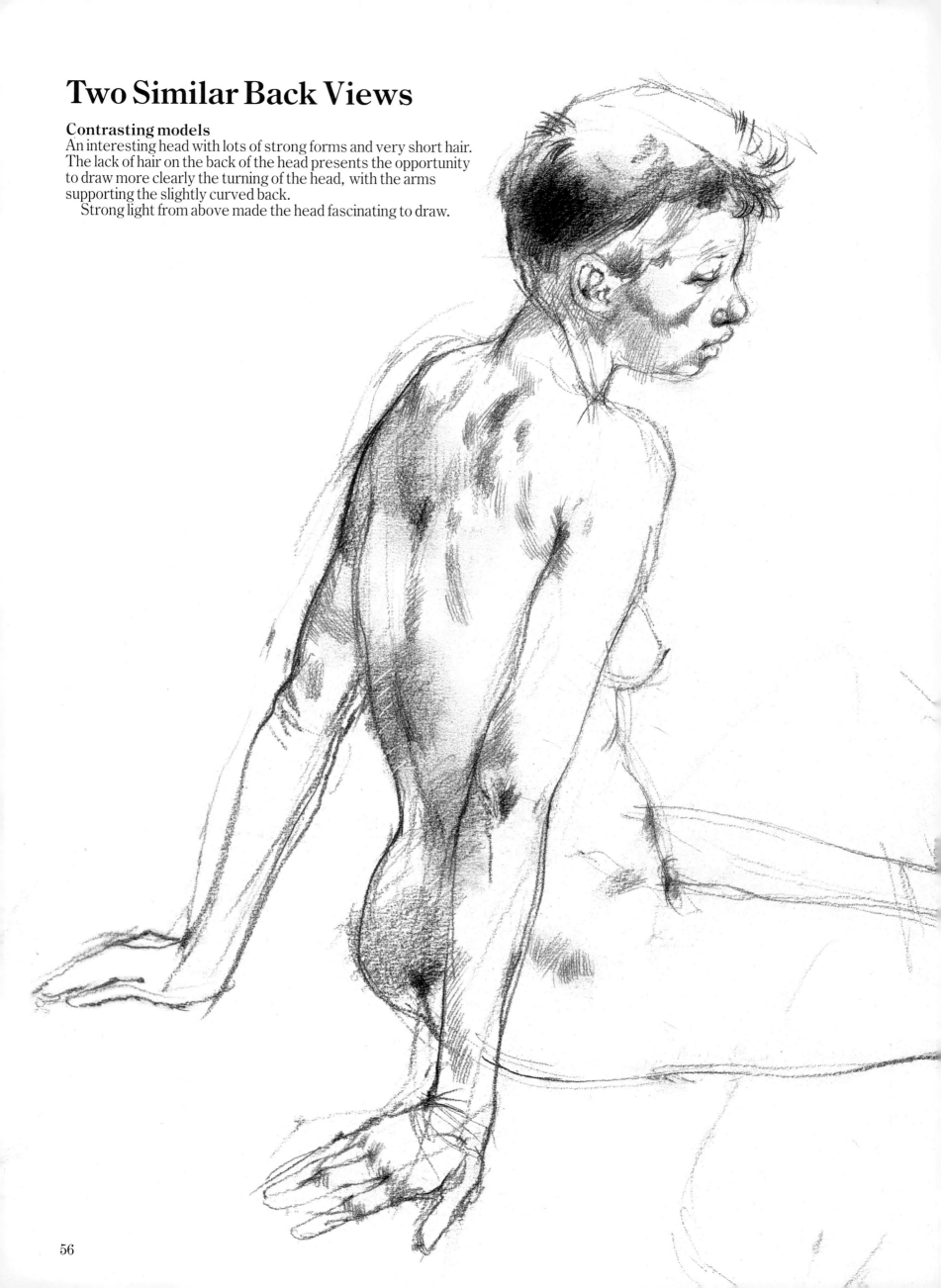

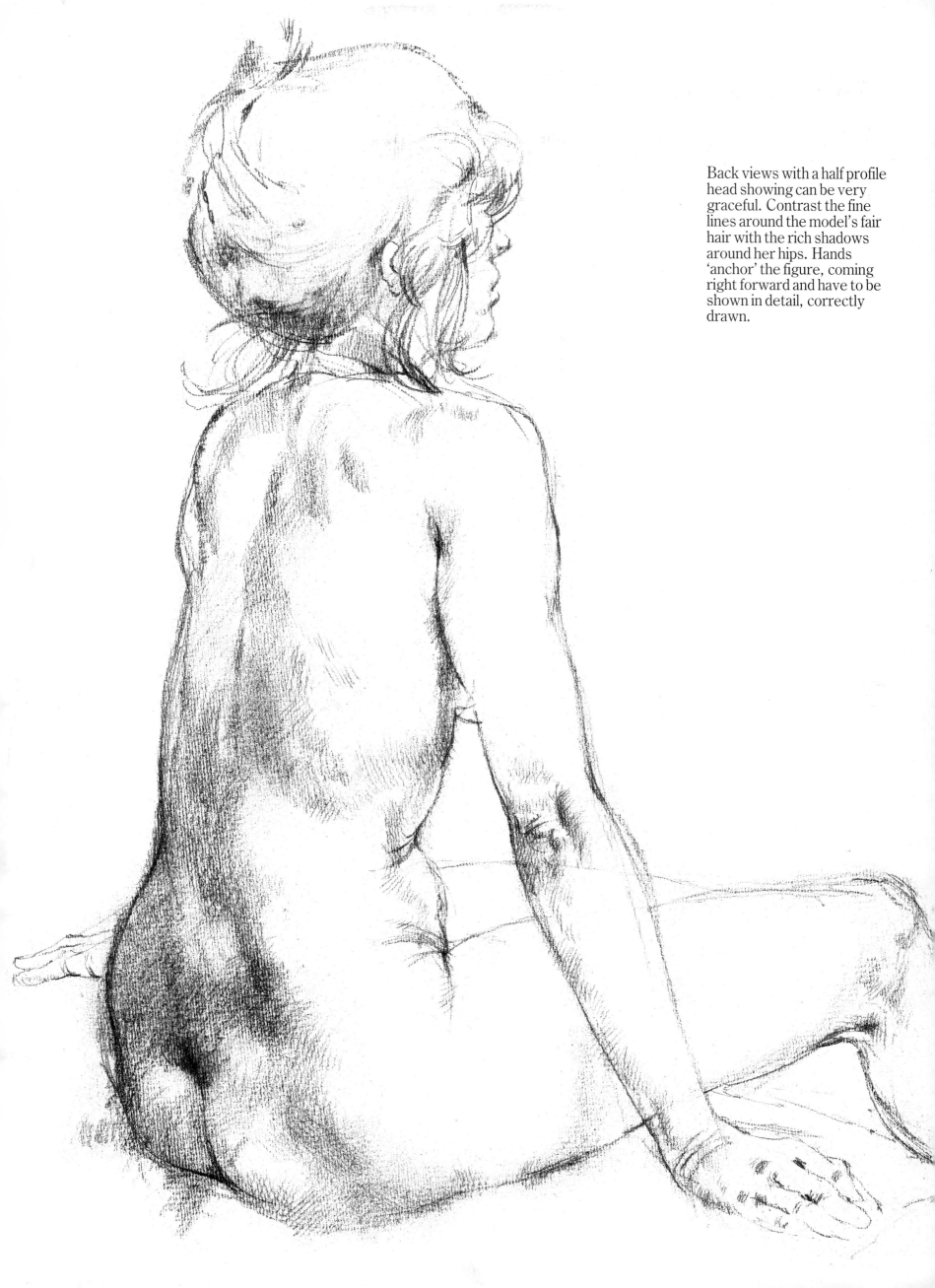

Back views with a half profile head showing can be very graceful. Contrast the fine lines around the model's fair hair with the rich shadows around her hips. Hands 'anchor' the figure, coming right forward and have to be shown in detail, correctly drawn.

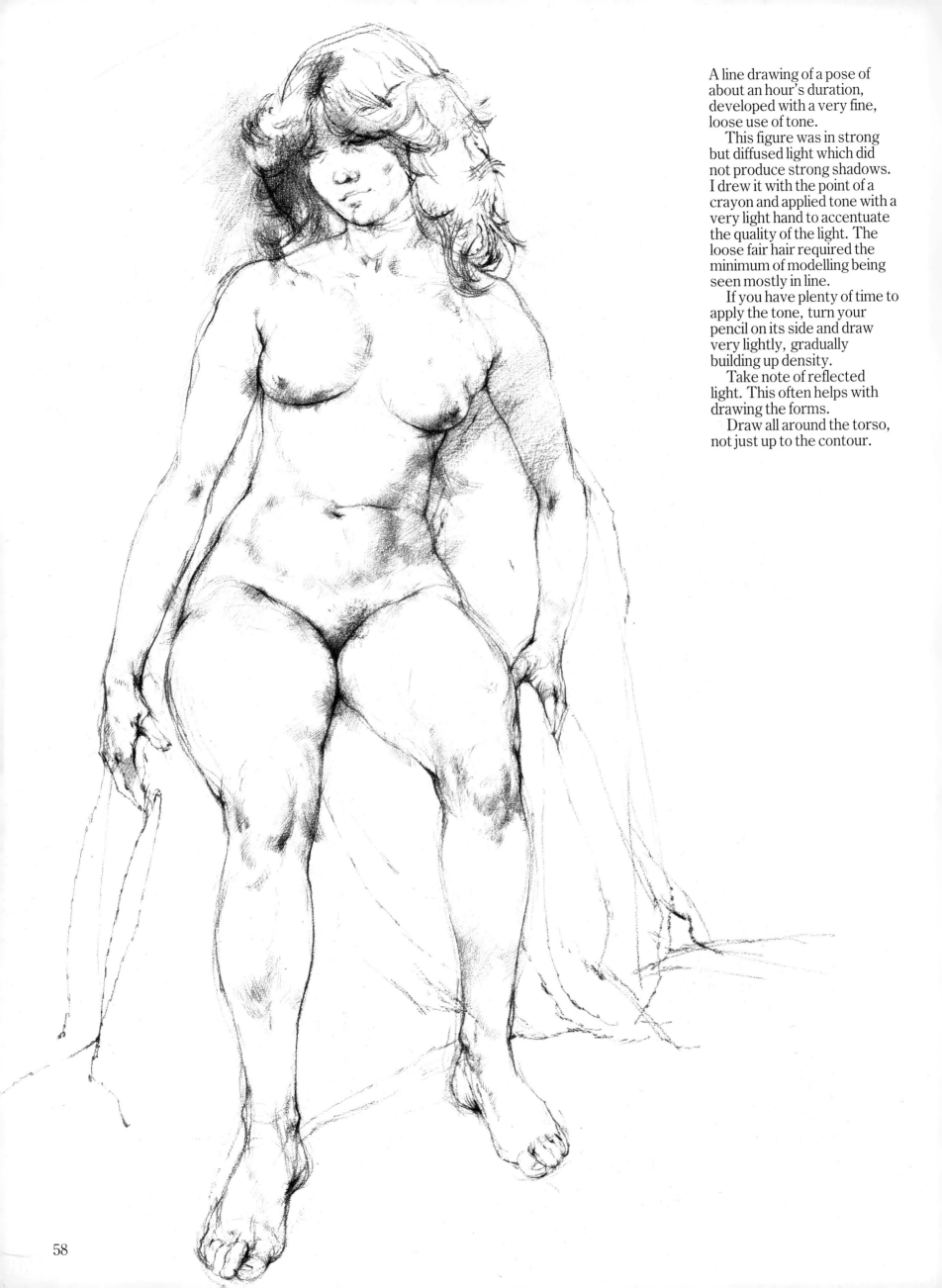

A line drawing of a pose of
about an hour's duration,
developed with a very fine,
loose use of tone.

This figure was in strong
but diffused light which did
not produce strong shadows.
I drew it with the point of a
crayon and applied tone with a
very light hand to accentuate
the quality of the light. The
loose fair hair required the
minimum of modelling being
seen mostly in line.

If you have plenty of time to
apply the tone, turn your
pencil on its side and draw
very lightly, gradually
building up density.

Take note of reflected
light. This often helps with
drawing the forms.

Draw all around the torso,
not just up to the contour.

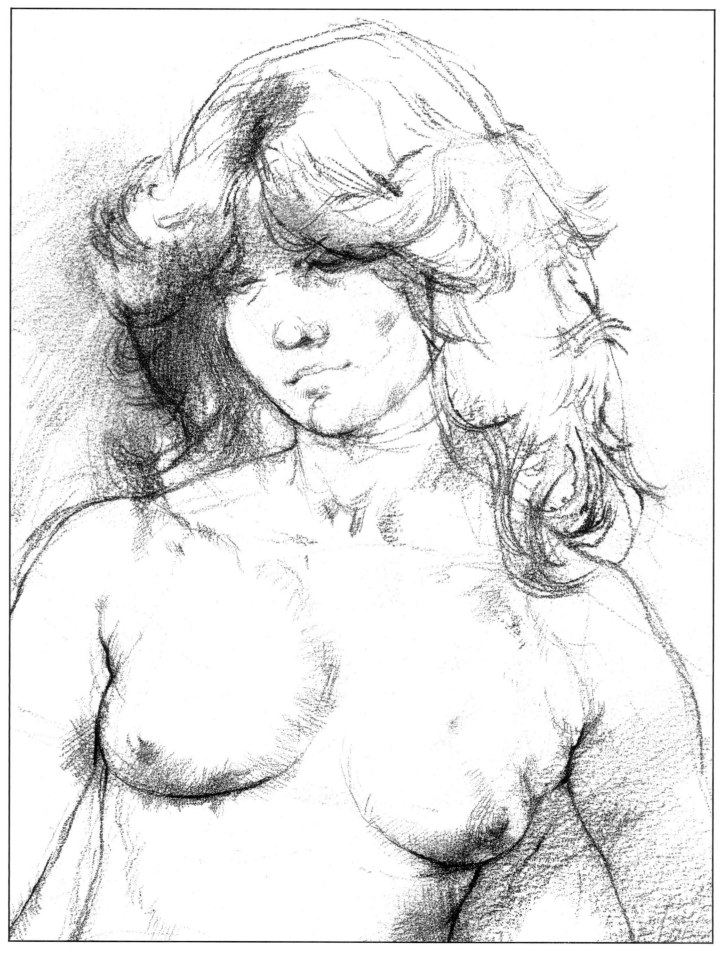

Detail. A very loose
indication of a nice head will
often work better than a
study which is fully worked out.

Looking Down

An extremely foreshortened figure drawn from above can be difficult.

Heads and hands coming very forward command attention to improve the perspective. A fairly strong and fast line assisted by shadow is laid loosely across the thighs of the model with charcoal.

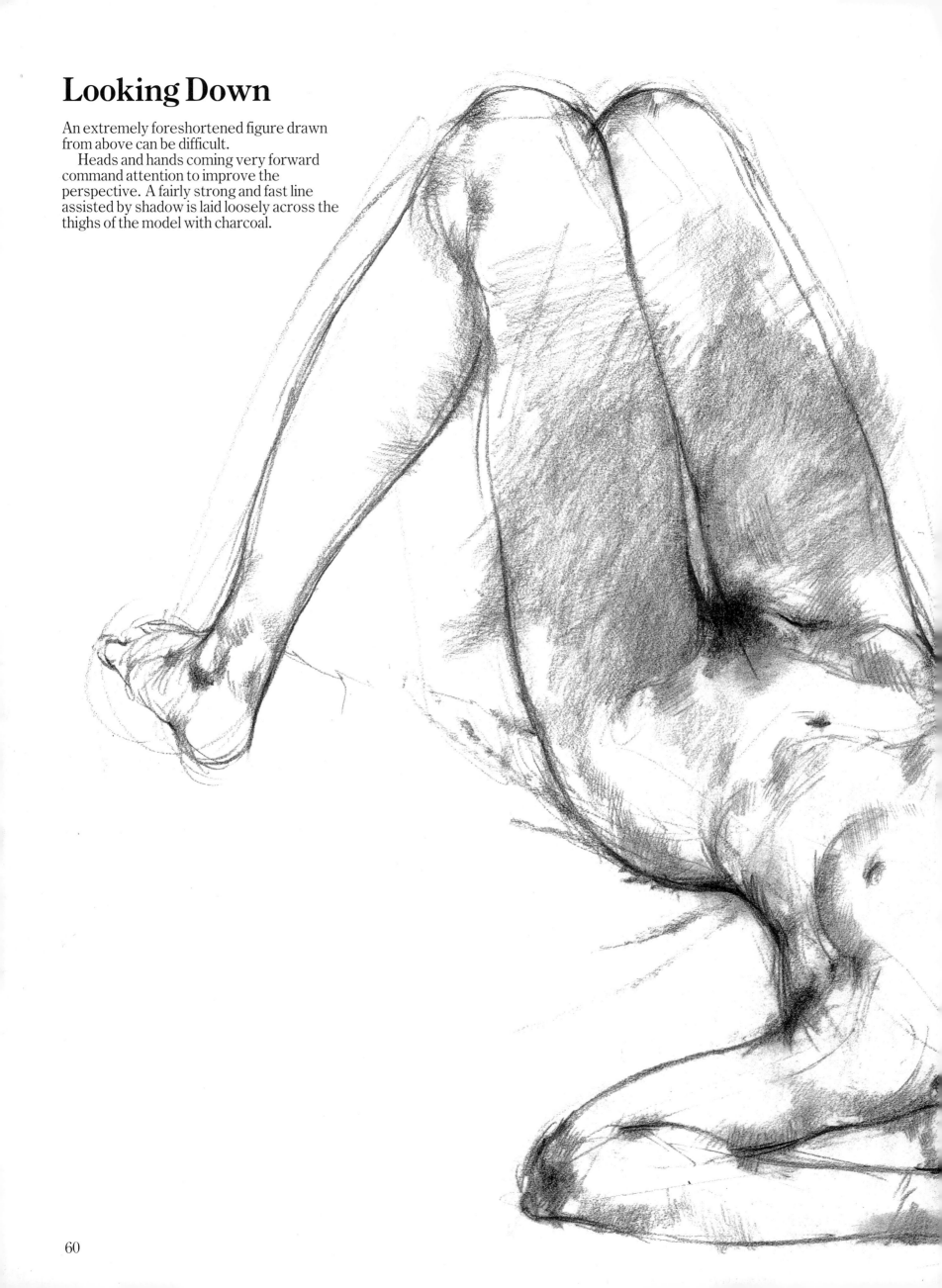

This young student has a very elegant head, made even more prominent by the short hairstyle.

Here is also a chance to draw a nice hand to complement the head.

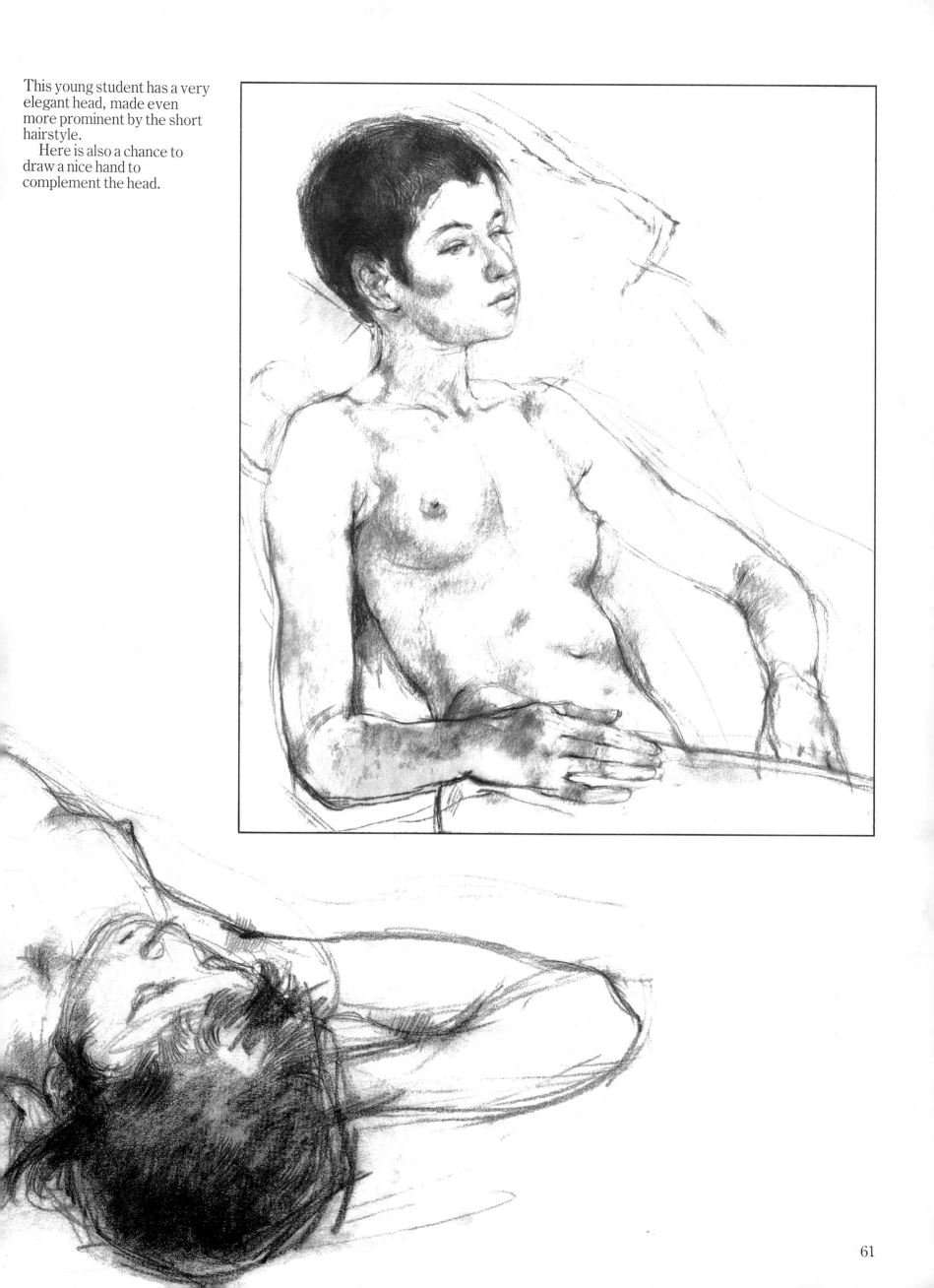

61

A Different Medium

Drawings produced by broad use of charcoal to get the quick effect of light and shadow.

The line almost disappears in these drawings, the figures being described mostly by tone alone.

The use of charcoal can have a very liberating effect on one's drawing, particularly when they are sketches for paintings as are these.

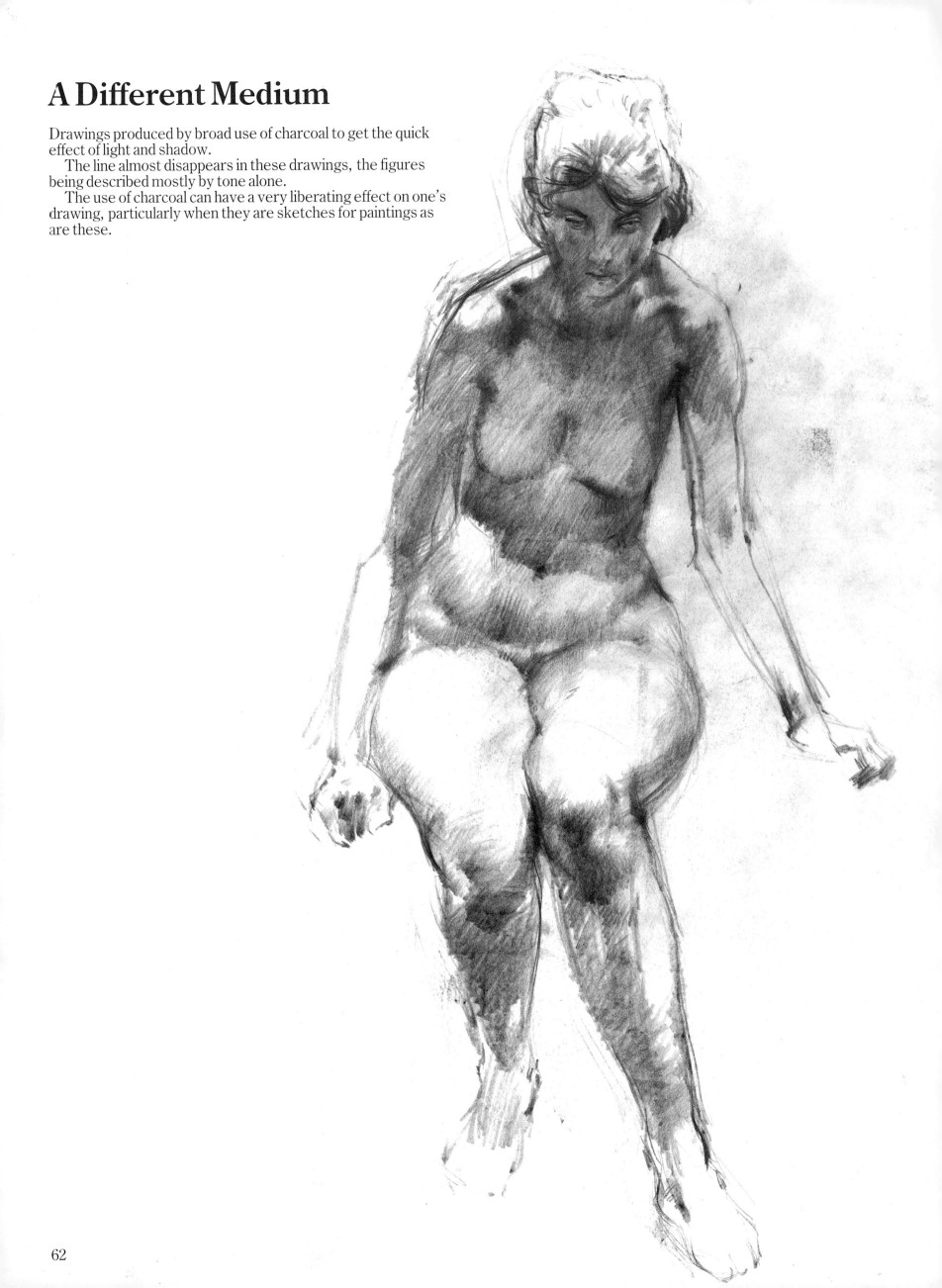

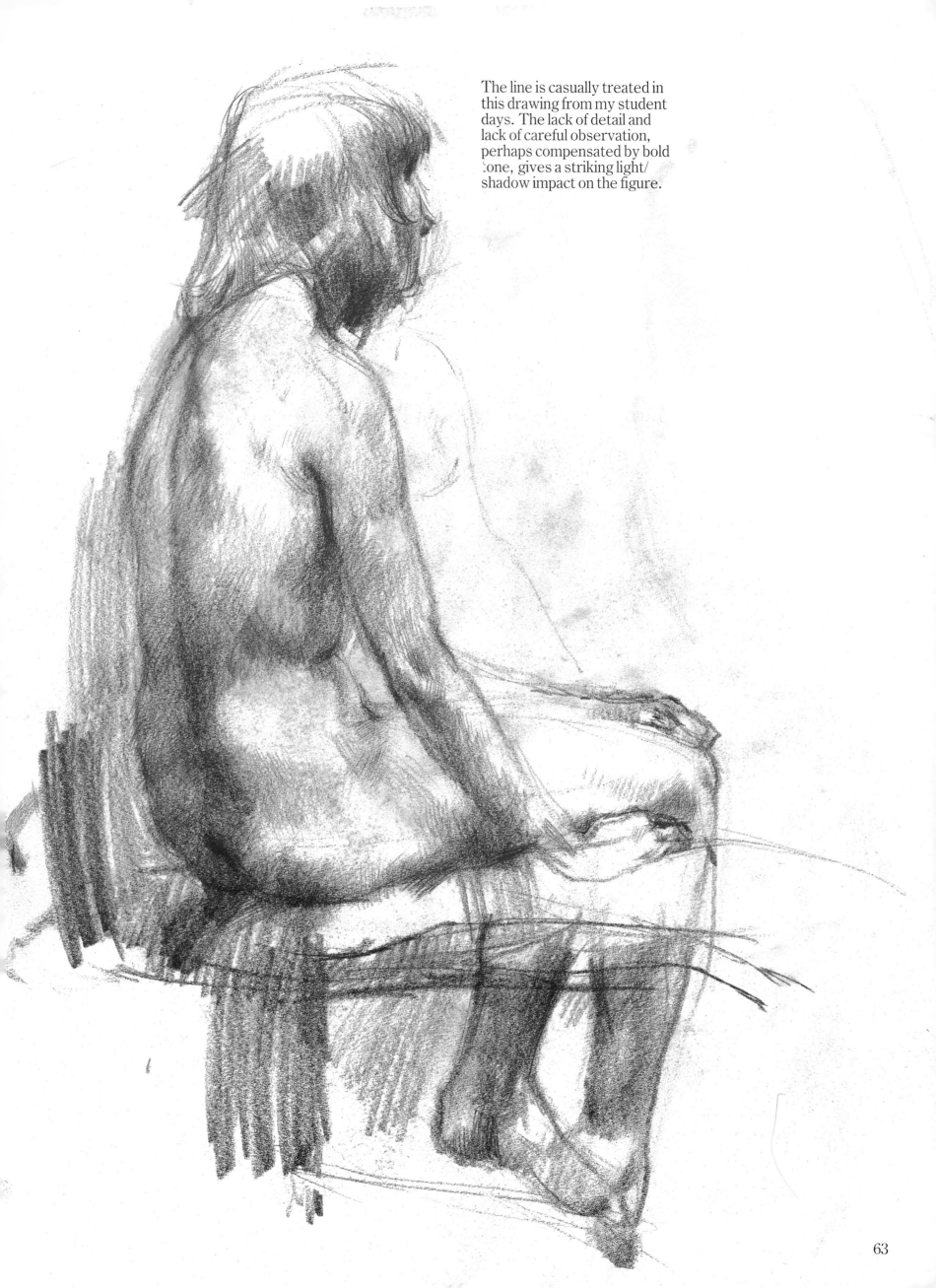

The line is casually treated in this drawing from my student days. The lack of detail and lack of careful observation, perhaps compensated by bold tone, gives a striking light/ shadow impact on the figure.

The Head

There is no better way of starting than with a man's head, particularly one with a lot of character. Always start with the outline and general structure of the head and work back towards detail. First draw the correct shape of the head and face. Make sure that its dimensions are not too wide or too long. Roughly mark in a line indicating the base of the nose and the line of the mouth. If you get these right, you are halfway to capturing the character of the subject. Next, mark in the line of the eyes, and compare the proportions carefully with those of the model. Then gradually work back to the features of the face, checking cheek bones, shape and size of the nose, curve of the mouth, direction of the eyelids, eyebrows and finally the position of the pupils in the eyes.

I then did some modelling using tone and line to create detail and to bring good strong bone structure to the head.

This drawing of a farmer, used to hard outdoor life, took about an hour.

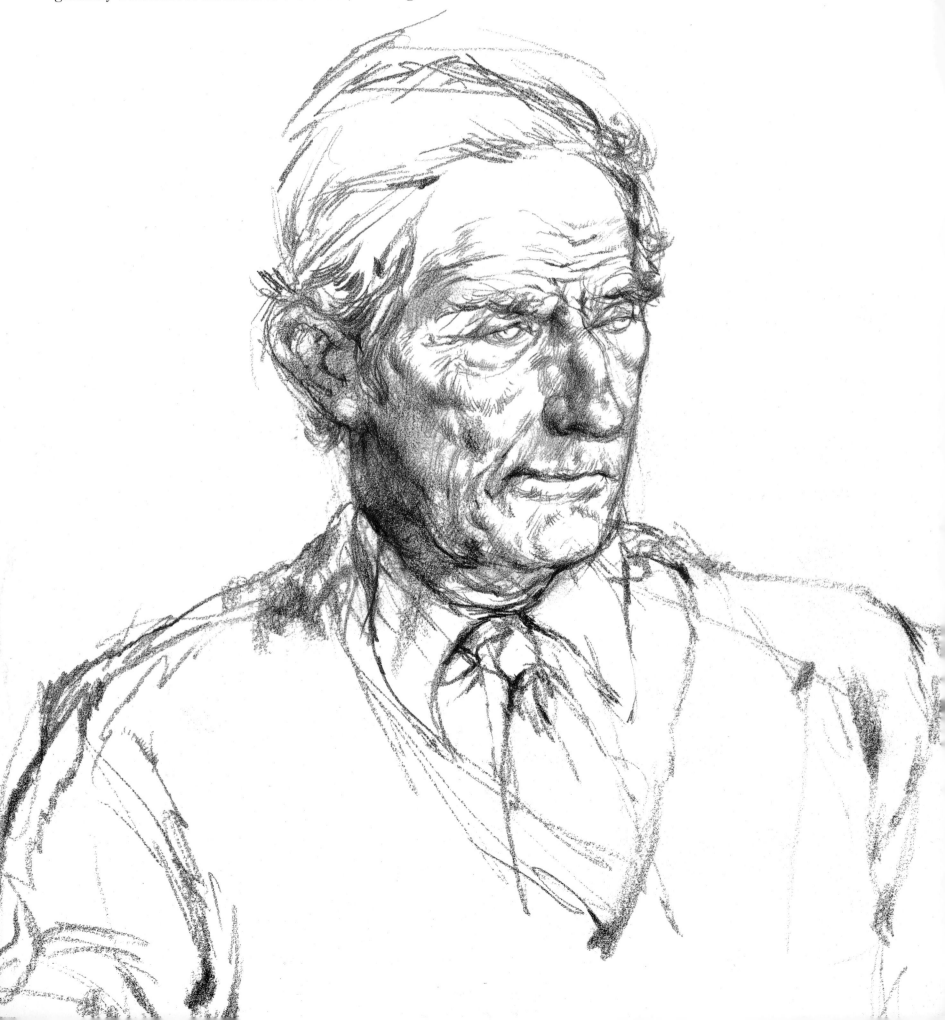

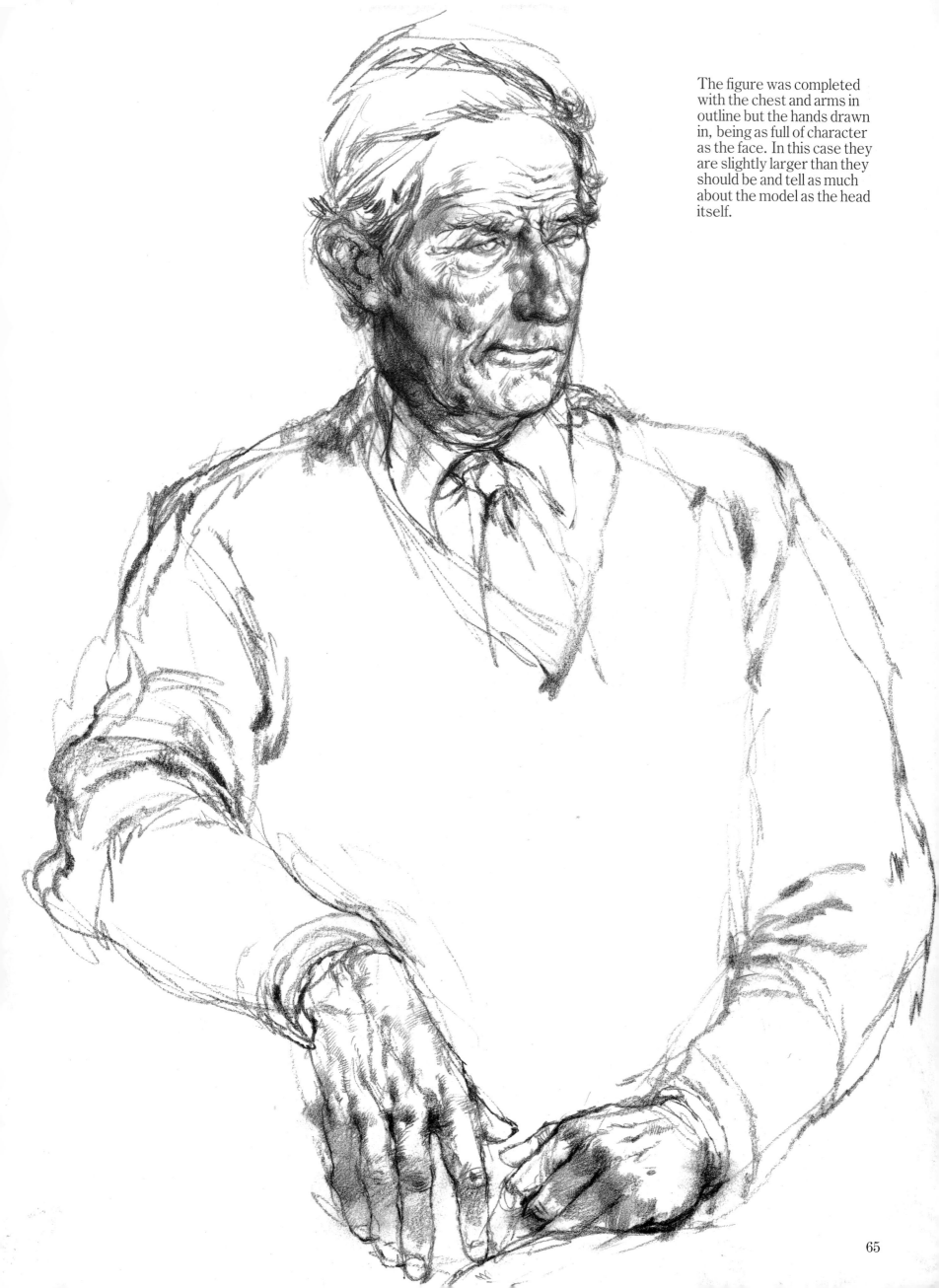

The figure was completed
with the chest and arms in
outline but the hands drawn
in, being as full of character
as the face. In this case they
are slightly larger than they
should be and tell as much
about the model as the head
itself.

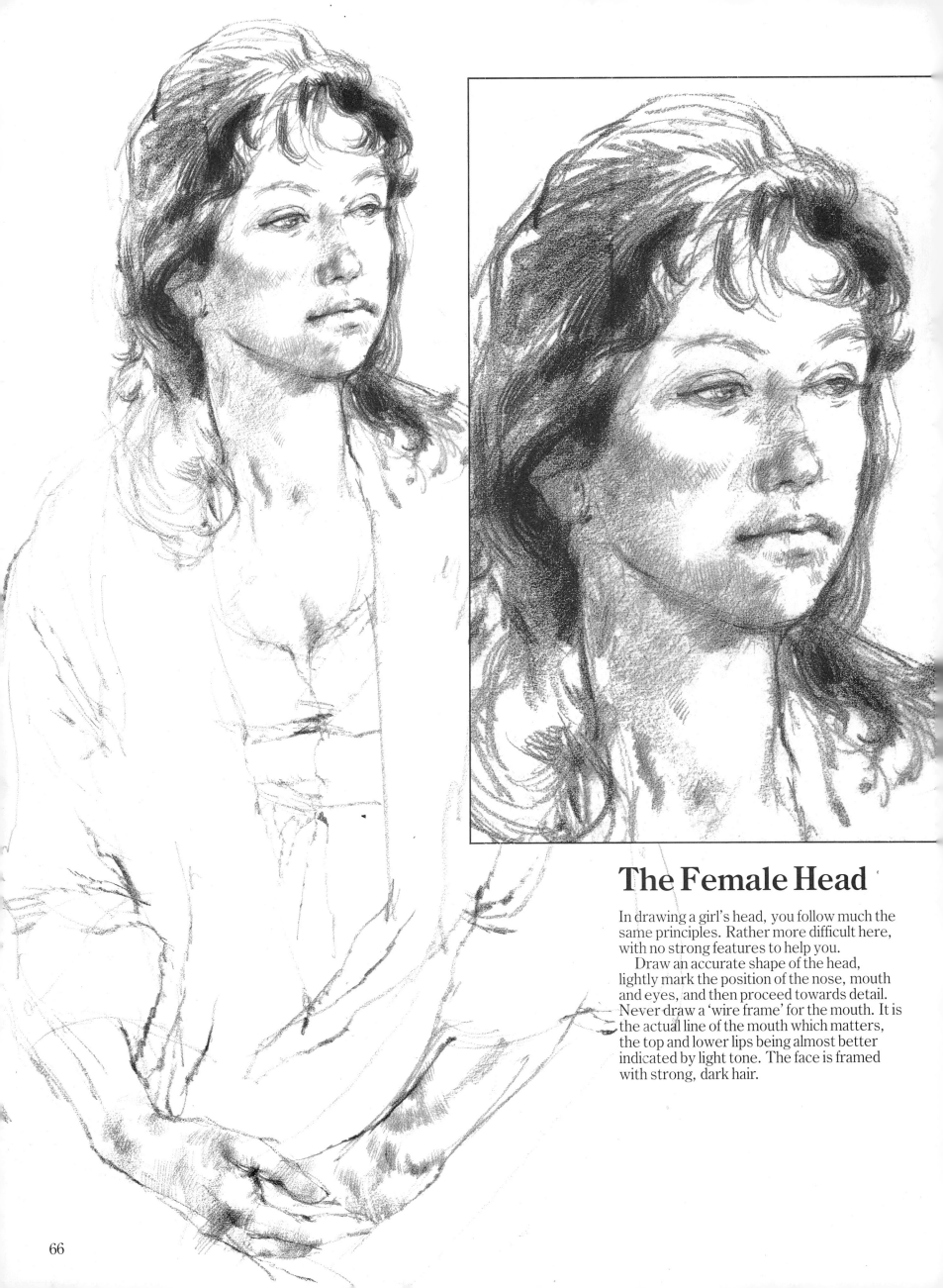

The Female Head

In drawing a girl's head, you follow much the
same principles. Rather more difficult here,
with no strong features to help you.

Draw an accurate shape of the head,
lightly mark the position of the nose, mouth
and eyes, and then proceed towards detail.
Never draw a 'wire frame' for the mouth. It is
the actual line of the mouth which matters,
the top and lower lips being almost better
indicated by light tone. The face is framed
with strong, dark hair.

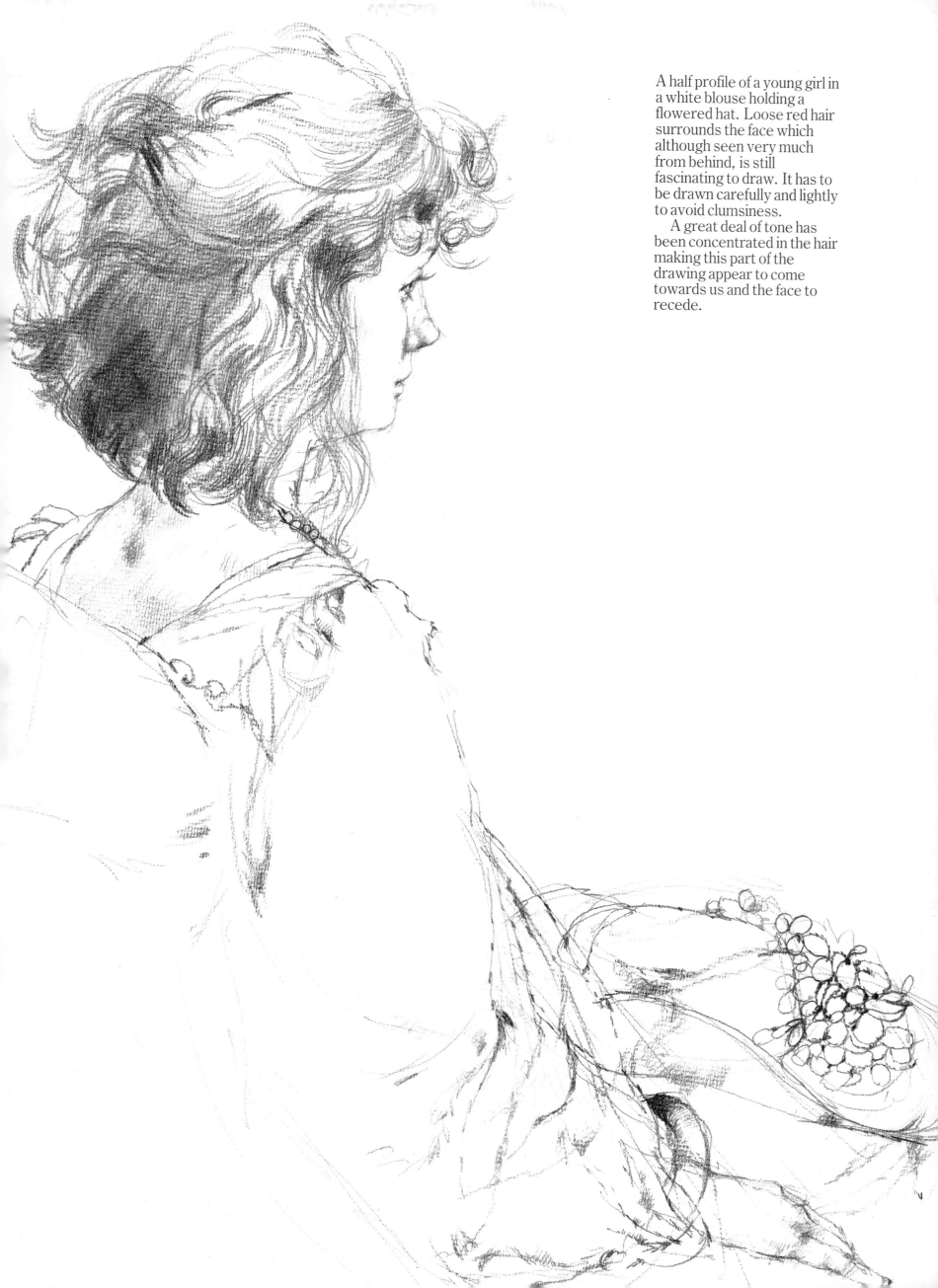

A half profile of a young girl in a white blouse holding a flowered hat. Loose red hair surrounds the face which although seen very much from behind, is still fascinating to draw. It has to be drawn carefully and lightly to avoid clumsiness.

A great deal of tone has been concentrated in the hair making this part of the drawing appear to come towards us and the face to recede.

Male and Female Heads

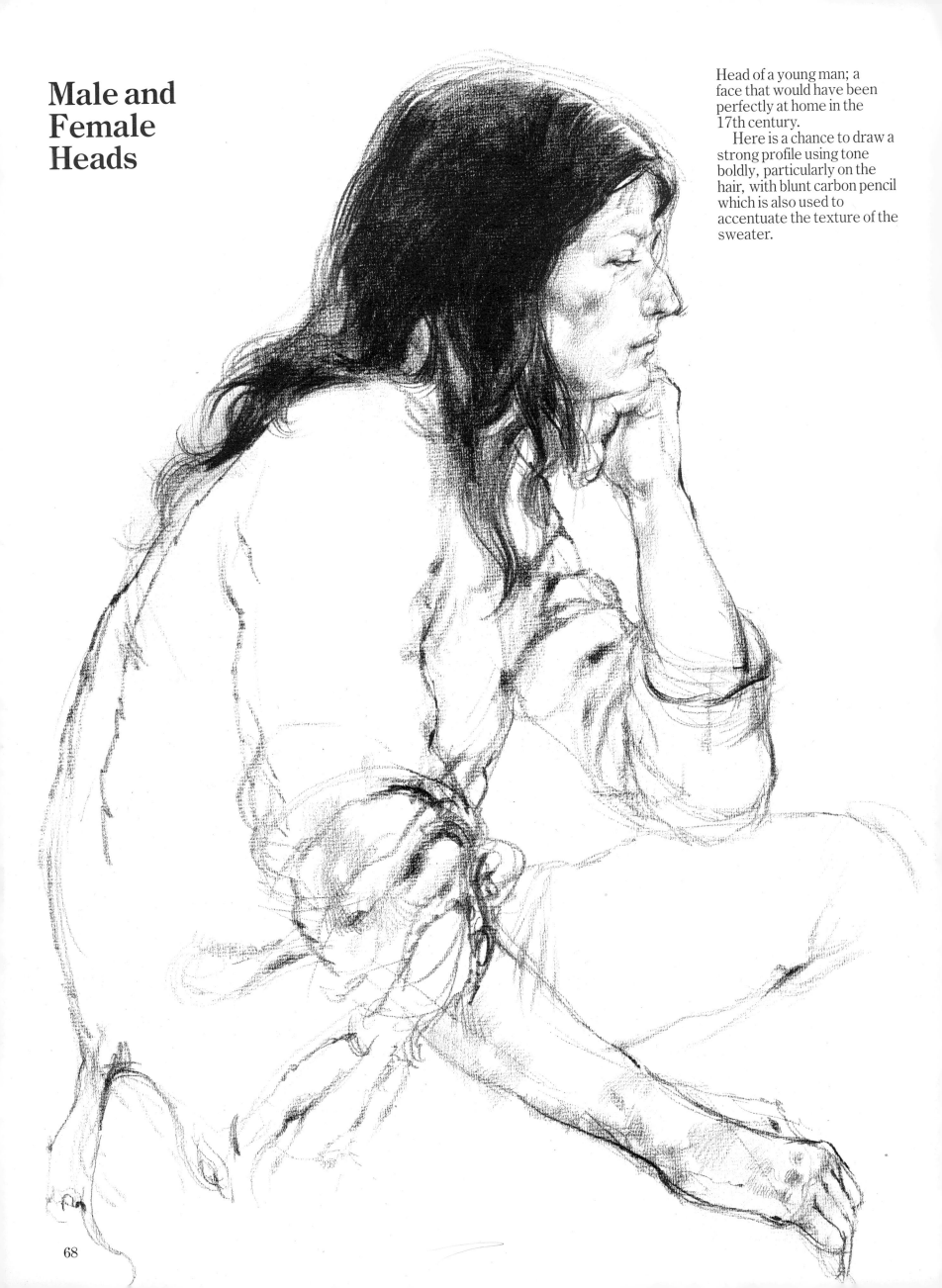

Head of a young man; a face that would have been perfectly at home in the 17th century.

Here is a chance to draw a strong profile using tone boldly, particularly on the hair, with blunt carbon pencil which is also used to accentuate the texture of the sweater.

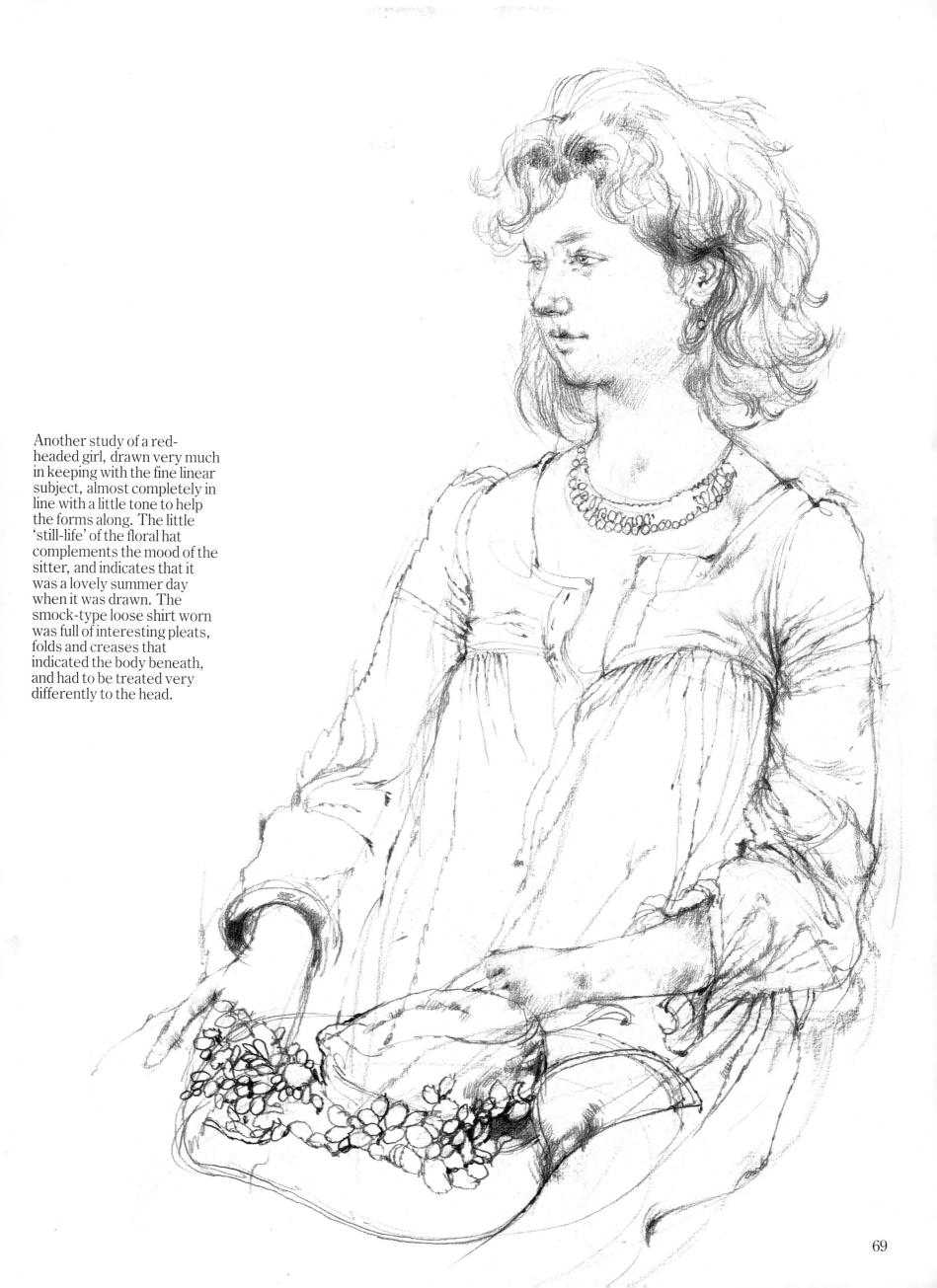

Another study of a red-headed girl, drawn very much in keeping with the fine linear subject, almost completely in line with a little tone to help the forms along. The little 'still-life' of the floral hat complements the mood of the sitter, and indicates that it was a lovely summer day when it was drawn. The smock-type loose shirt worn was full of interesting pleats, folds and creases that indicated the body beneath, and had to be treated very differently to the head.

Two Girls

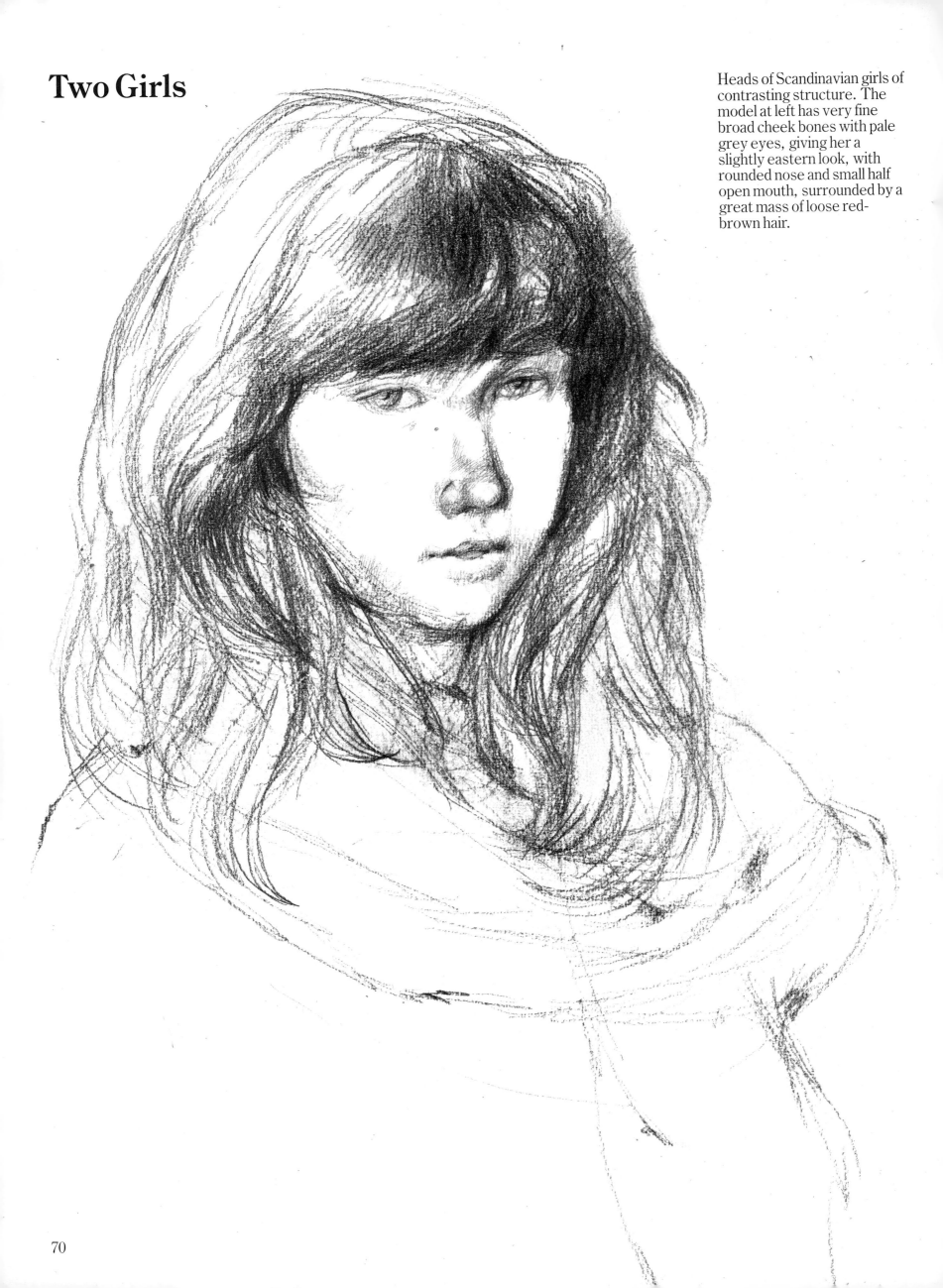

Heads of Scandinavian girls of contrasting structure. The model at left has very fine broad cheek bones with pale grey eyes, giving her a slightly eastern look, with rounded nose and small half open mouth, surrounded by a great mass of loose red-brown hair.

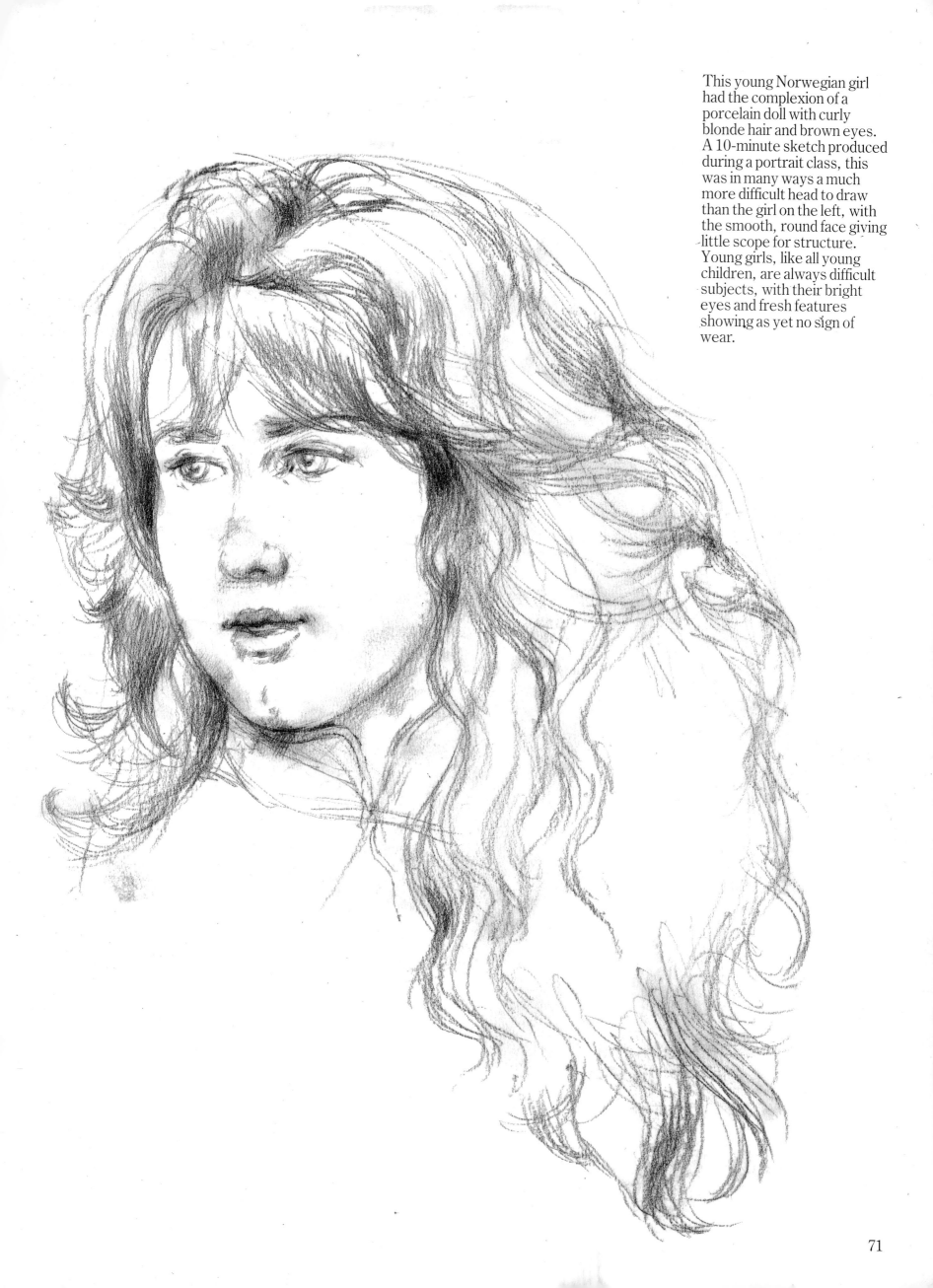

This young Norwegian girl had the complexion of a porcelain doll with curly blonde hair and brown eyes. A 10-minute sketch produced during a portrait class, this was in many ways a much more difficult head to draw than the girl on the left, with the smooth, round face giving little scope for structure. Young girls, like all young children, are always difficult subjects, with their bright eyes and fresh features showing as yet no sign of wear.

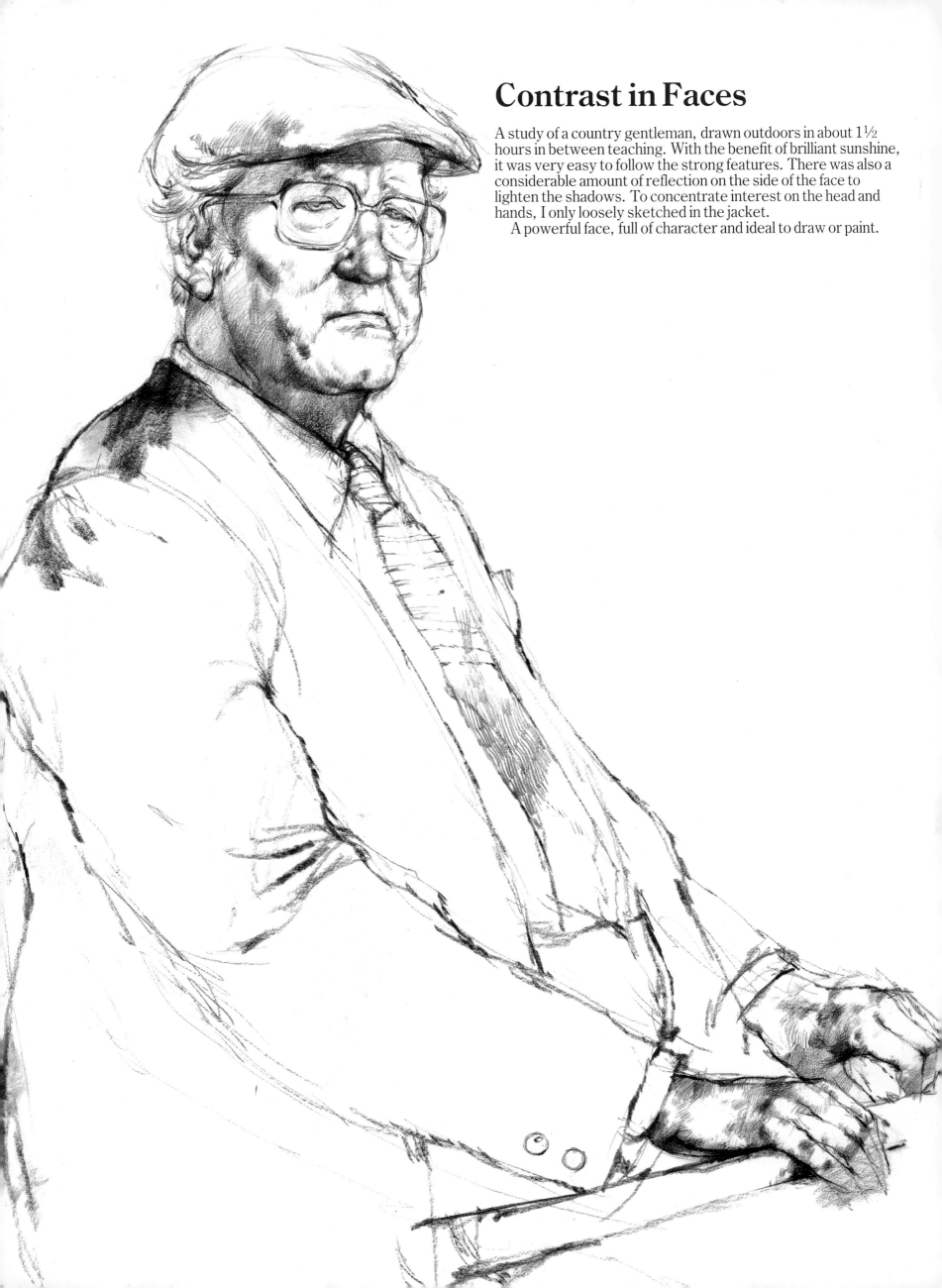

Contrast in Faces

A study of a country gentleman, drawn outdoors in about 1½ hours in between teaching. With the benefit of brilliant sunshine, it was very easy to follow the strong features. There was also a considerable amount of reflection on the side of the face to lighten the shadows. To concentrate interest on the head and hands, I only loosely sketched in the jacket.

A powerful face, full of character and ideal to draw or paint.

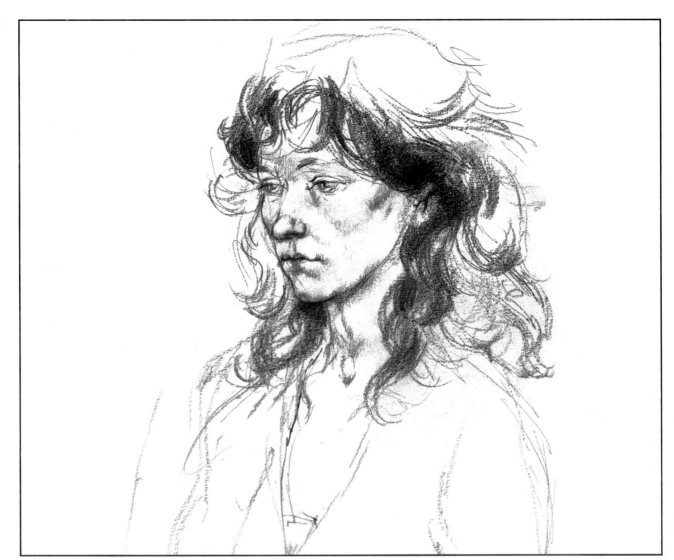

A drawing of a girl whose troubled life was reflected in her face. With eyes staring ahead, she was far away deep in thought. A face full of feeling and expression and a challenge to draw.

The black hair tied in a bun and fine profile reminded me of early Italian portraits, with the loose strands of hair providing a decorative quality to the drawing.

A small amount of shading helped to form an otherwise solid black and white image.

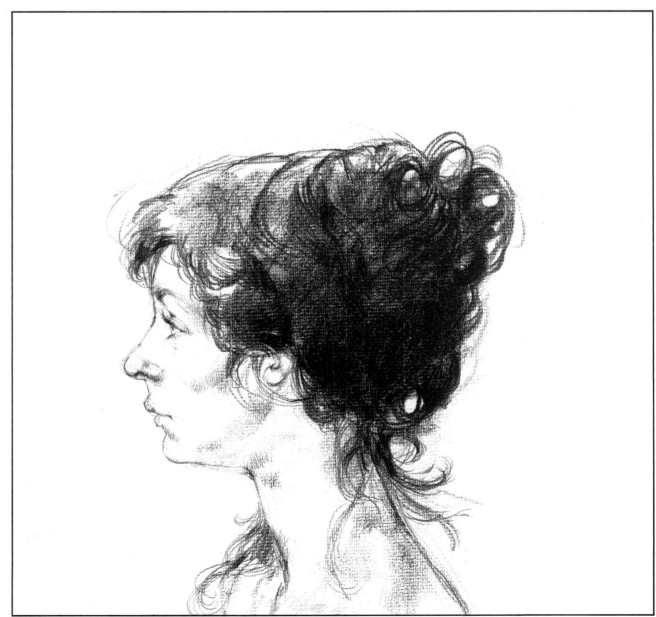

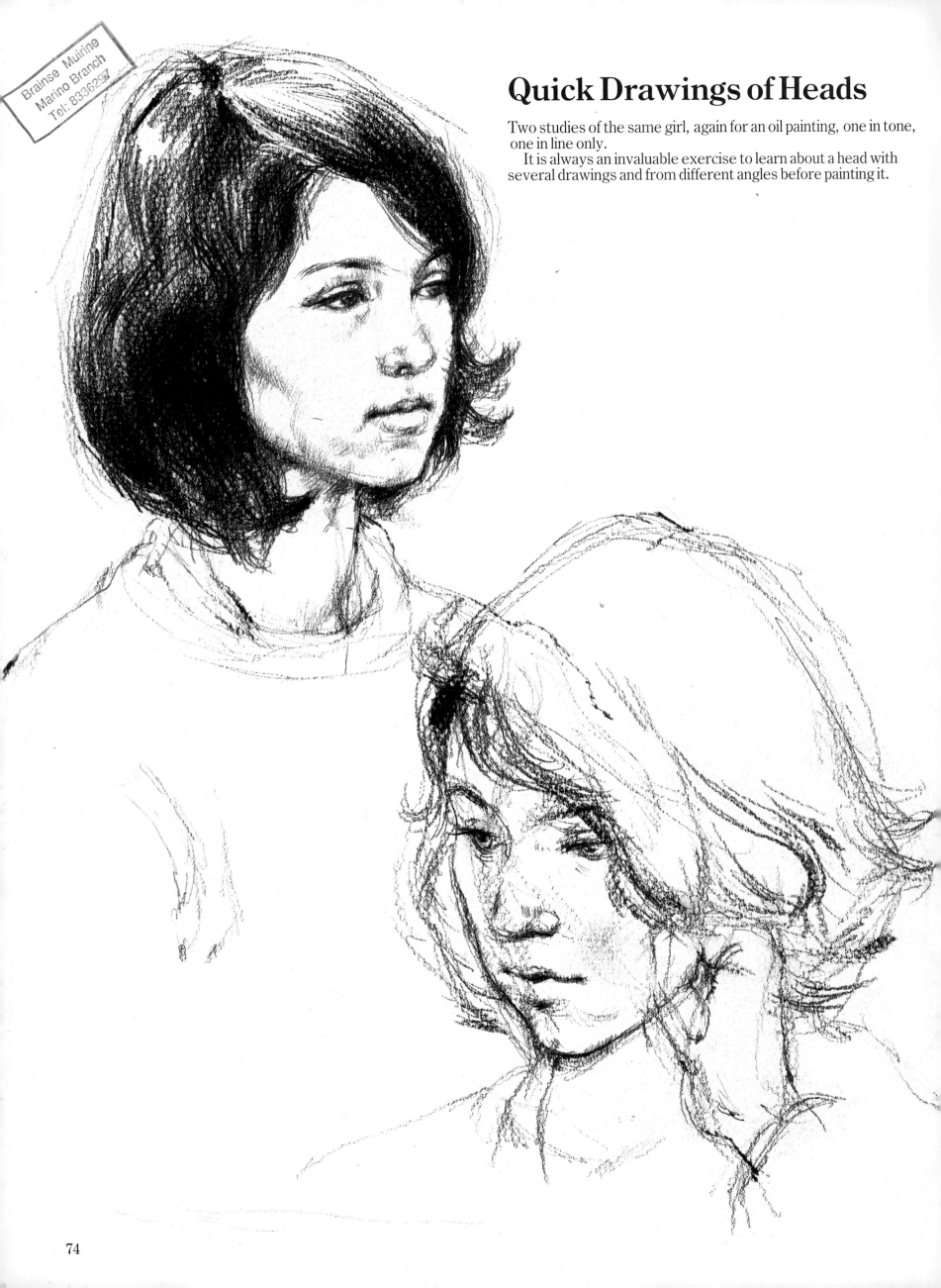

Quick Drawings of Heads

Two studies of the same girl, again for an oil painting, one in tone, one in line only.

It is always an invaluable exercise to learn about a head with several drawings and from different angles before painting it.

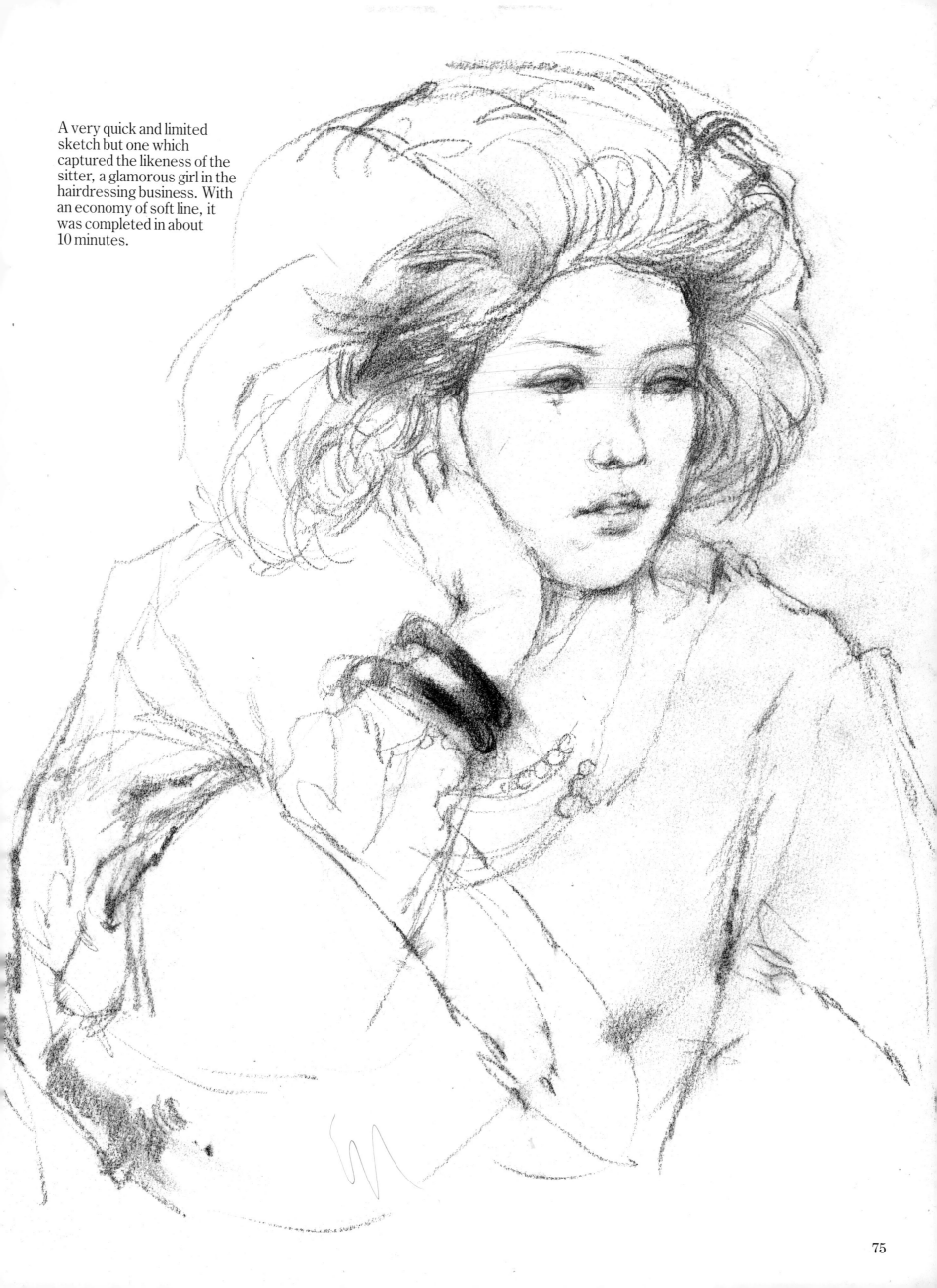

A very quick and limited sketch but one which captured the likeness of the sitter, a glamorous girl in the hairdressing business. With an economy of soft line, it was completed in about 10 minutes.

Sketching

Line drawings of my son watching television, the kind of drawings for which you should use a sketchbook.

In my student days we were sent to railway stations or to anywhere where people sat still long enough to be sketched. It was a very valuable experience useful in later years when I had to draw from memory.

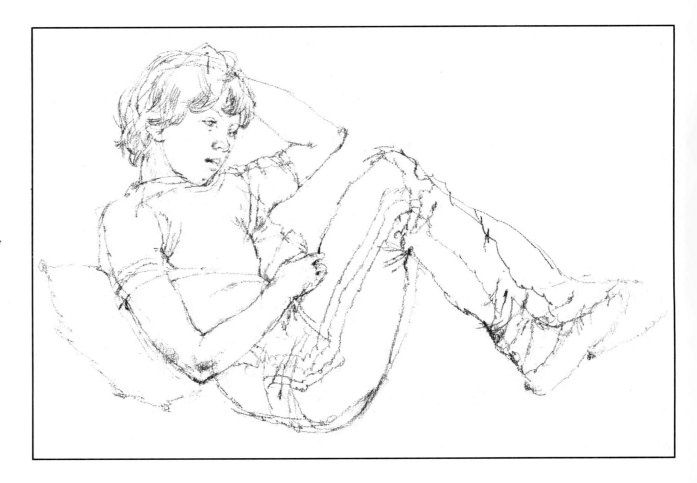

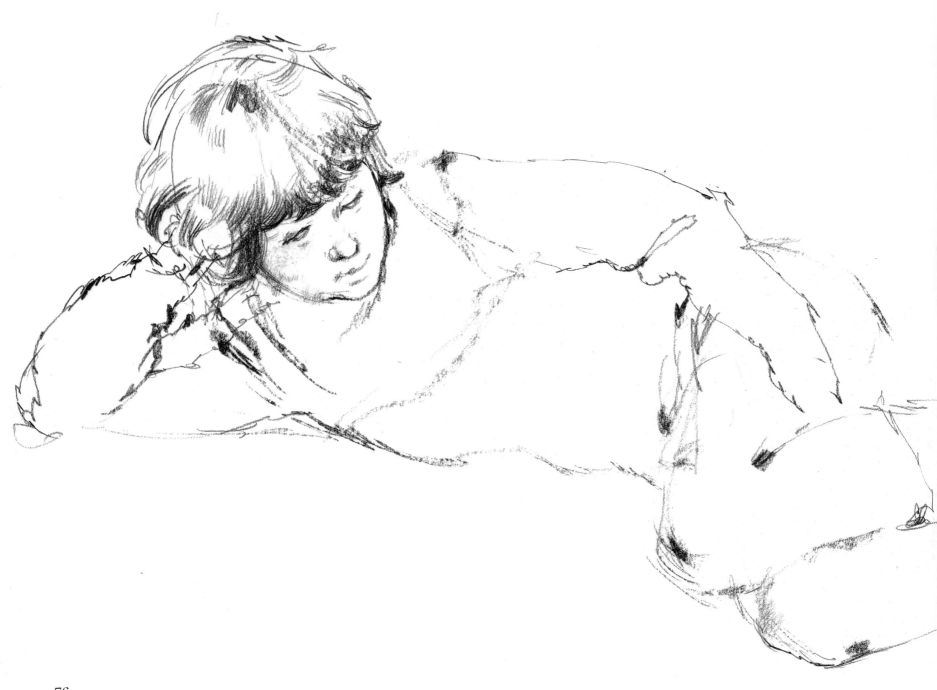

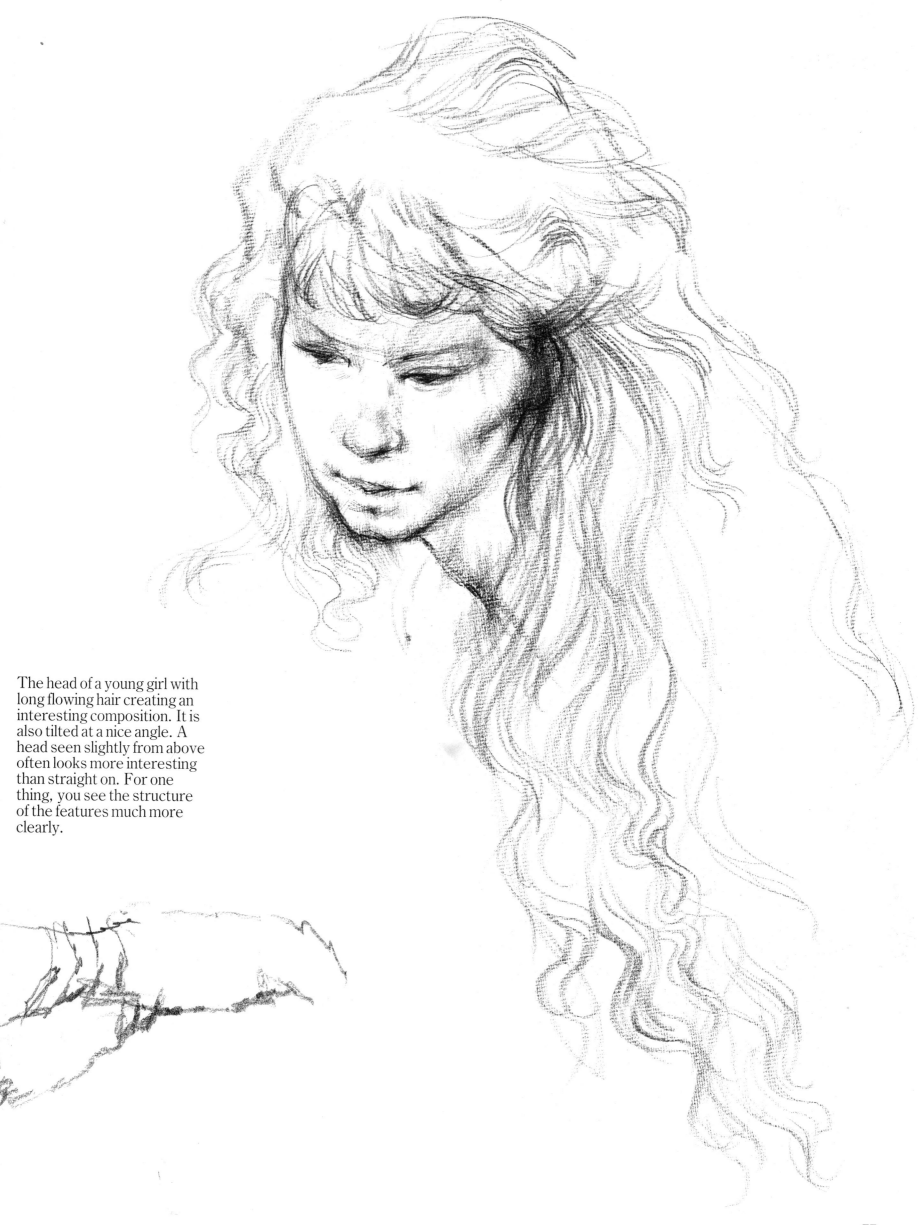

The head of a young girl with long flowing hair creating an interesting composition. It is also tilted at a nice angle. A head seen slightly from above often looks more interesting than straight on. For one thing, you see the structure of the features much more clearly.

Heads and Hands

A fast drawing of a young lady with a Teddy bear. Young children are a pleasure to draw but very difficult. Young faces do not have the same strong features as adults, but have that bright-eyed freshness to compensate.

The expression on the bear's face is purely accidental, but goes well with the little girl's mood.

Right: A drawing of an older woman in contrast to a young girl's head. Full of forms in the strong light, she was a superb subject for a study.

With the placement of the hands, the pose gives a feeling of reflection, perhaps on the advancement of age.

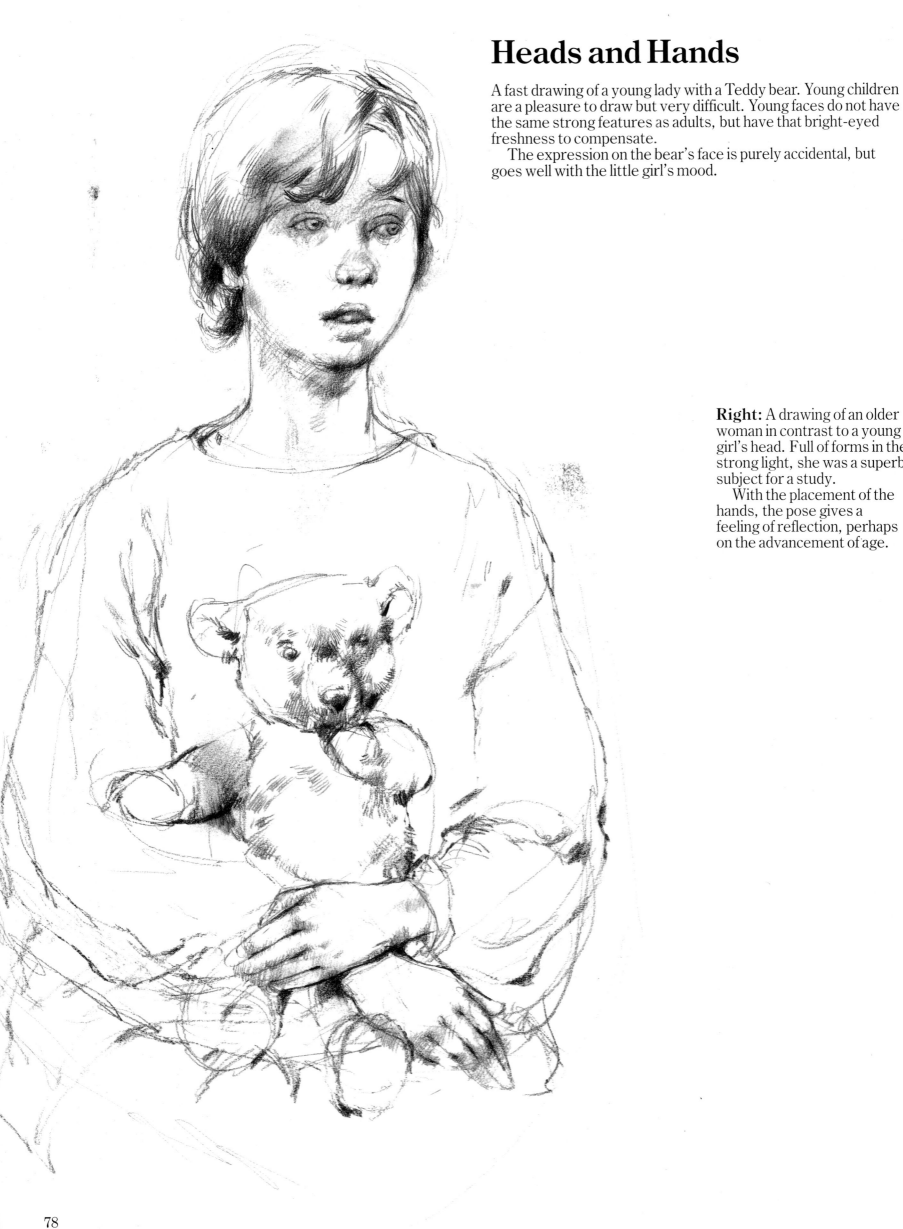

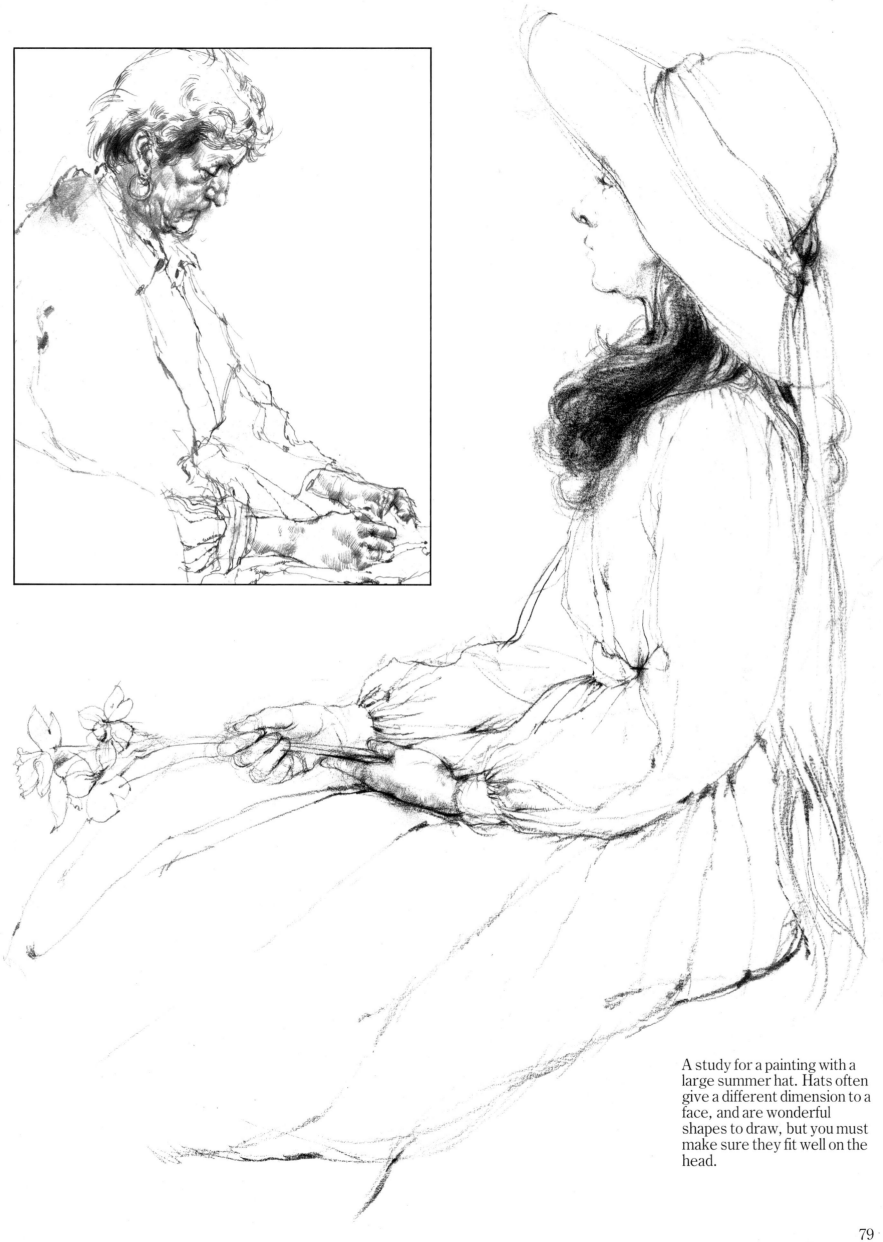

A study for a painting with a large summer hat. Hats often give a different dimension to a face, and are wonderful shapes to draw, but you must make sure they fit well on the head.

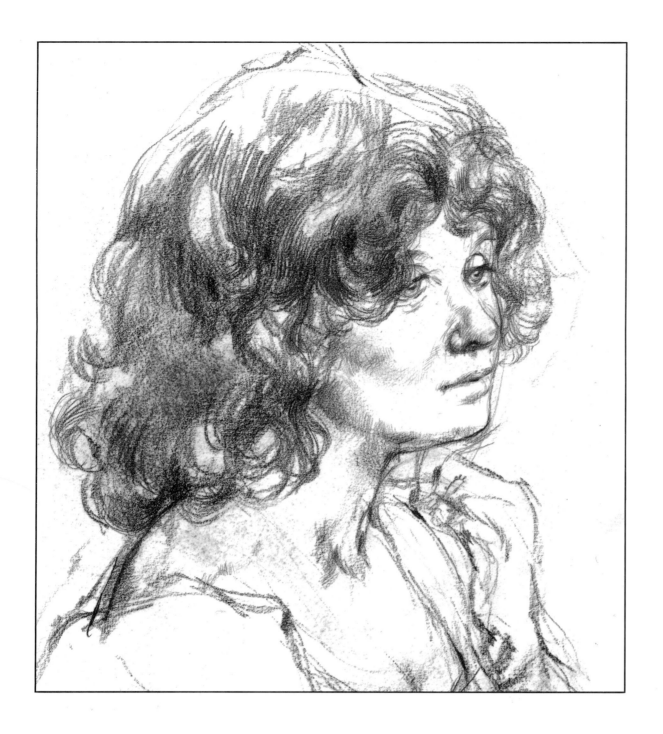

Two Interesting Heads

Light, curly fair hair framing the face of an attractive young mother with domestic problems on her mind. The underlying tension shows in her expression.

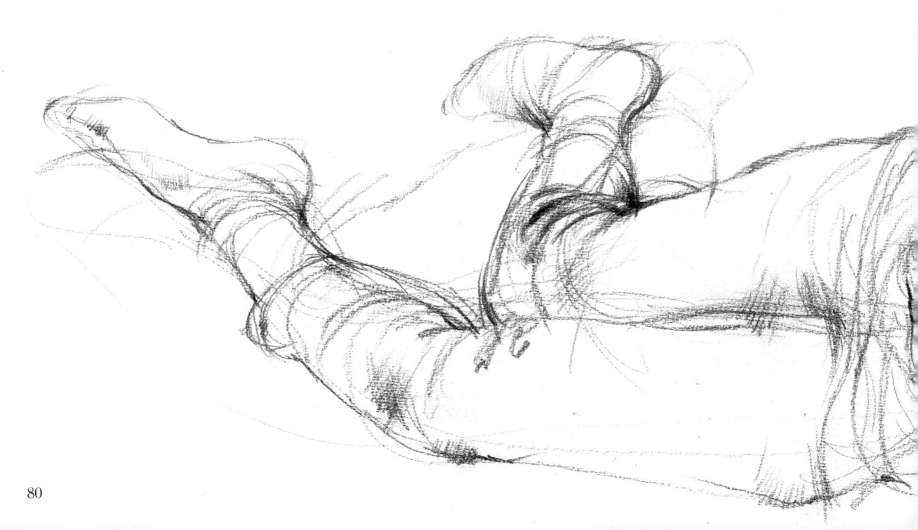

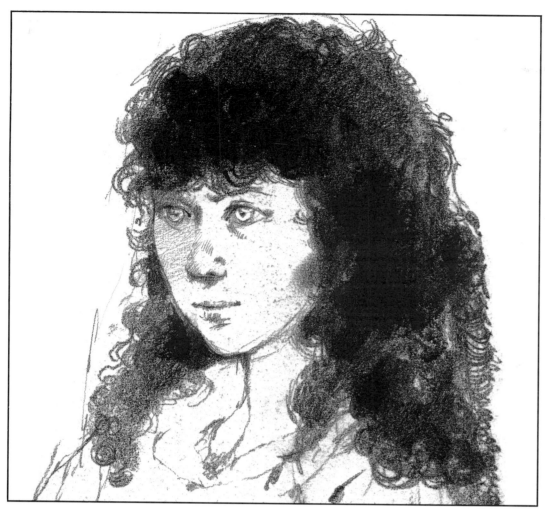

Very pale blue eyes with rich dark curls. A sketch almost entirely in black and white without half-tone. The technique is dictated by the model, in this case, white skin against rich black hair.

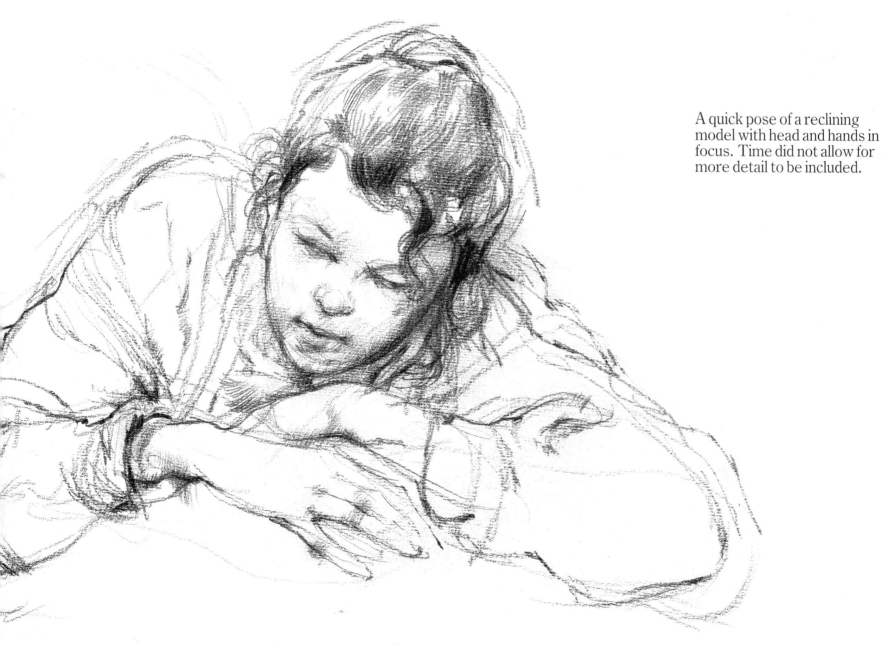

A quick pose of a reclining model with head and hands in focus. Time did not allow for more detail to be included.

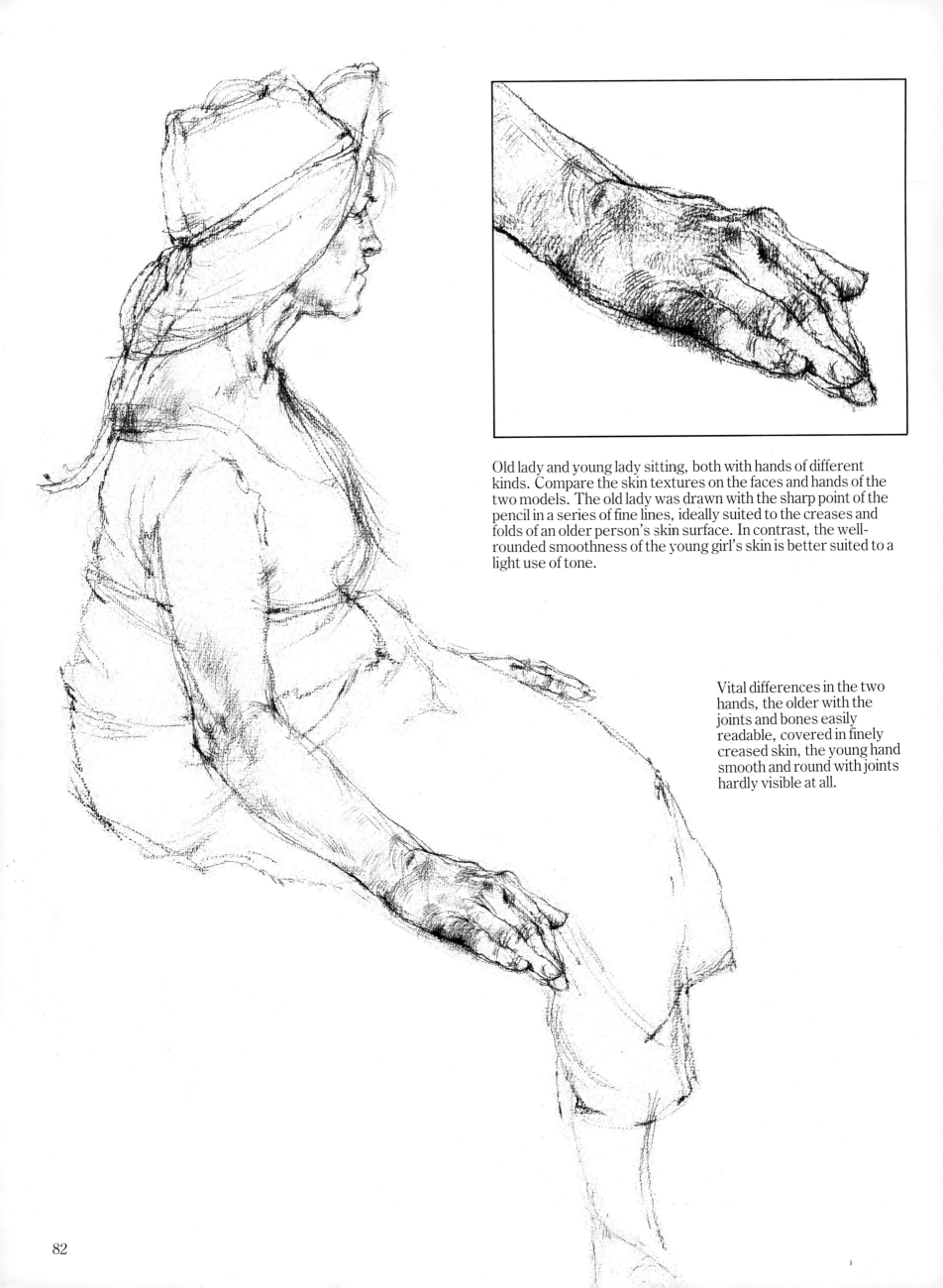

Old lady and young lady sitting, both with hands of different kinds. Compare the skin textures on the faces and hands of the two models. The old lady was drawn with the sharp point of the pencil in a series of fine lines, ideally suited to the creases and folds of an older person's skin surface. In contrast, the well-rounded smoothness of the young girl's skin is better suited to a light use of tone.

Vital differences in the two hands, the older with the joints and bones easily readable, covered in finely creased skin, the young hand smooth and round with joints hardly visible at all.

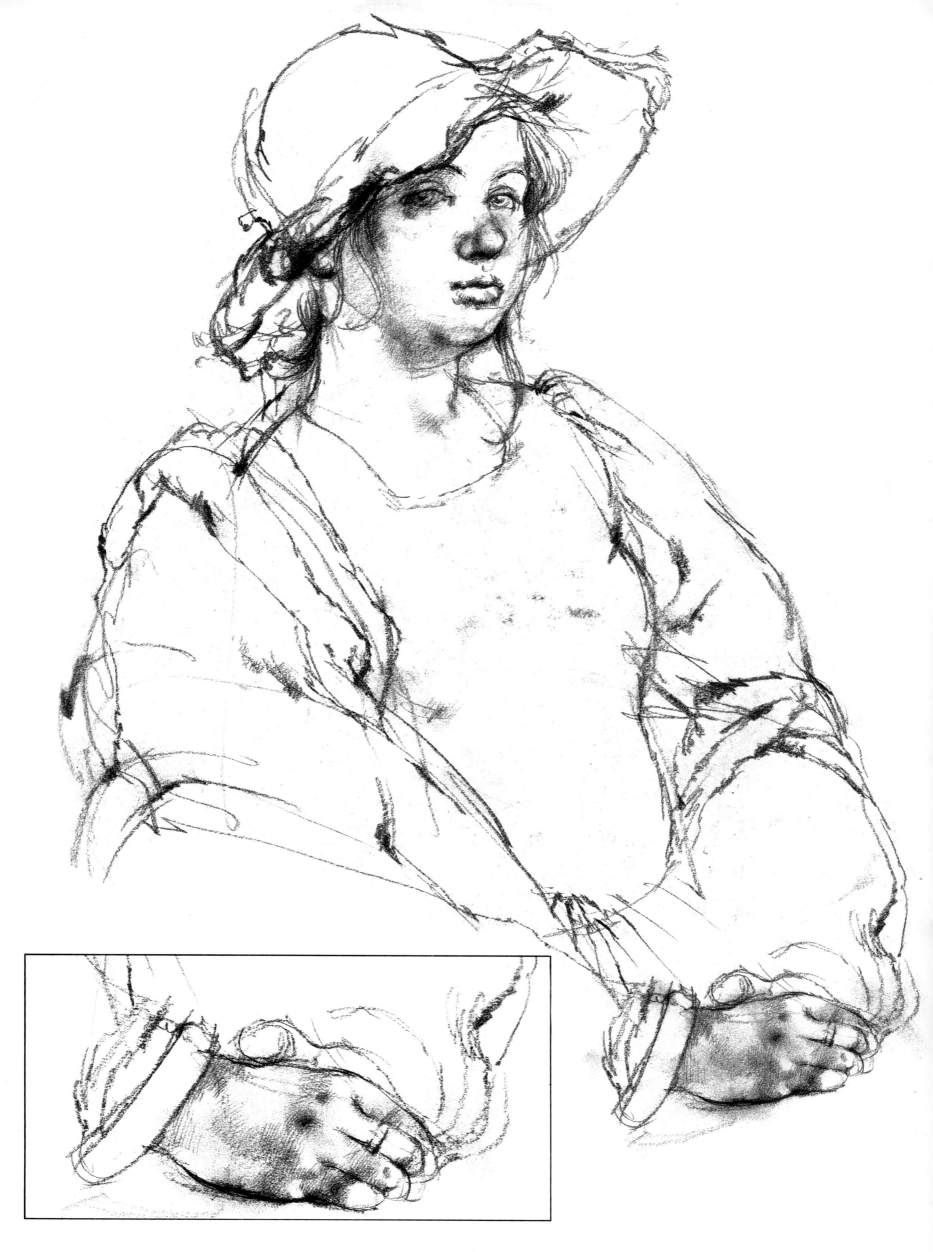

Drawing a Head with Tone

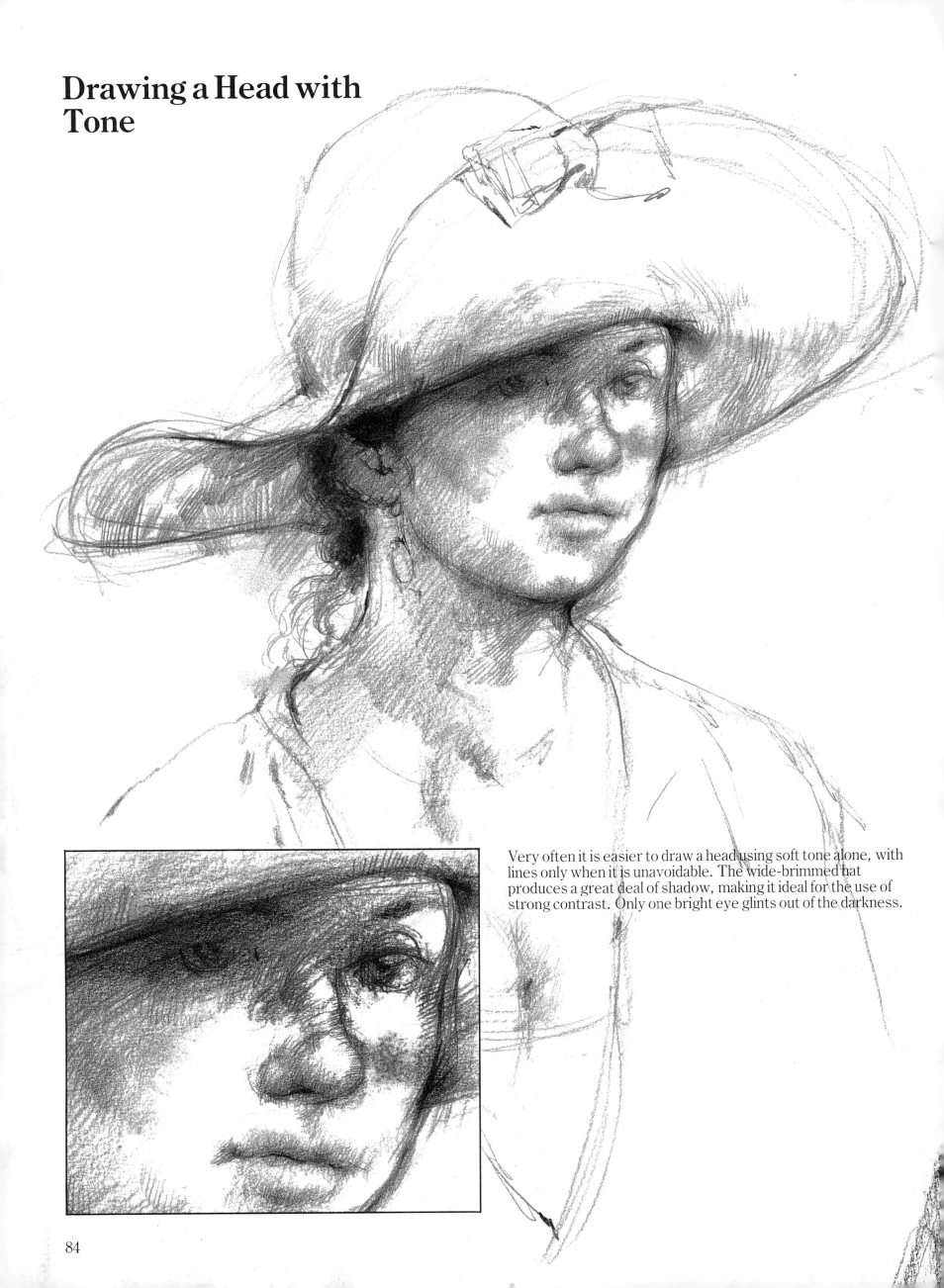

Very often it is easier to draw a head using soft tone alone, with lines only when it is unavoidable. The wide-brimmed hat produces a great deal of shadow, making it ideal for the use of strong contrast. Only one bright eye glints out of the darkness.

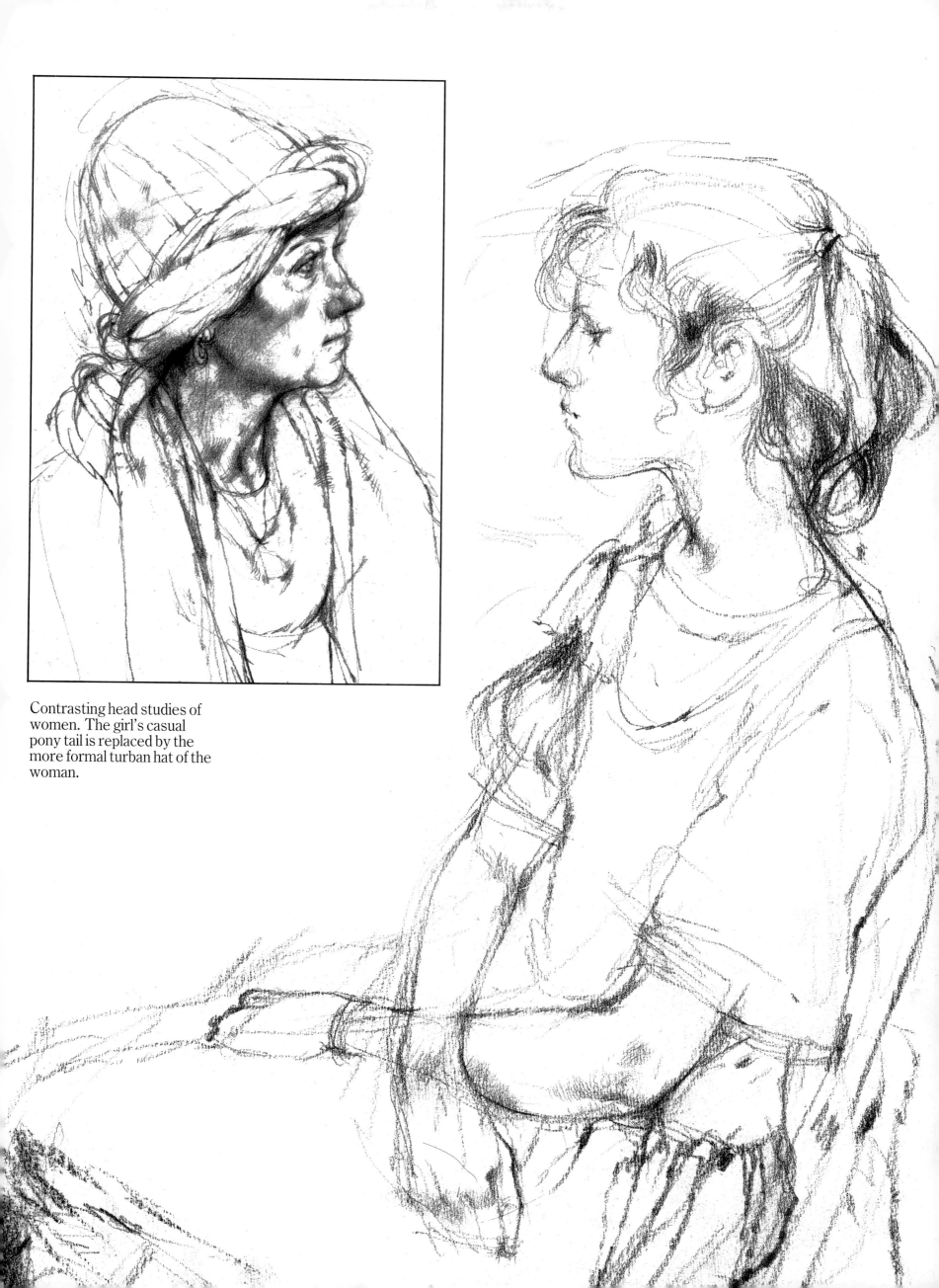

Contrasting head studies of
women. The girl's casual
pony tail is replaced by the
more formal turban hat of the
woman.

Drawing Hair

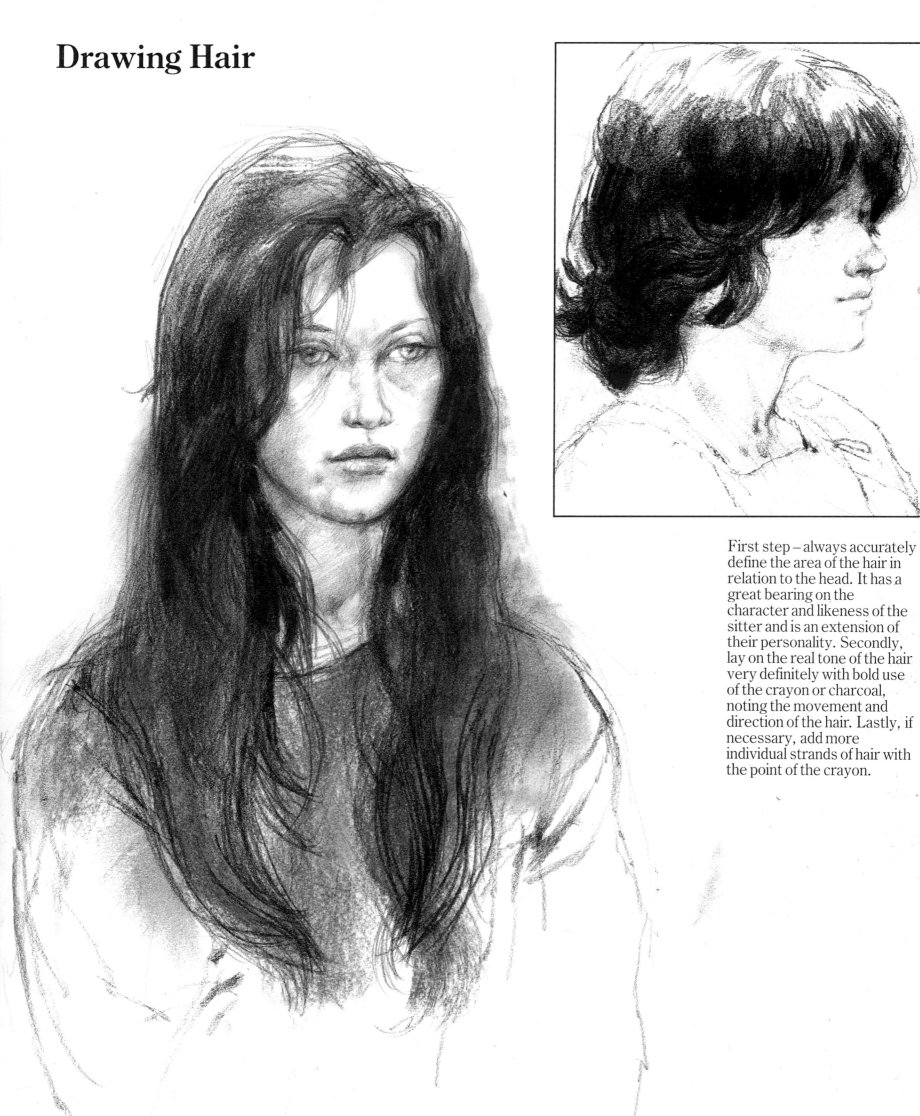

First step – always accurately define the area of the hair in relation to the head. It has a great bearing on the character and likeness of the sitter and is an extension of their personality. Secondly, lay on the real tone of the hair very definitely with bold use of the crayon or charcoal, noting the movement and direction of the hair. Lastly, if necessary, add more individual strands of hair with the point of the crayon.

Right: This simple sketch with a soft pencil lightly outlining the form is totally changed by the dense rendering of the hair.

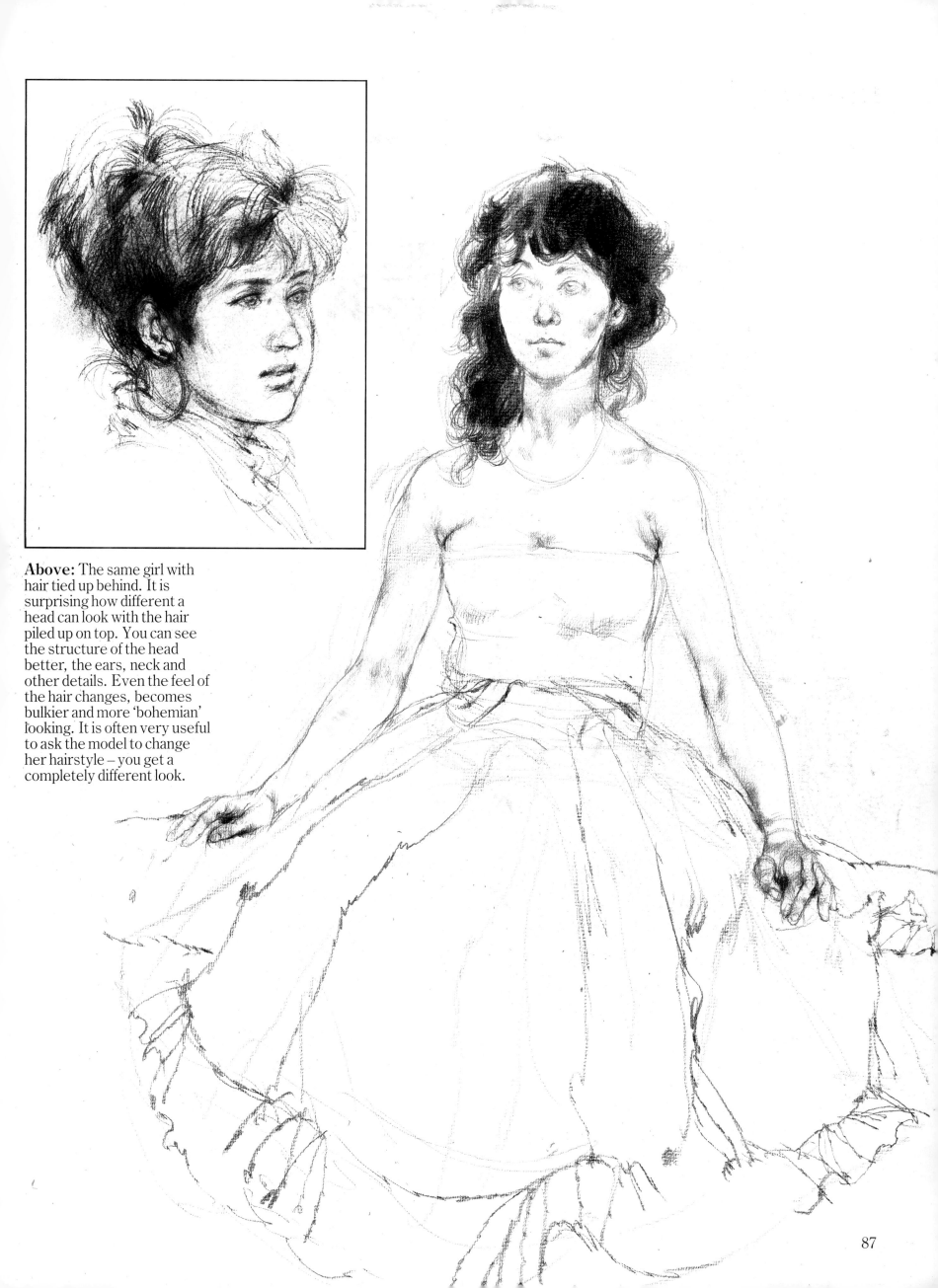

Above: The same girl with hair tied up behind. It is surprising how different a head can look with the hair piled up on top. You can see the structure of the head better, the ears, neck and other details. Even the feel of the hair changes, becomes bulkier and more 'bohemian' looking. It is often very useful to ask the model to change her hairstyle – you get a completely different look.

Studies of various heads which took varying amounts of time to draw. It took about an hour to explore the half-tones and finer details of the head of the older woman below.
The drawing on the right is a quick sketch in line only using the blunt point of a carbon pencil for speed.

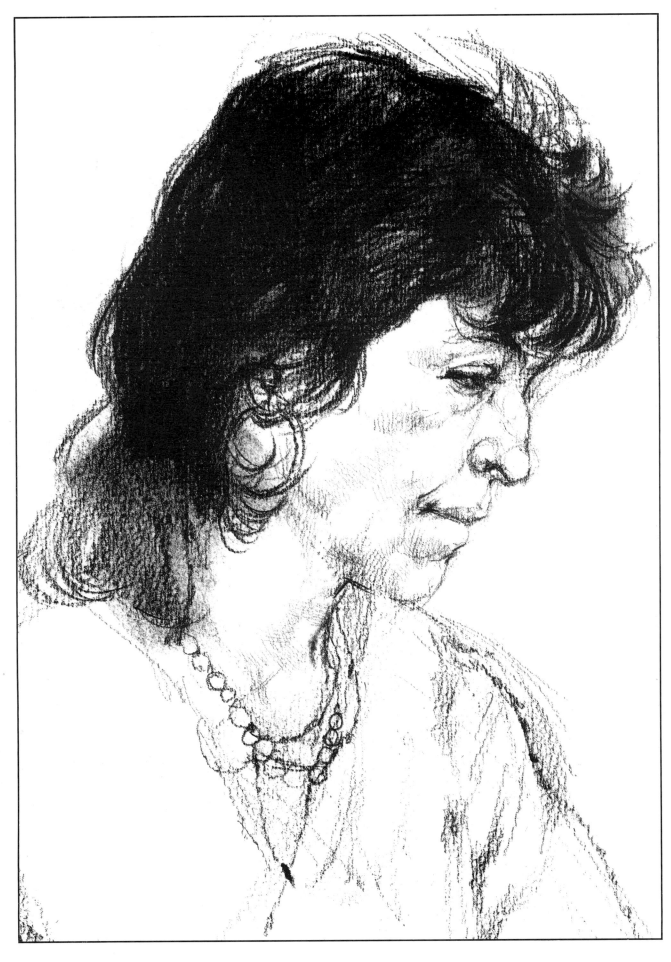

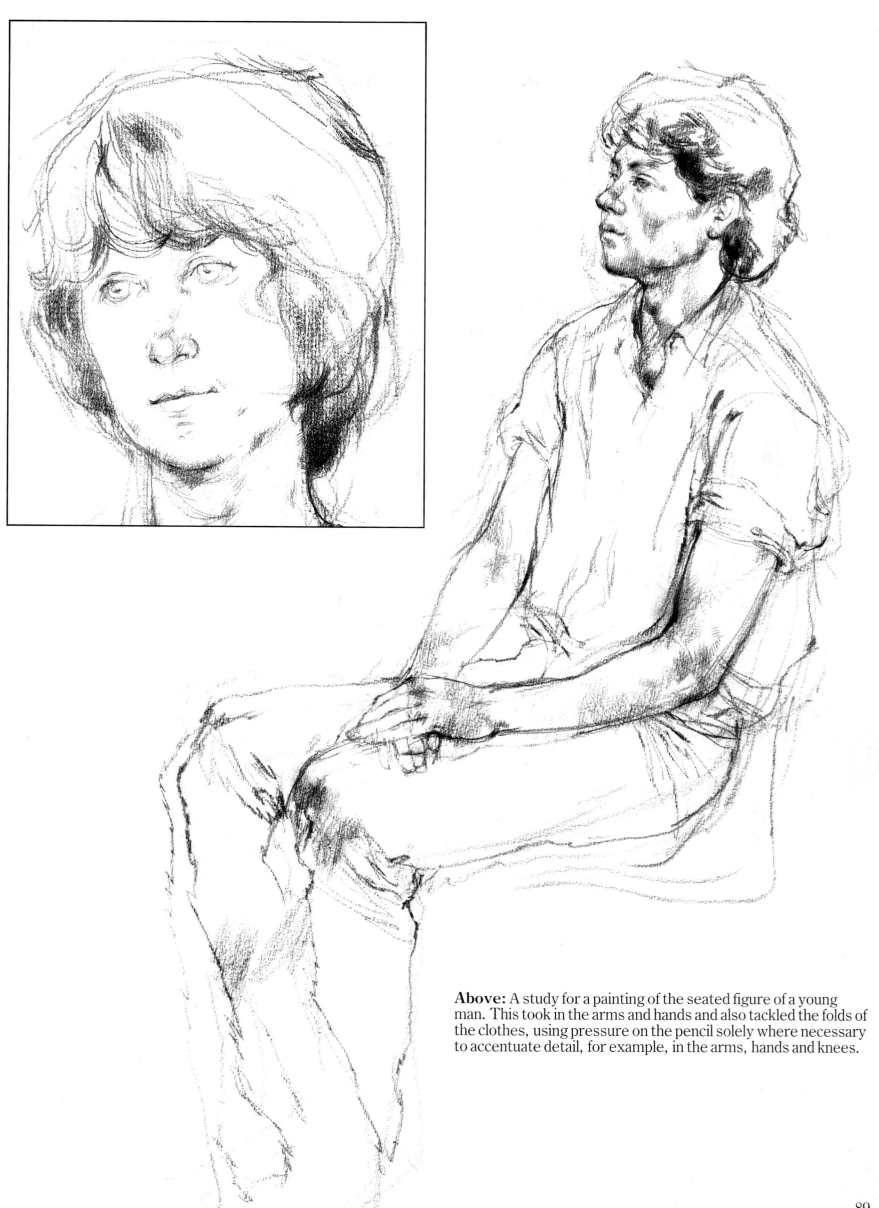

Above: A study for a painting of the seated figure of a young man. This took in the arms and hands and also tackled the folds of the clothes, using pressure on the pencil solely where necessary to accentuate detail, for example, in the arms, hands and knees.

Drawing Hands

Never start with the fingers – they will not be successful unless the bulk of the hands was correctly drawn. Around the knuckles you usually find differences in light. For example, from the knuckles backwards there is often a darker tone. This helps greatly with a foreshortened view of a hand. The same applies to the joints of the fingers, so be prepared.

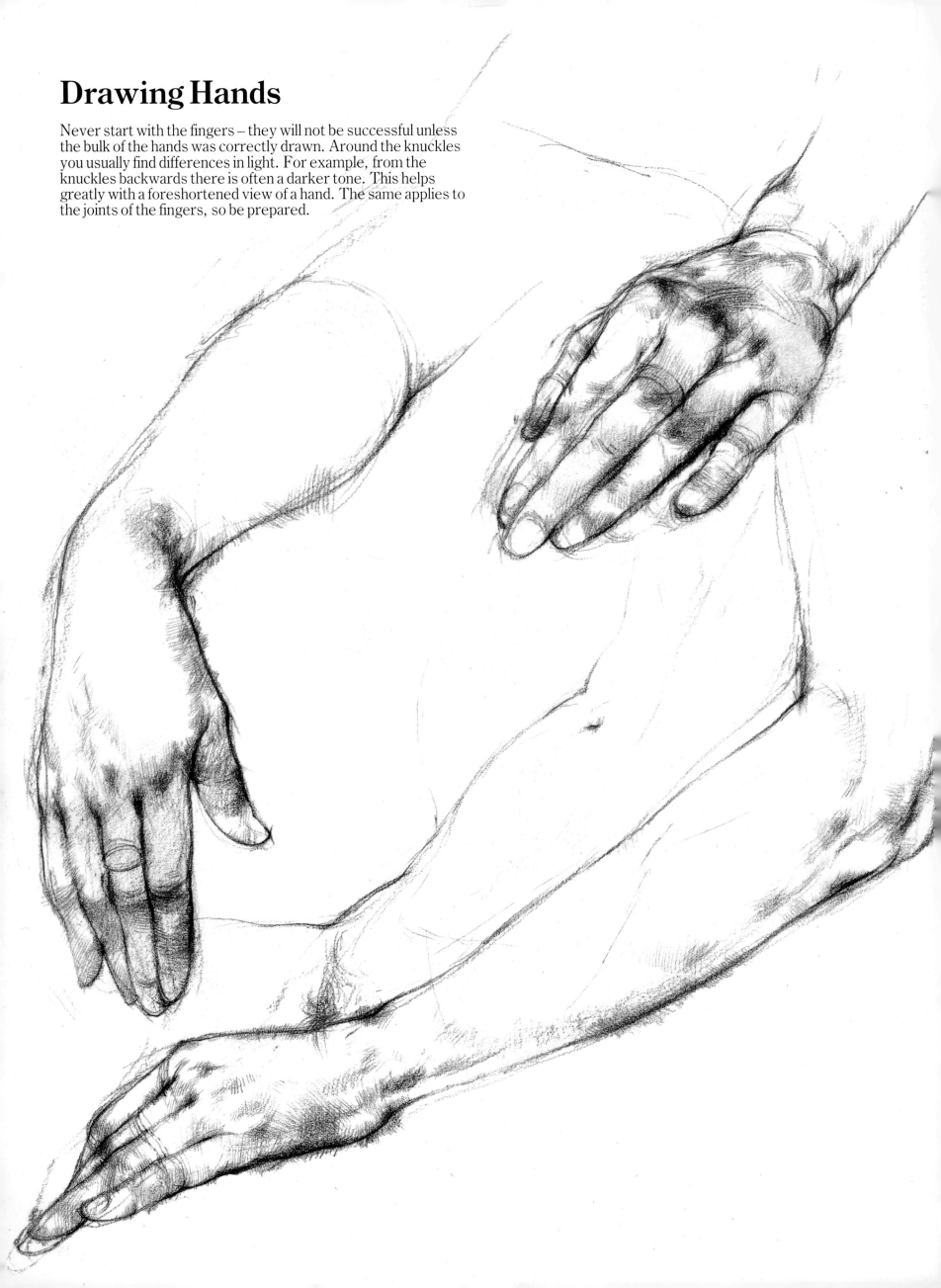

You have noticed in the previous drawings how important hands can be. Here is a whole page of them, old and young, male and female. As with everything else, start with the general shape of the hand or fist. Draw the correct outline and then proceed to find the knuckles, wrist, first joint of the fingers, and indicate them with a light line. If all is correct, including the angle of the wrist, proceed to draw in the fingers in more detail.

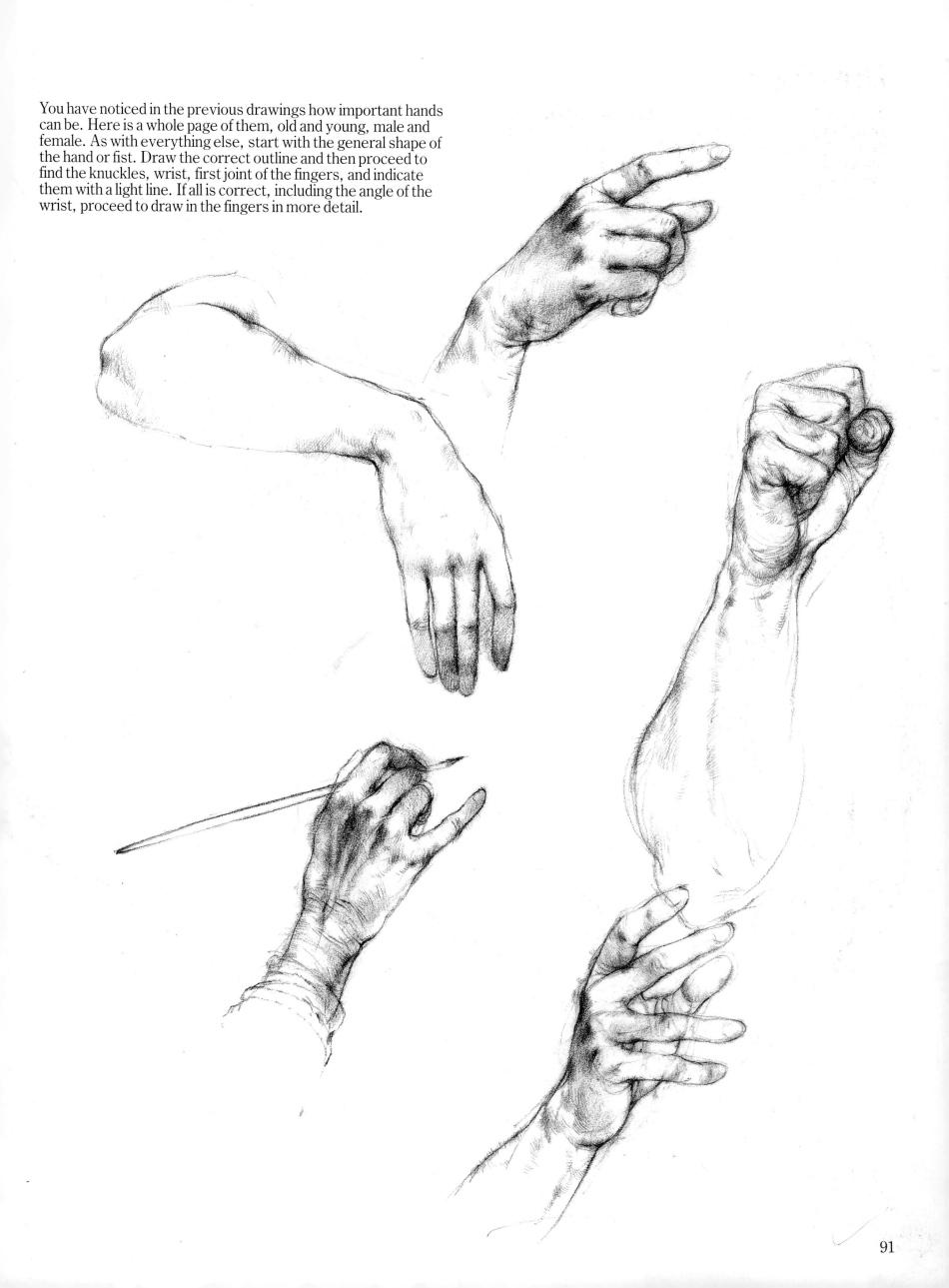

Drawings in Line

A line only drawing of a country woman using line hatching to achieve modelling on the body. Note that clothing does not lie flat but must indicate the form of the body beneath.

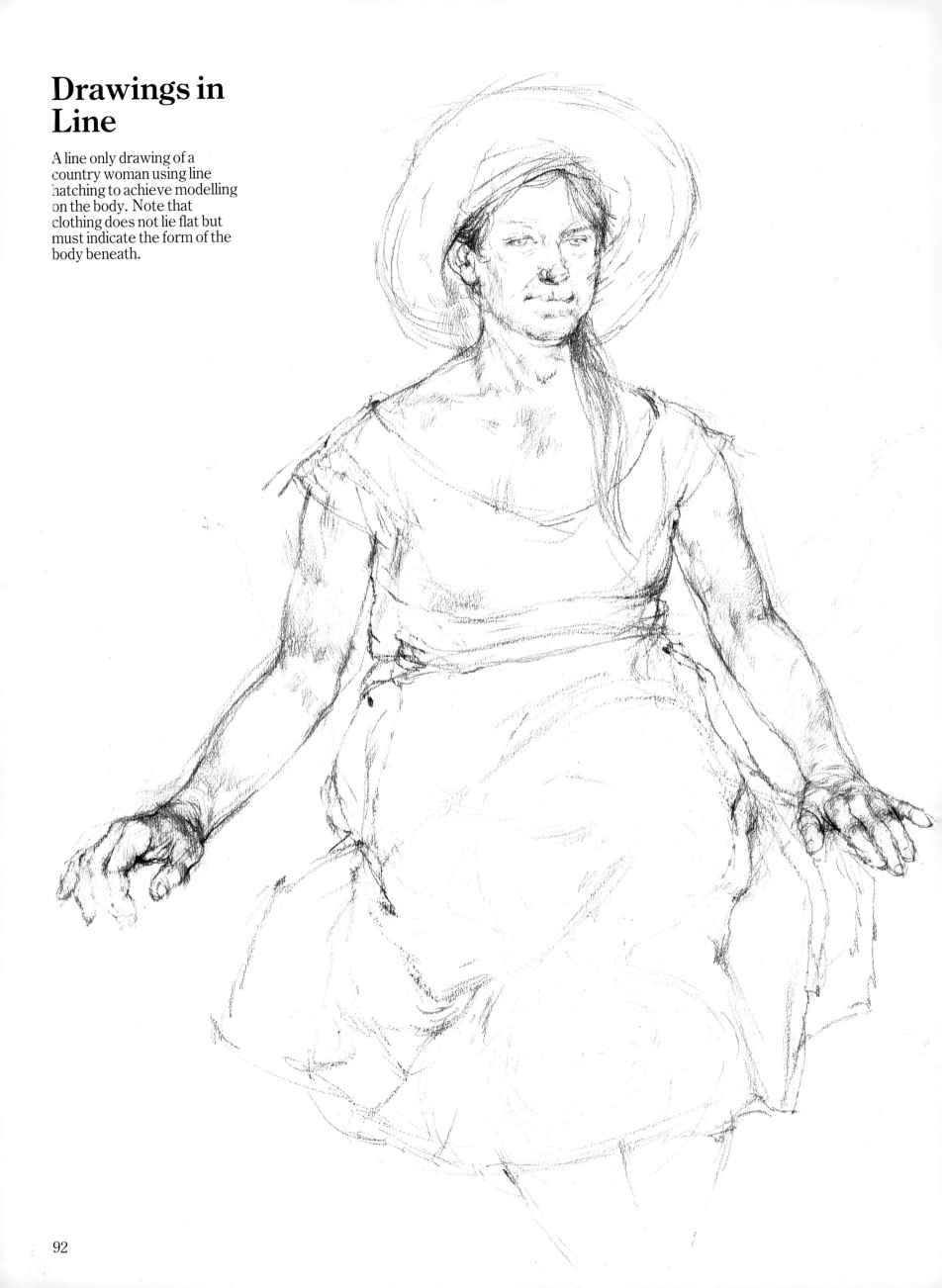

A line drawing of a young man with long hair. Face and clothing are treated in much the same way, but with more detail by means of line hatching on the arms and head. If you use hatching, it should always follow the form. Never run lines in identical directions, but change them slightly to model the shapes that you are describing.

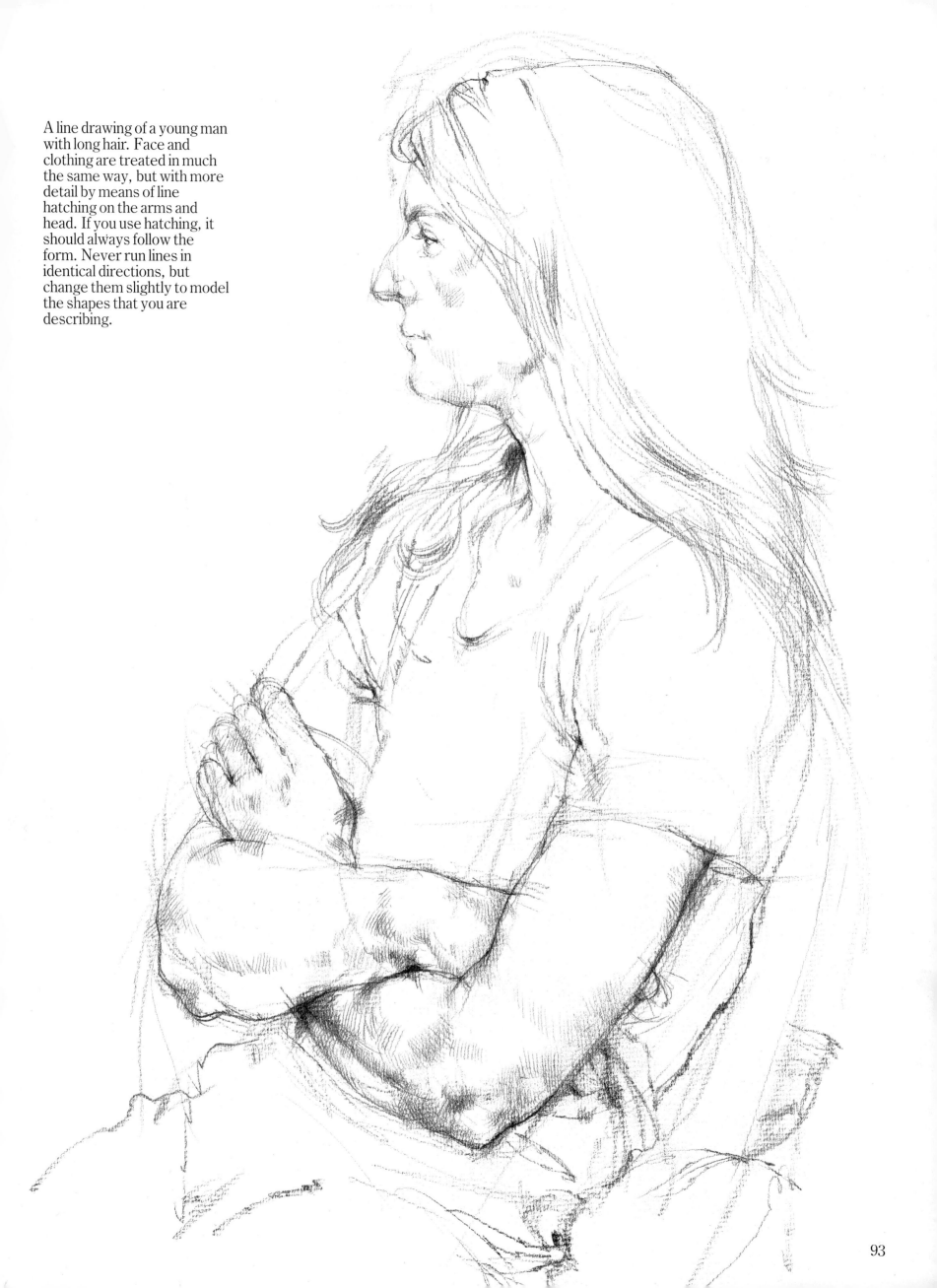

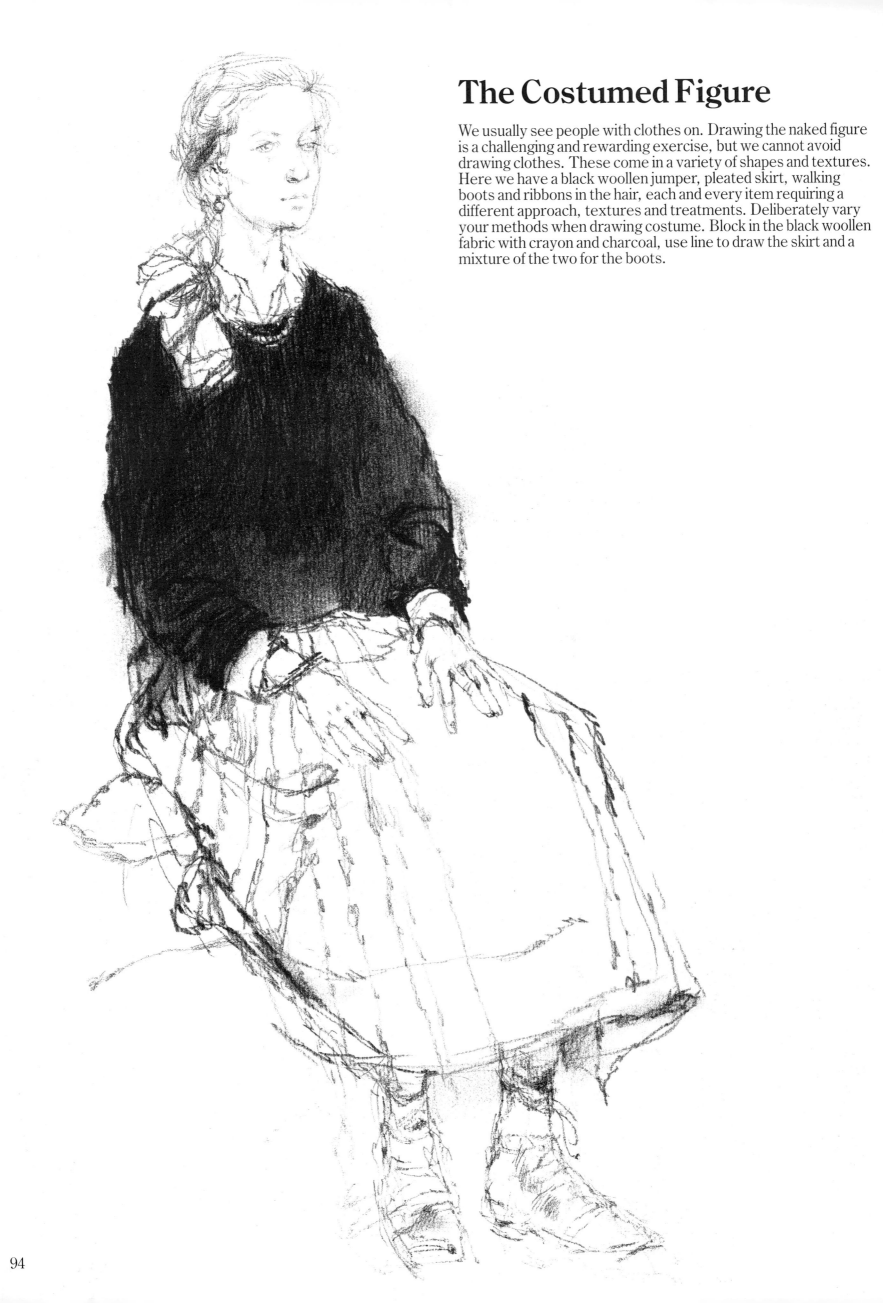

The Costumed Figure

We usually see people with clothes on. Drawing the naked figure is a challenging and rewarding exercise, but we cannot avoid drawing clothes. These come in a variety of shapes and textures. Here we have a black woollen jumper, pleated skirt, walking boots and ribbons in the hair, each and every item requiring a different approach, textures and treatments. Deliberately vary your methods when drawing costume. Block in the black woollen fabric with crayon and charcoal, use line to draw the skirt and a mixture of the two for the boots.

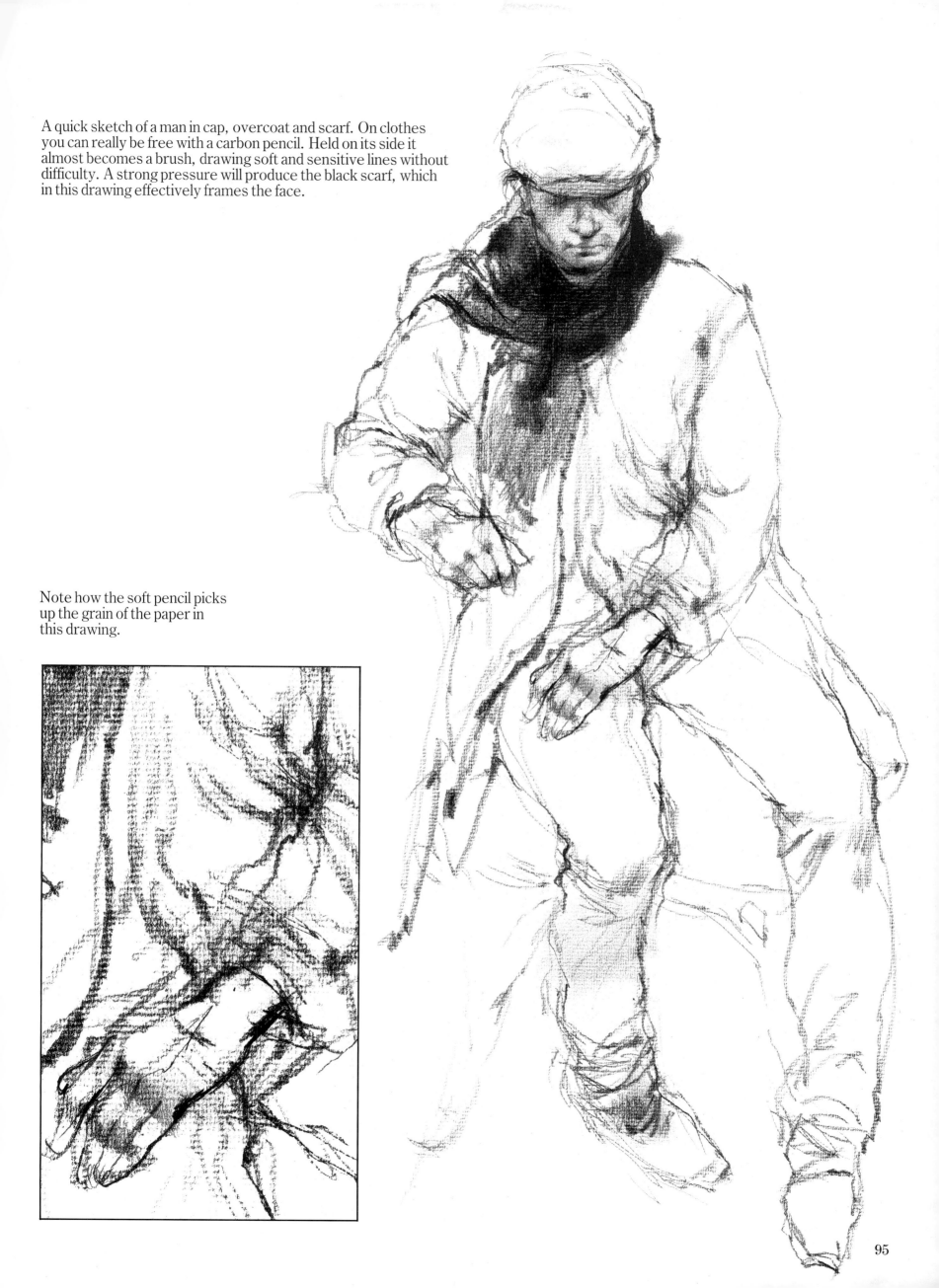

A quick sketch of a man in cap, overcoat and scarf. On clothes you can really be free with a carbon pencil. Held on its side it almost becomes a brush, drawing soft and sensitive lines without difficulty. A strong pressure will produce the black scarf, which in this drawing effectively frames the face.

Note how the soft pencil picks up the grain of the paper in this drawing.

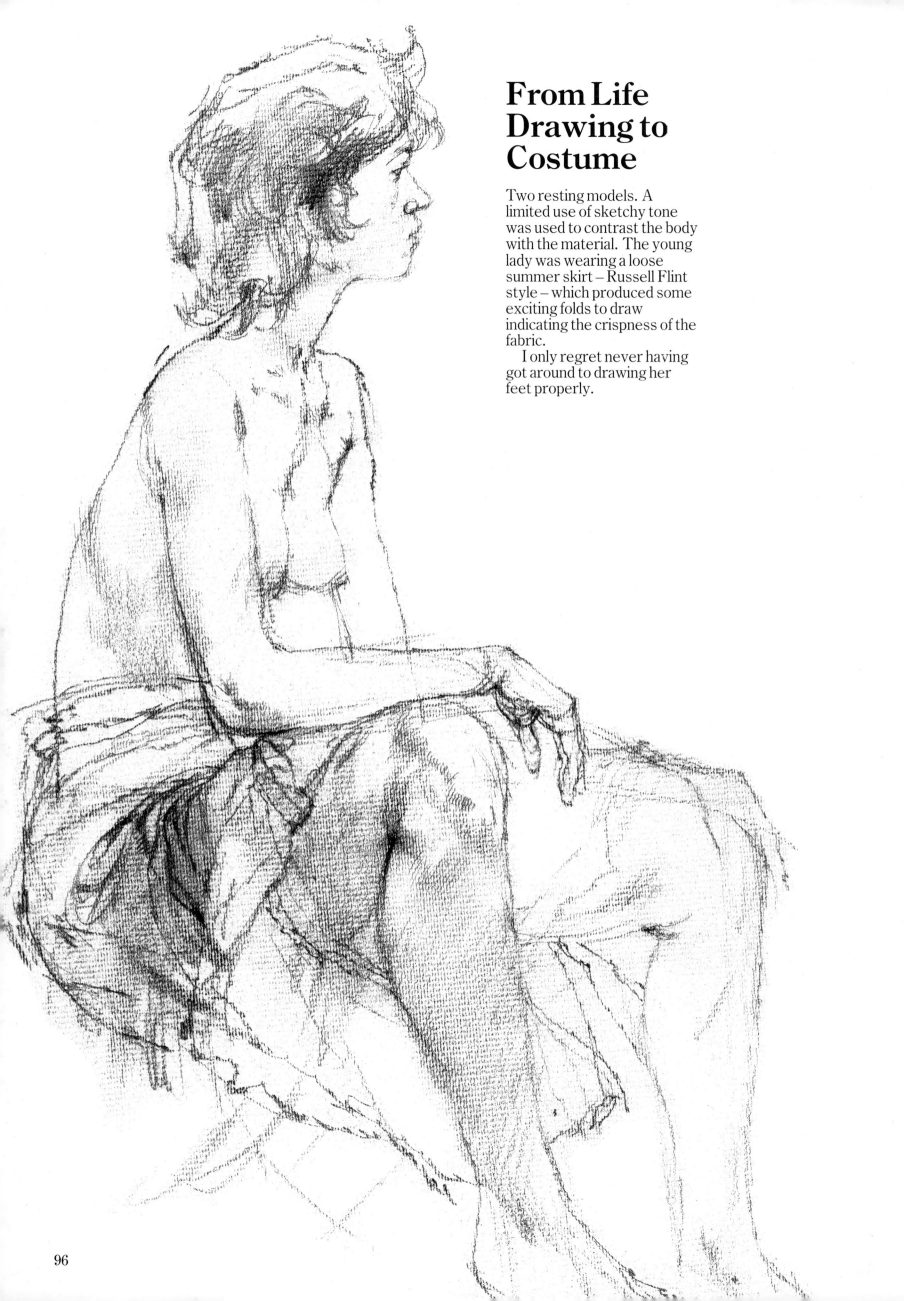

From Life Drawing to Costume

Two resting models. A limited use of sketchy tone was used to contrast the body with the material. The young lady was wearing a loose summer skirt – Russell Flint style – which produced some exciting folds to draw indicating the crispness of the fabric.

I only regret never having got around to drawing her feet properly.

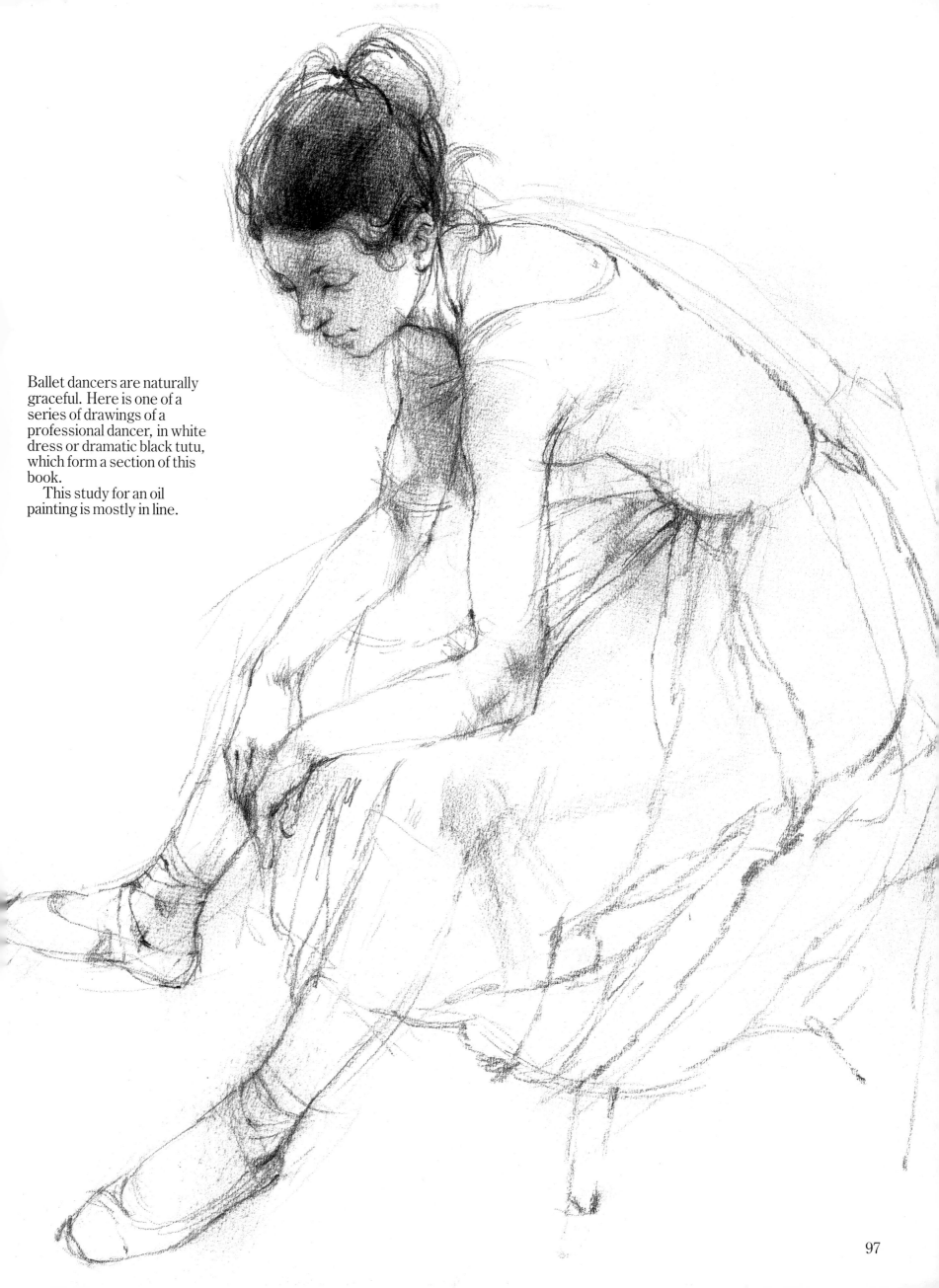

Ballet dancers are naturally graceful. Here is one of a series of drawings of a professional dancer, in white dress or dramatic black tutu, which form a section of this book.

 This study for an oil painting is mostly in line.

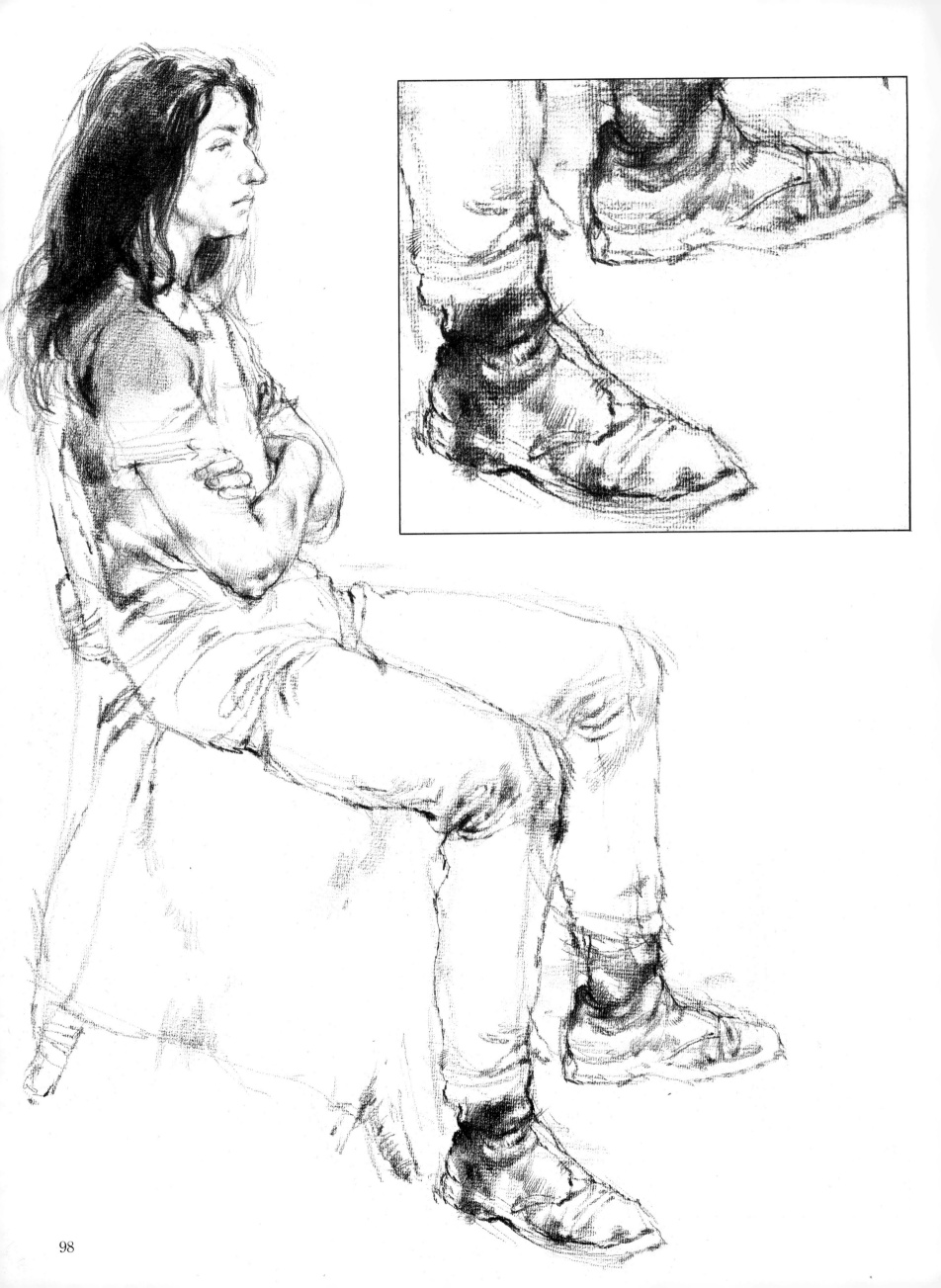

Drawing Feet

Have you ever noticed the amount of character shoes possess? A few pages along there are drawings of ballet shoes. Here are two sets of boots, those of the girl are Victorian-style and made of soft leather, on the opposite page the man's are thick-soled hefty walking boots.

The creases and folds of the different weights of leather are quite fascinating. No wonder boots are often set to draw for 'still life' in art classes.

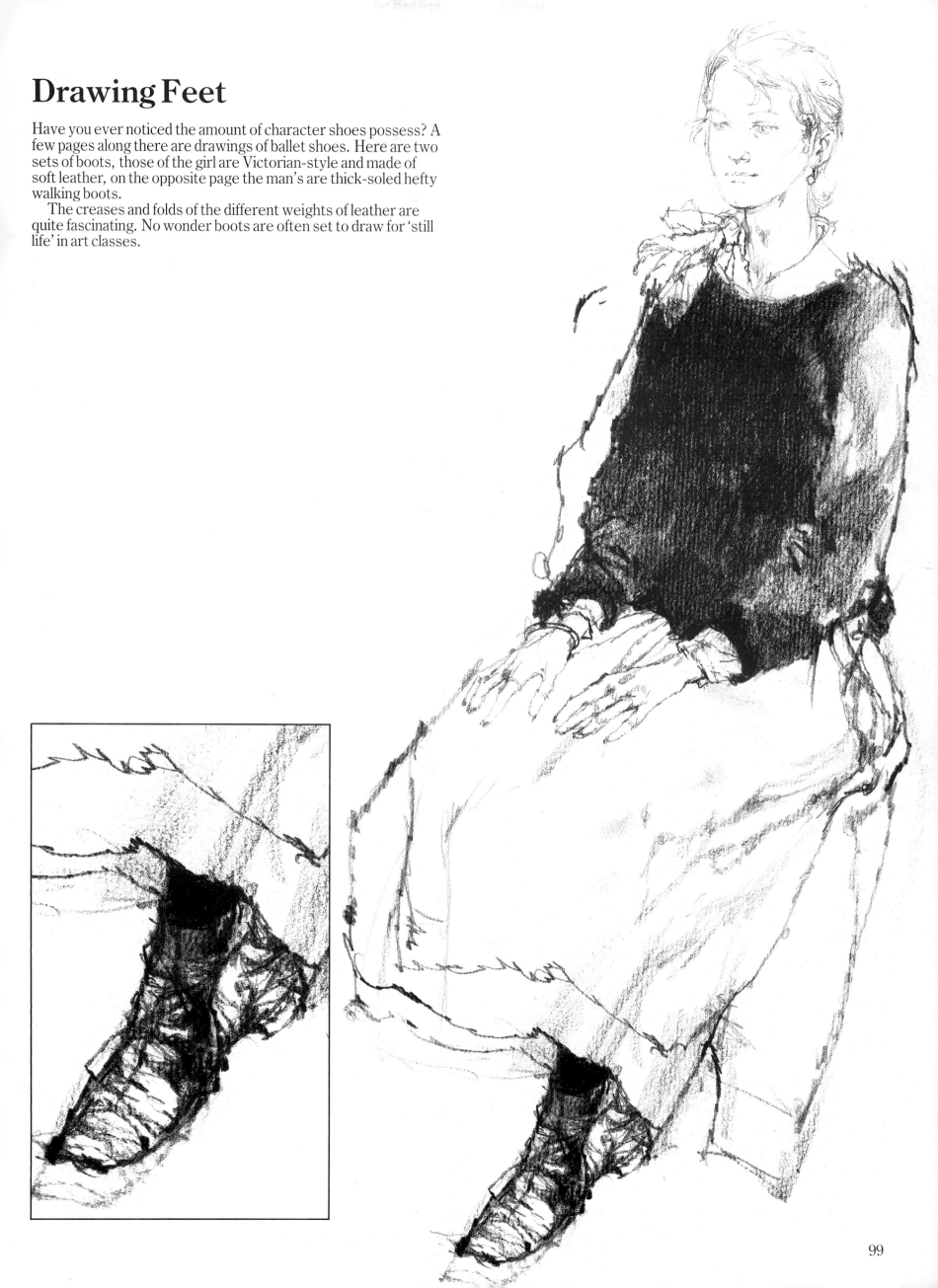

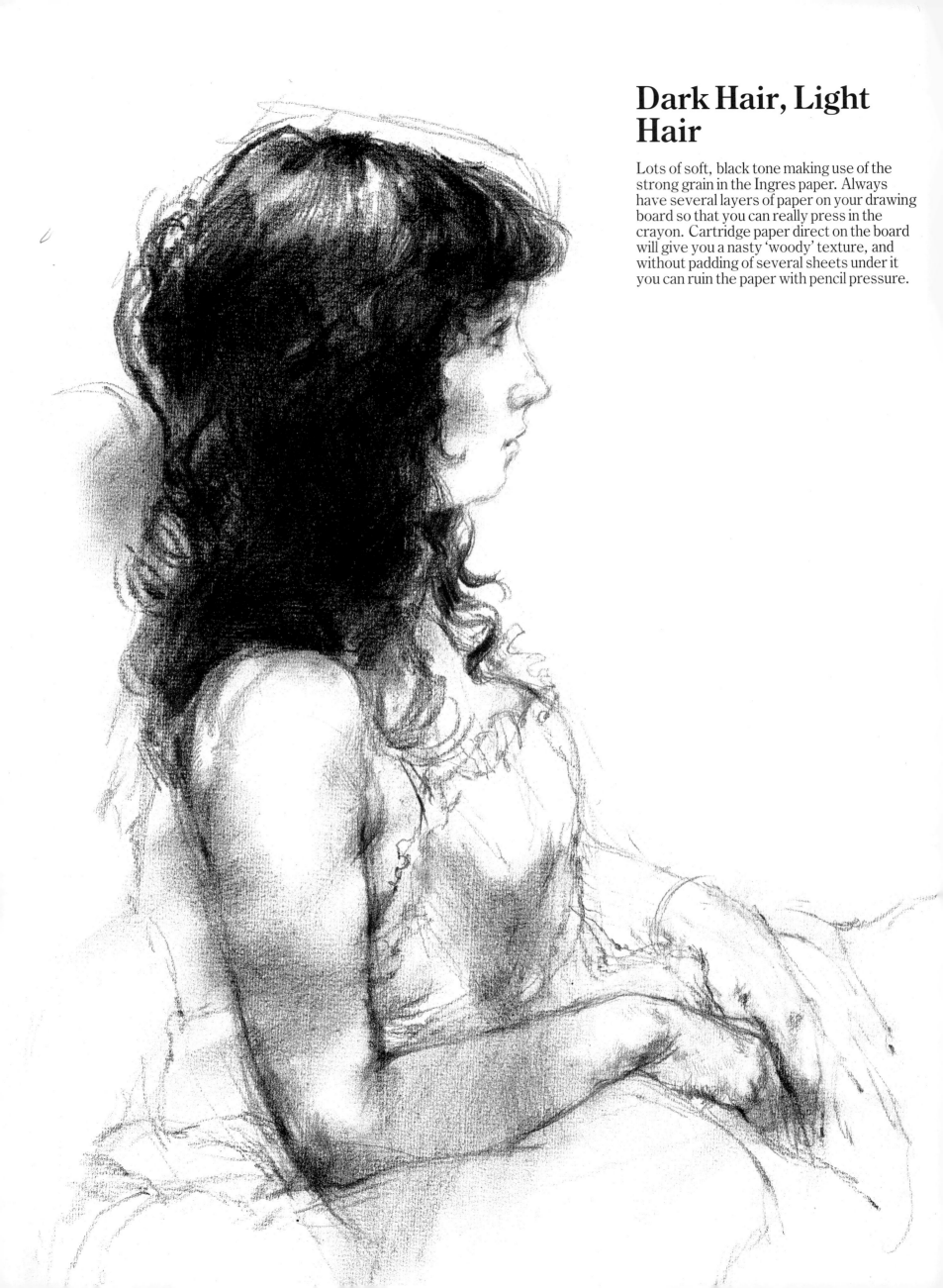

Dark Hair, Light Hair

Lots of soft, black tone making use of the strong grain in the Ingres paper. Always have several layers of paper on your drawing board so that you can really press in the crayon. Cartridge paper direct on the board will give you a nasty 'woody' texture, and without padding of several sheets under it you can ruin the paper with pencil pressure.

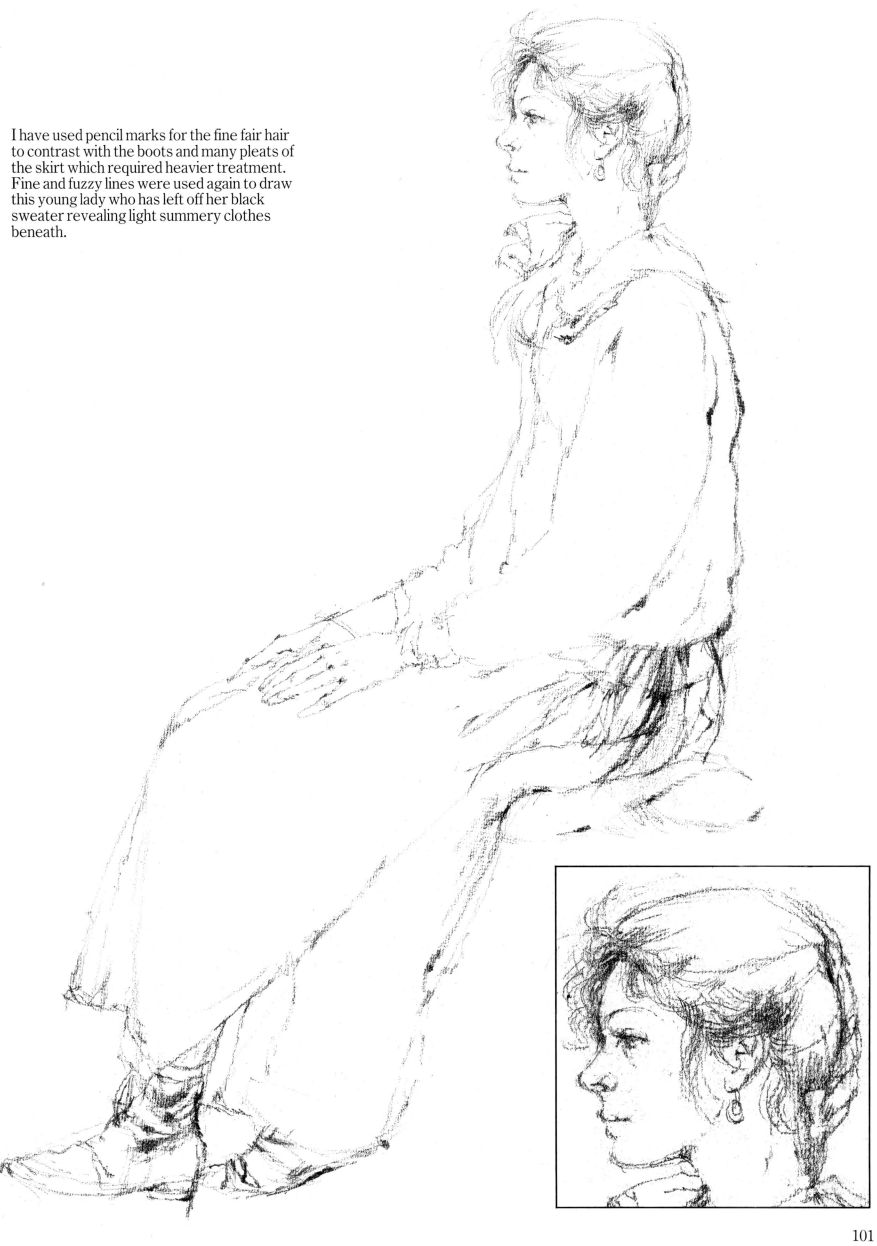

I have used pencil marks for the fine fair hair to contrast with the boots and many pleats of the skirt which required heavier treatment. Fine and fuzzy lines were used again to draw this young lady who has left off her black sweater revealing light summery clothes beneath.

Different Clothes and Hairstyles

A much more modern-looking hairstyle on a teenager, complete with loose trousers and sandals. A very different subject to the one opposite. Rather limiting in some ways, but very up to date.

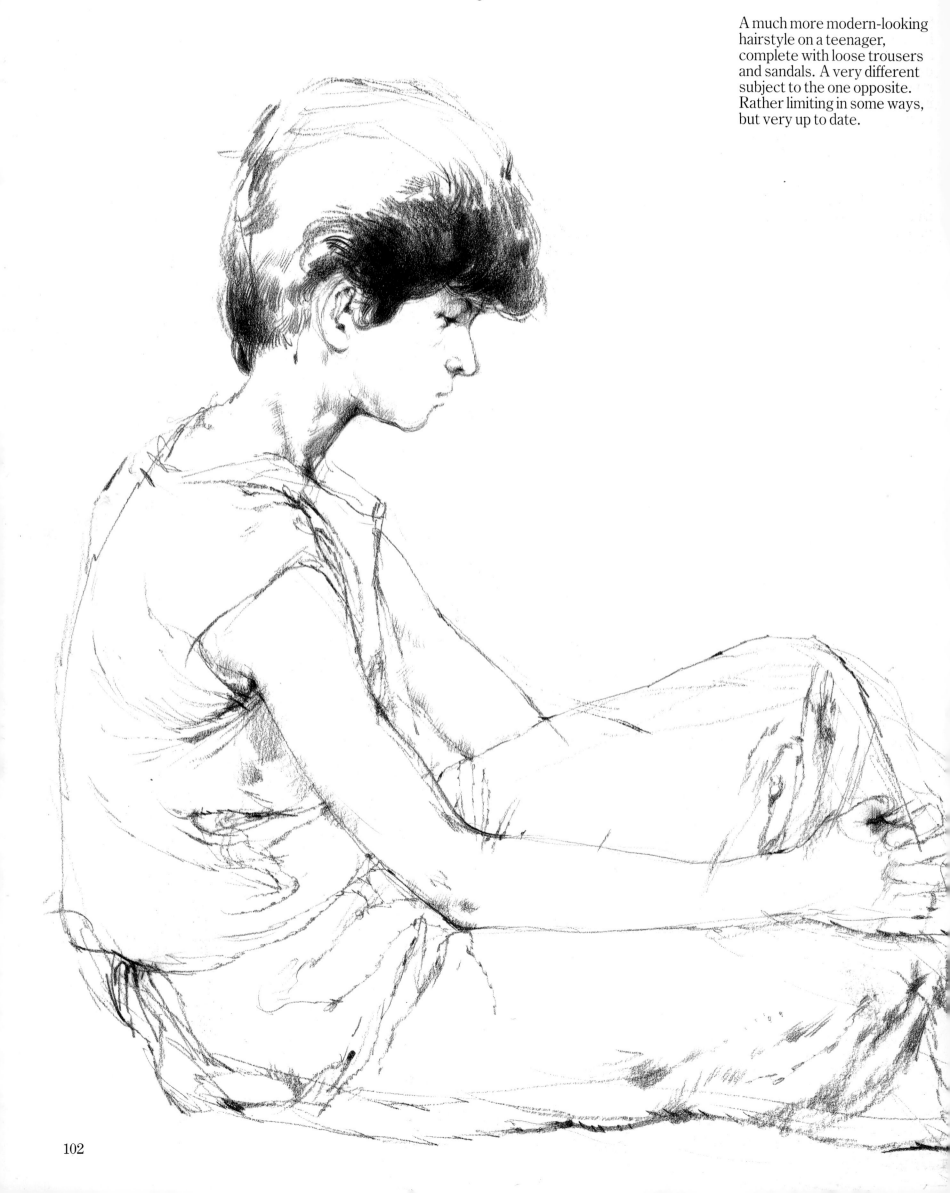

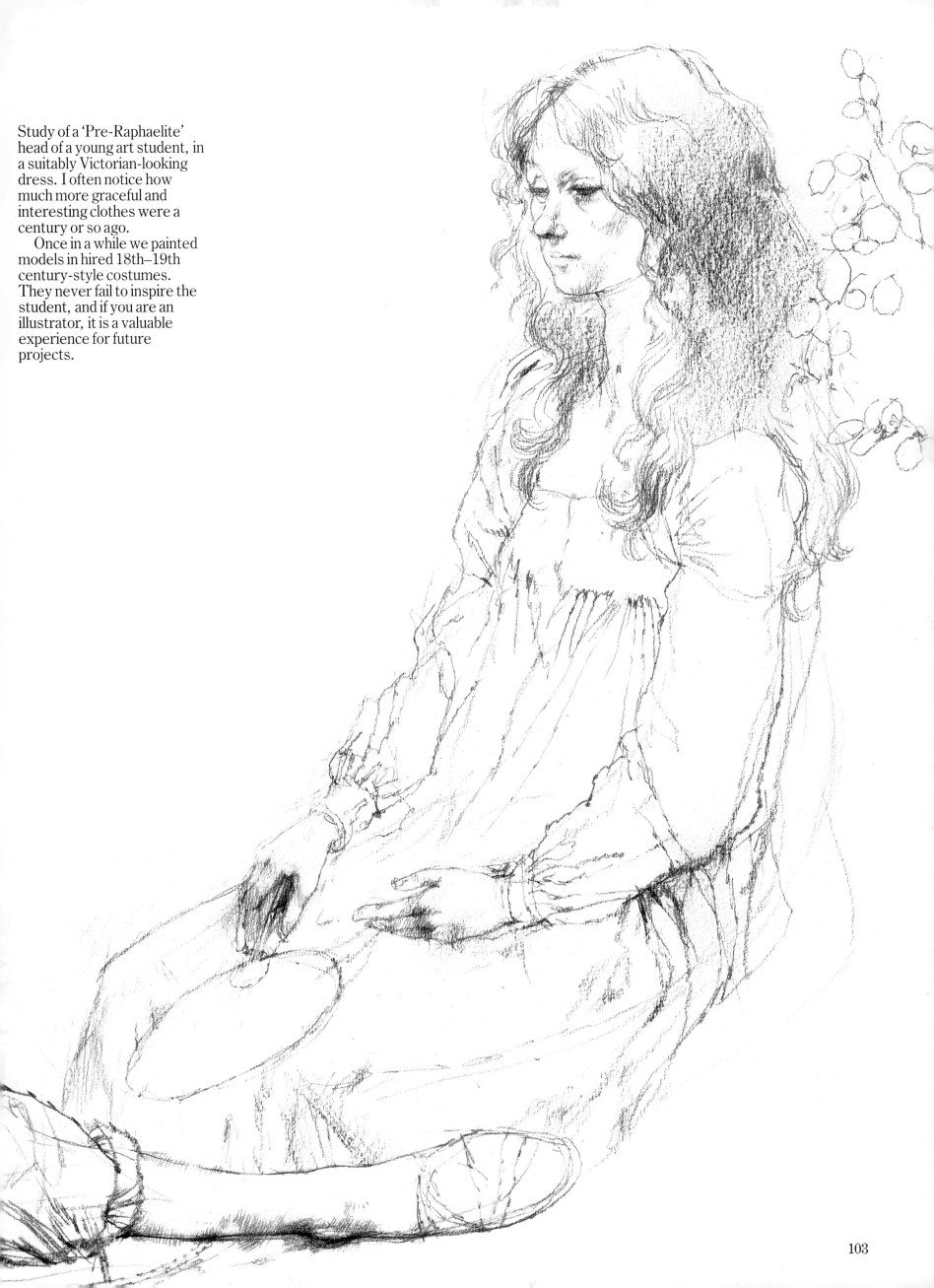

Study of a 'Pre-Raphaelite' head of a young art student, in a suitably Victorian-looking dress. I often notice how much more graceful and interesting clothes were a century or so ago.

Once in a while we painted models in hired 18th–19th century-style costumes. They never fail to inspire the student, and if you are an illustrator, it is a valuable experience for future projects.

Ballet Dancers

We were fortunate to have a professional dancer as a model. Being a dancer, she always moves with style and has a graceful trim figure. This in fact was a 15-minute sketch, one of a series of short poses seen in this chapter.

For most of the poses she wore black costume, providing stark focus and contrast to the rest of the body. The black lace of the tutu always added a touch of base tone to prevent the drawings from tightening up.

Carbon pencil B-2B was held loosely on its side to assist quick drawing, and the face was merely suggested.

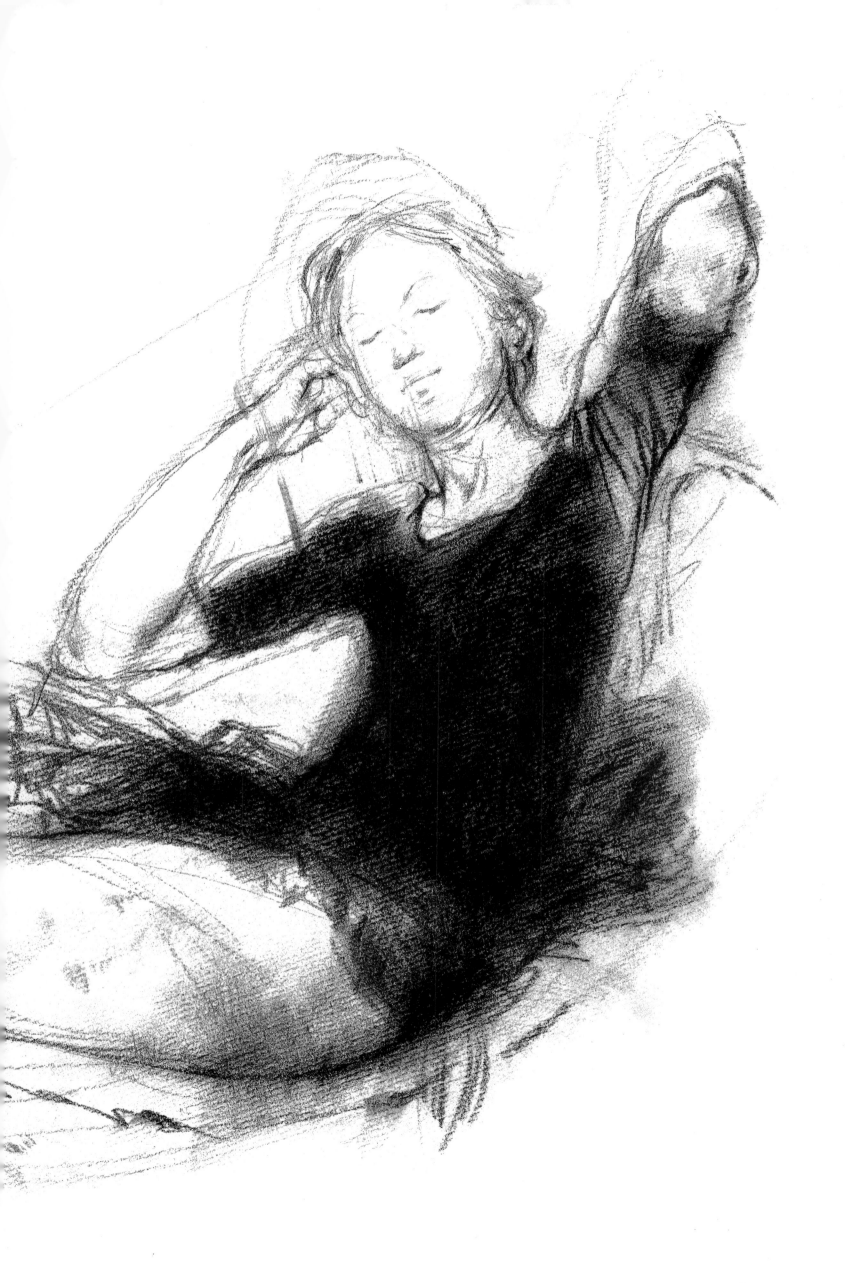

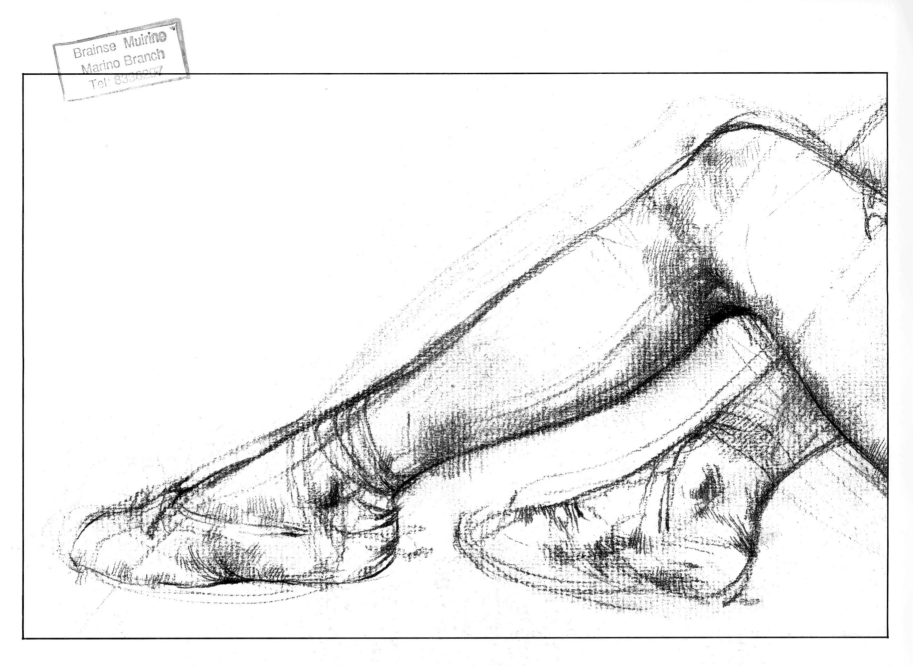

Above: Numerous 'search lines' indicate a struggle to get the legs right, and to give the correct feel to the ballet shoes.

Right: Another 20-minute pose, where I concentrated on the back view of a typical ballet dancer's head, being long and straight-necked with smooth neat hair in a tight bun. Careful line drawing was needed in the drawing of the ears and the head so that it sits soundly on the neck. The generous use of black tone laid on heavily indicated the costume.

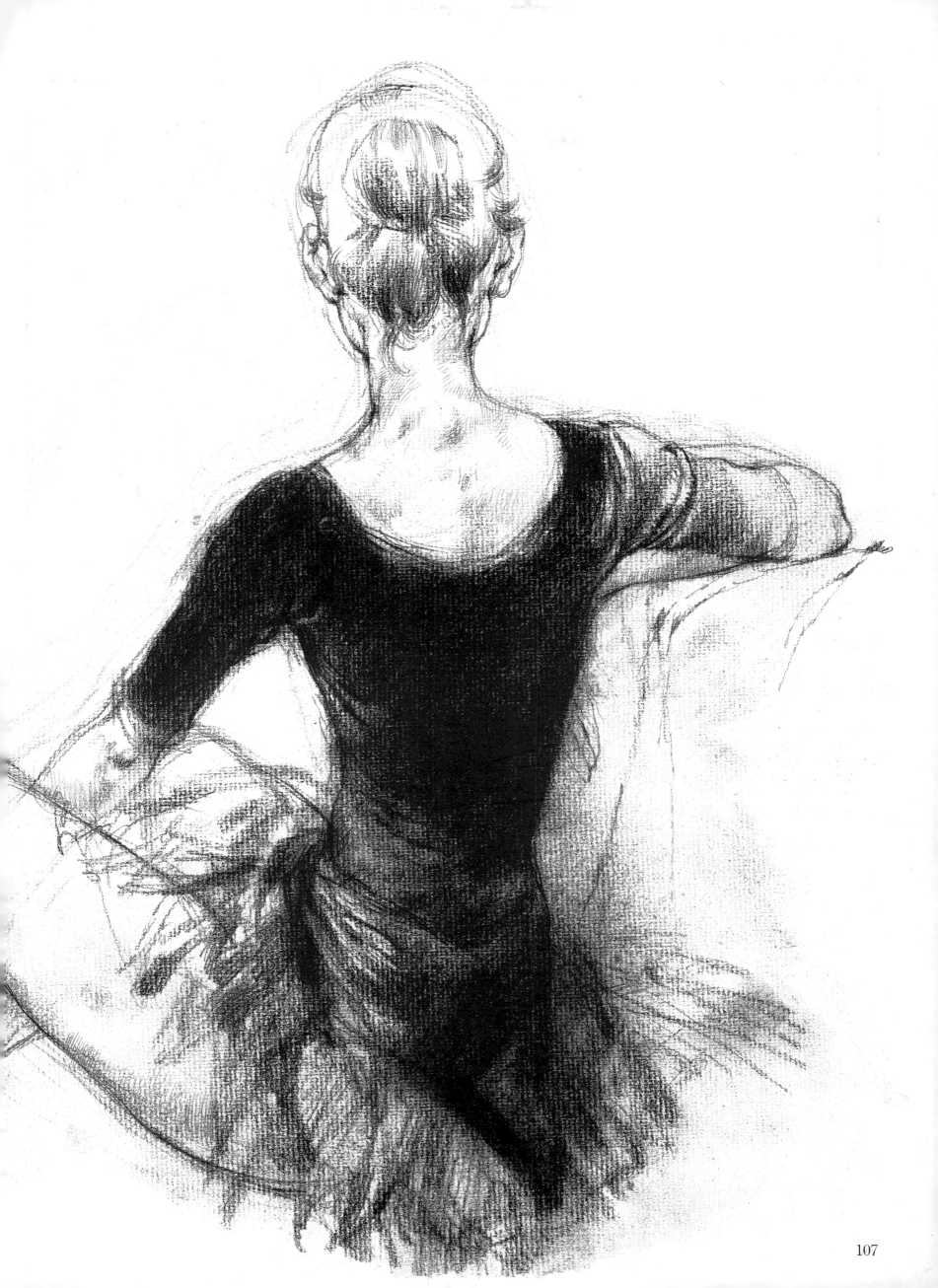

Standing Poses

Sketch for a painting. For this purpose, I was more interested in tone than line, as it is a working drawing to paint from should the need arise.

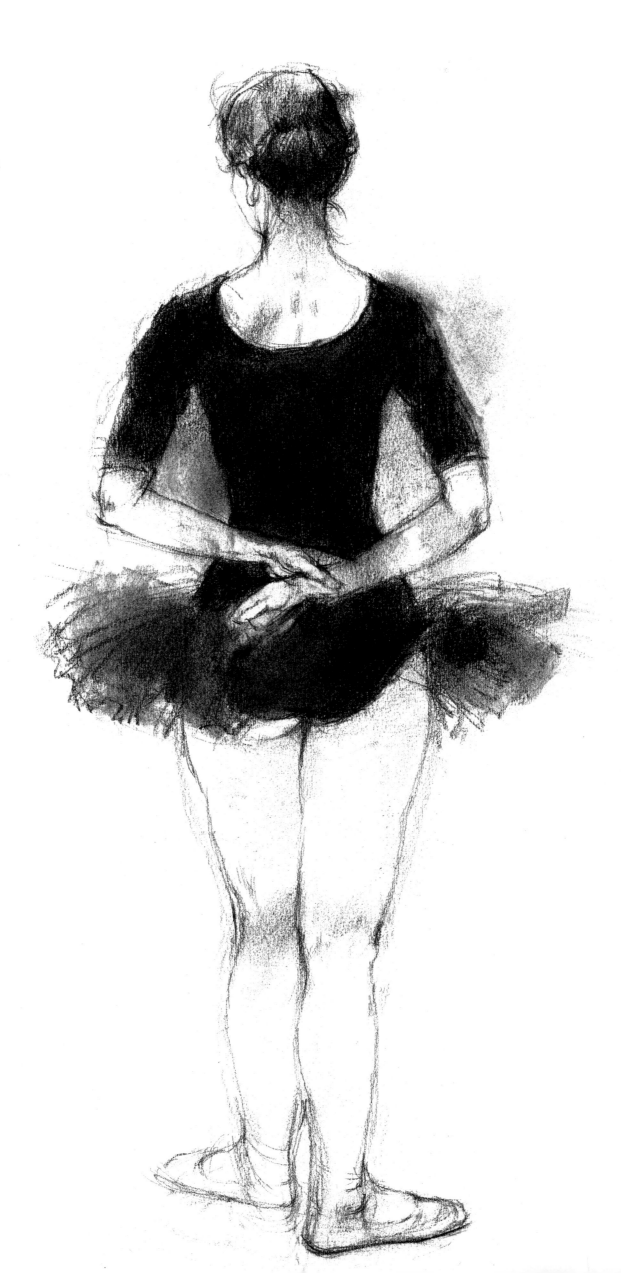

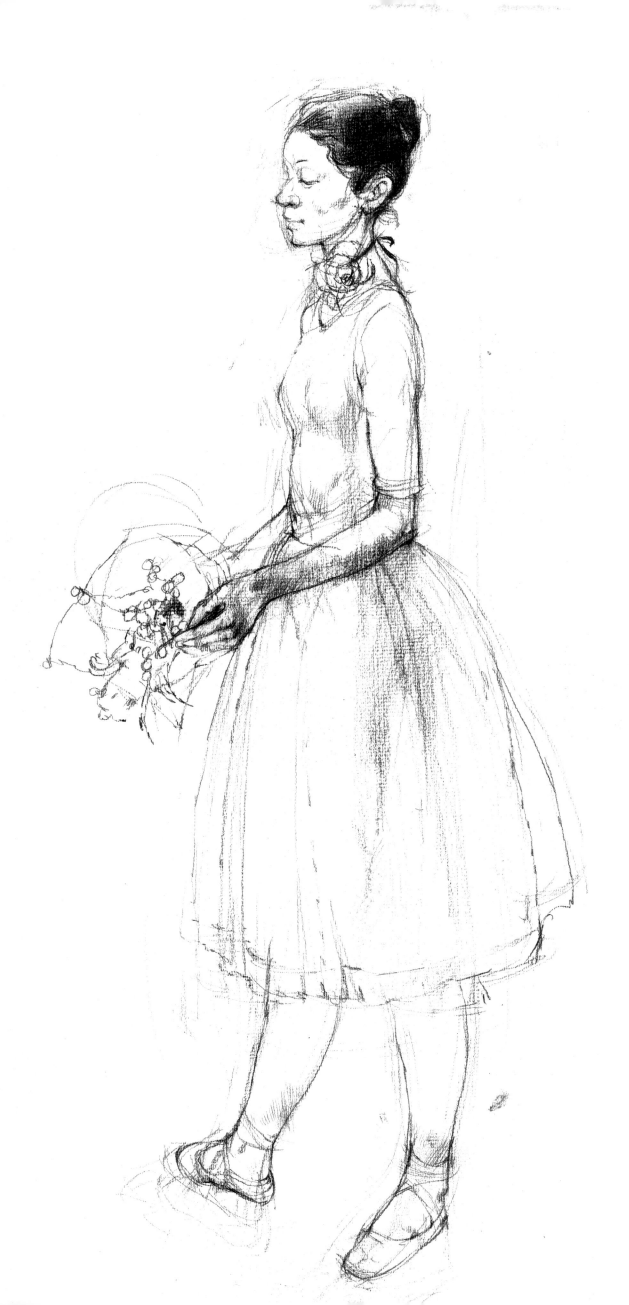

The longer white costume of
light material required a fine
line and very delicate tone
treatment. This was an
experimental pose for a
painting, but was not
eventually used. Hands and
head had to be fairly
accurately recorded.

The End of a Tiring Day

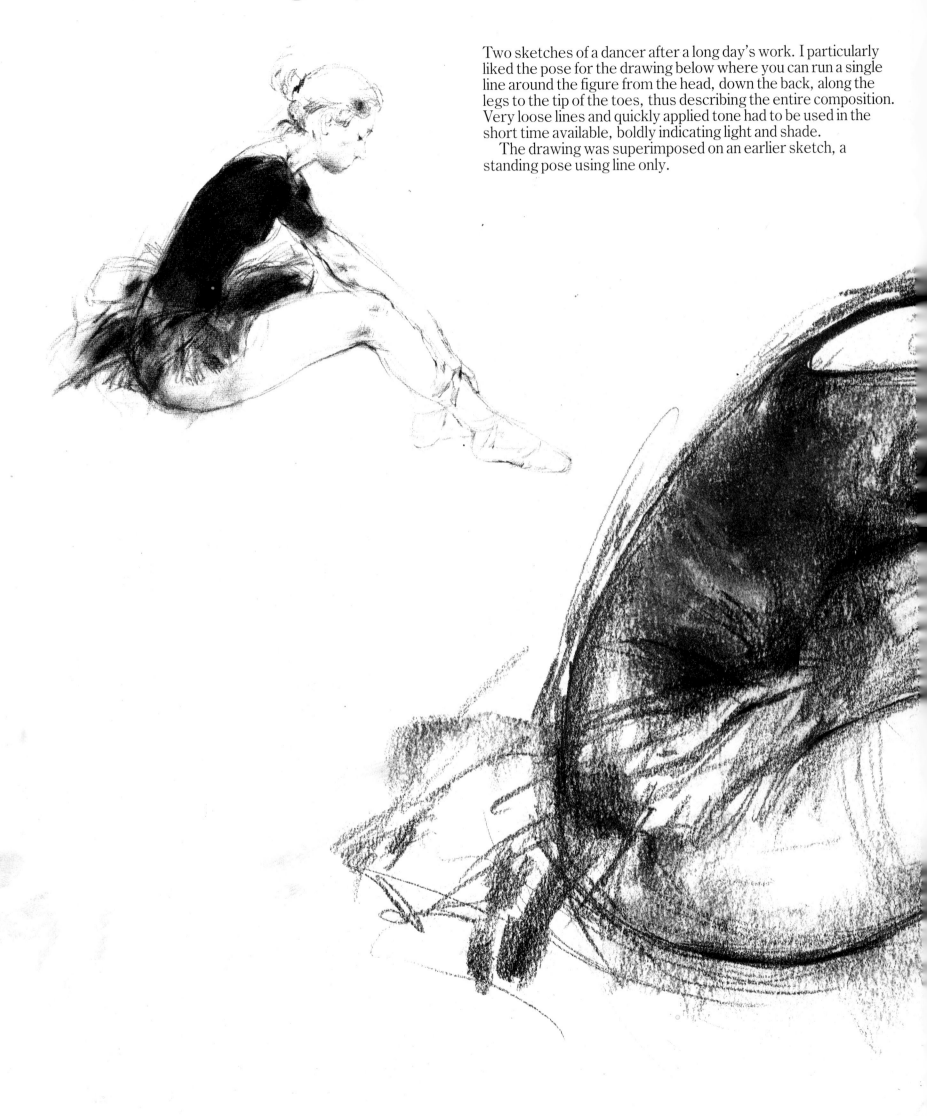

Two sketches of a dancer after a long day's work. I particularly liked the pose for the drawing below where you can run a single line around the figure from the head, down the back, along the legs to the tip of the toes, thus describing the entire composition. Very loose lines and quickly applied tone had to be used in the short time available, boldly indicating light and shade.

The drawing was superimposed on an earlier sketch, a standing pose using line only.

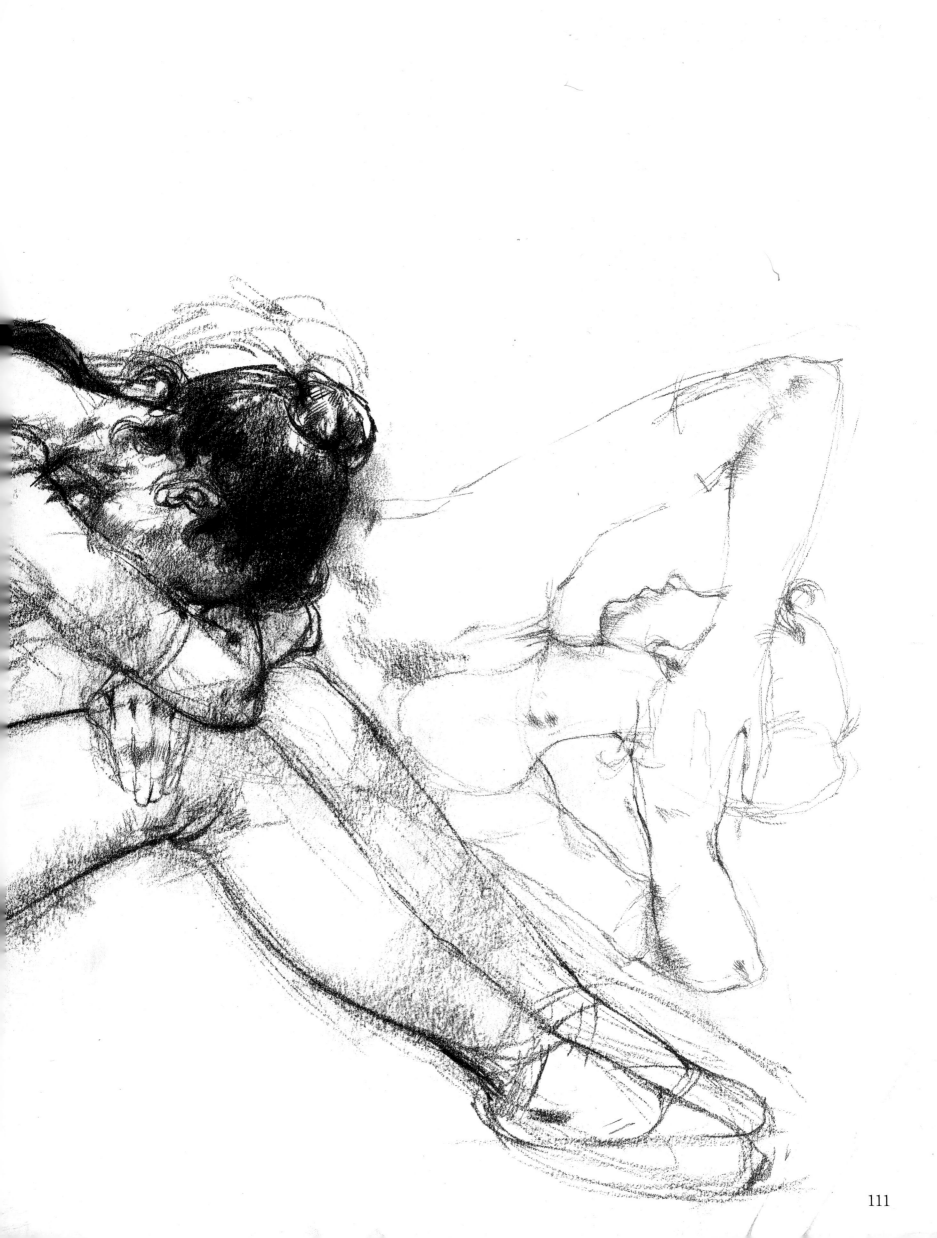

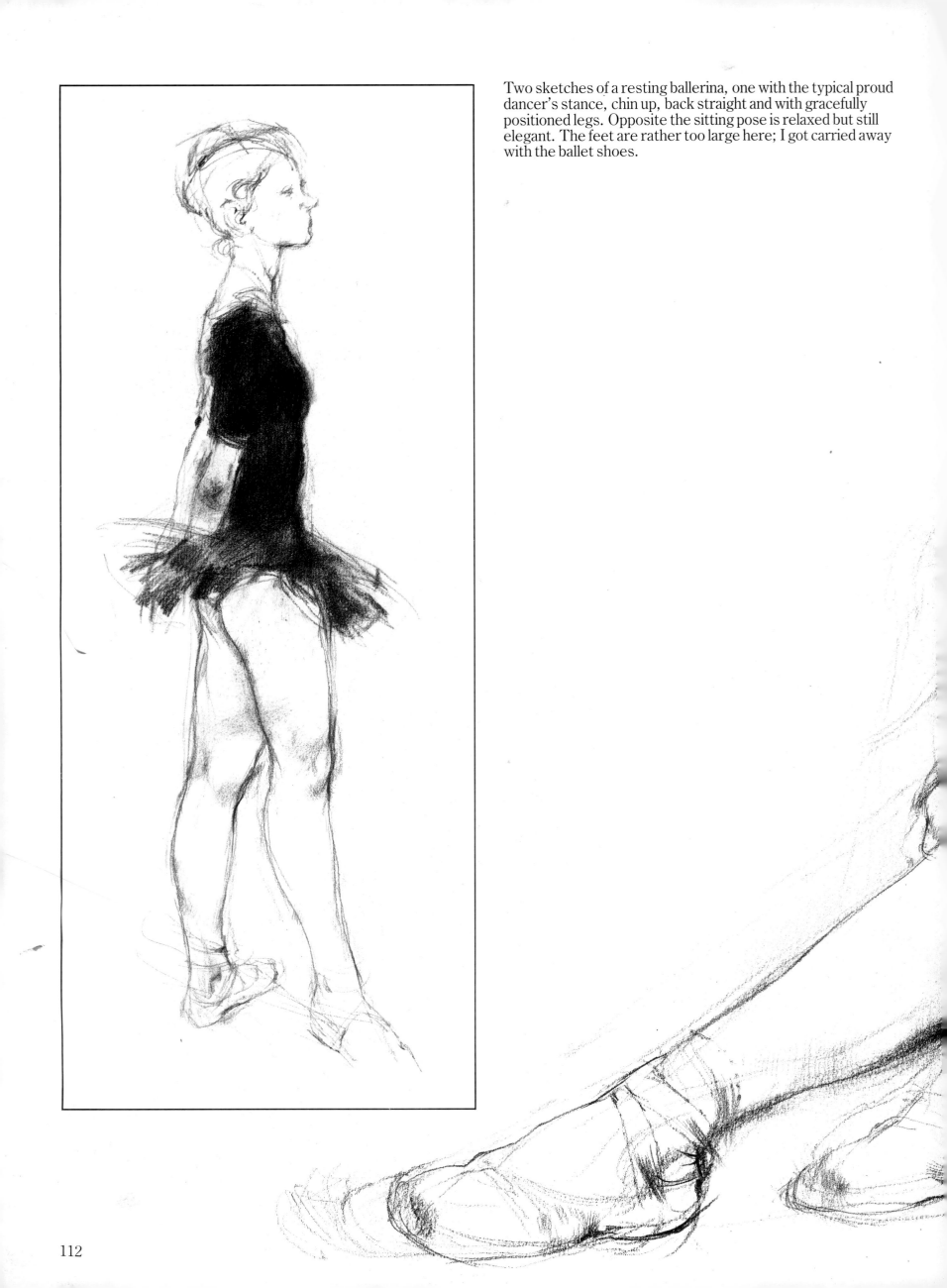

Two sketches of a resting ballerina, one with the typical proud dancer's stance, chin up, back straight and with gracefully positioned legs. Opposite the sitting pose is relaxed but still elegant. The feet are rather too large here; I got carried away with the ballet shoes.

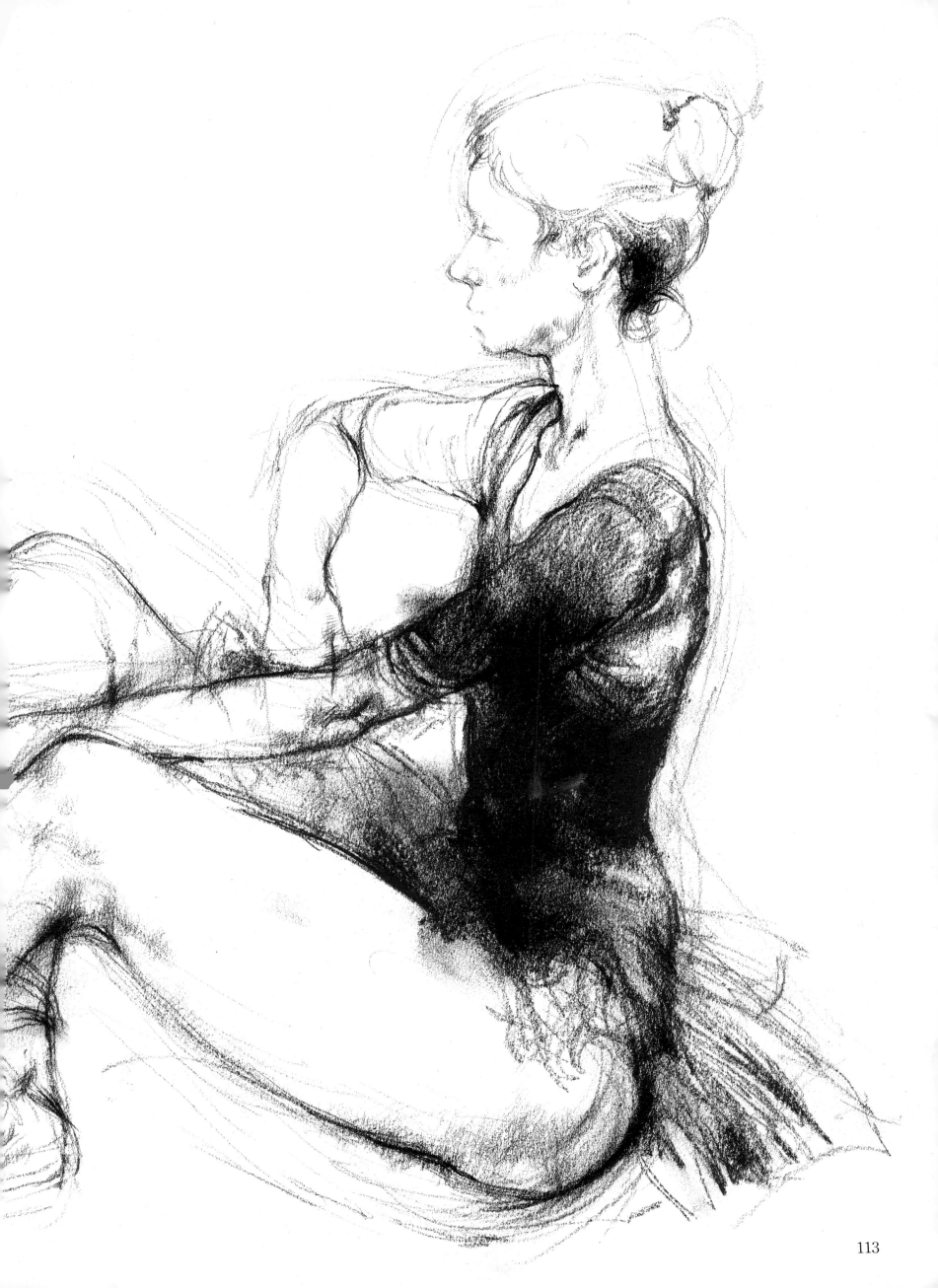

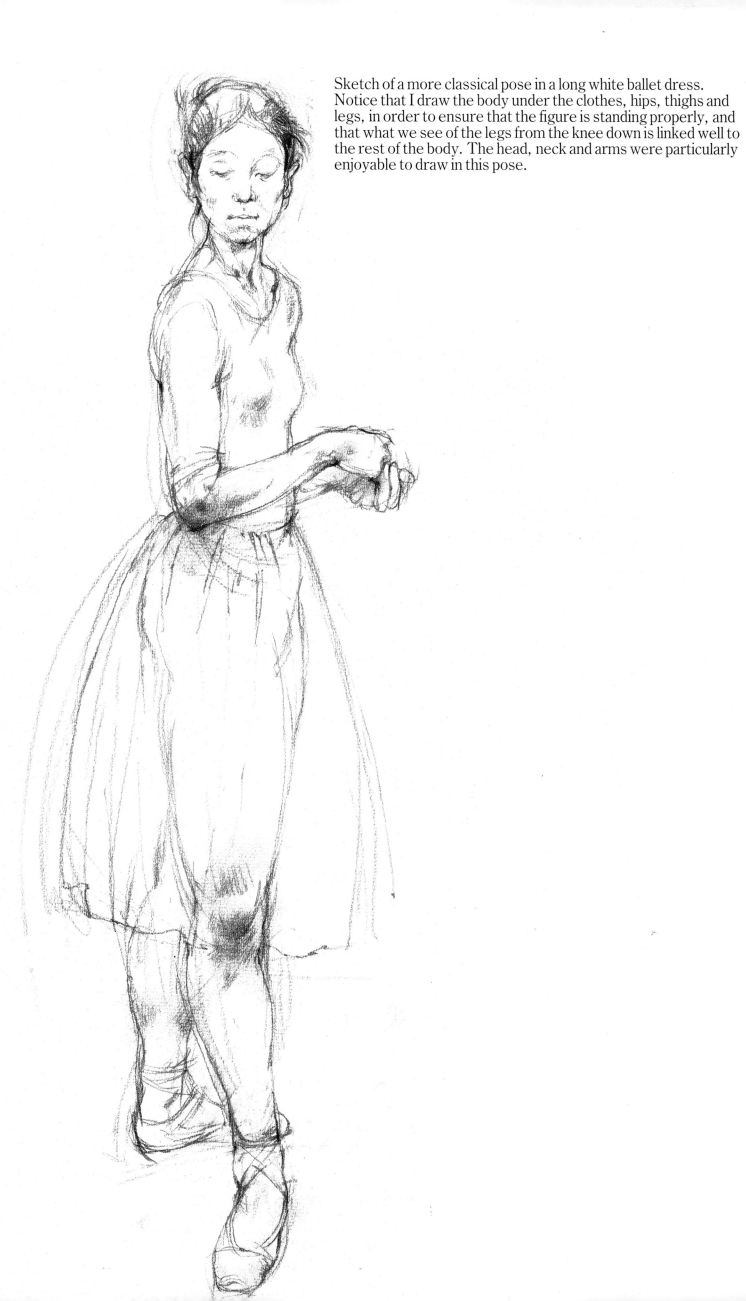

Sketch of a more classical pose in a long white ballet dress. Notice that I draw the body under the clothes, hips, thighs and legs, in order to ensure that the figure is standing properly, and that what we see of the legs from the knee down is linked well to the rest of the body. The head, neck and arms were particularly enjoyable to draw in this pose.

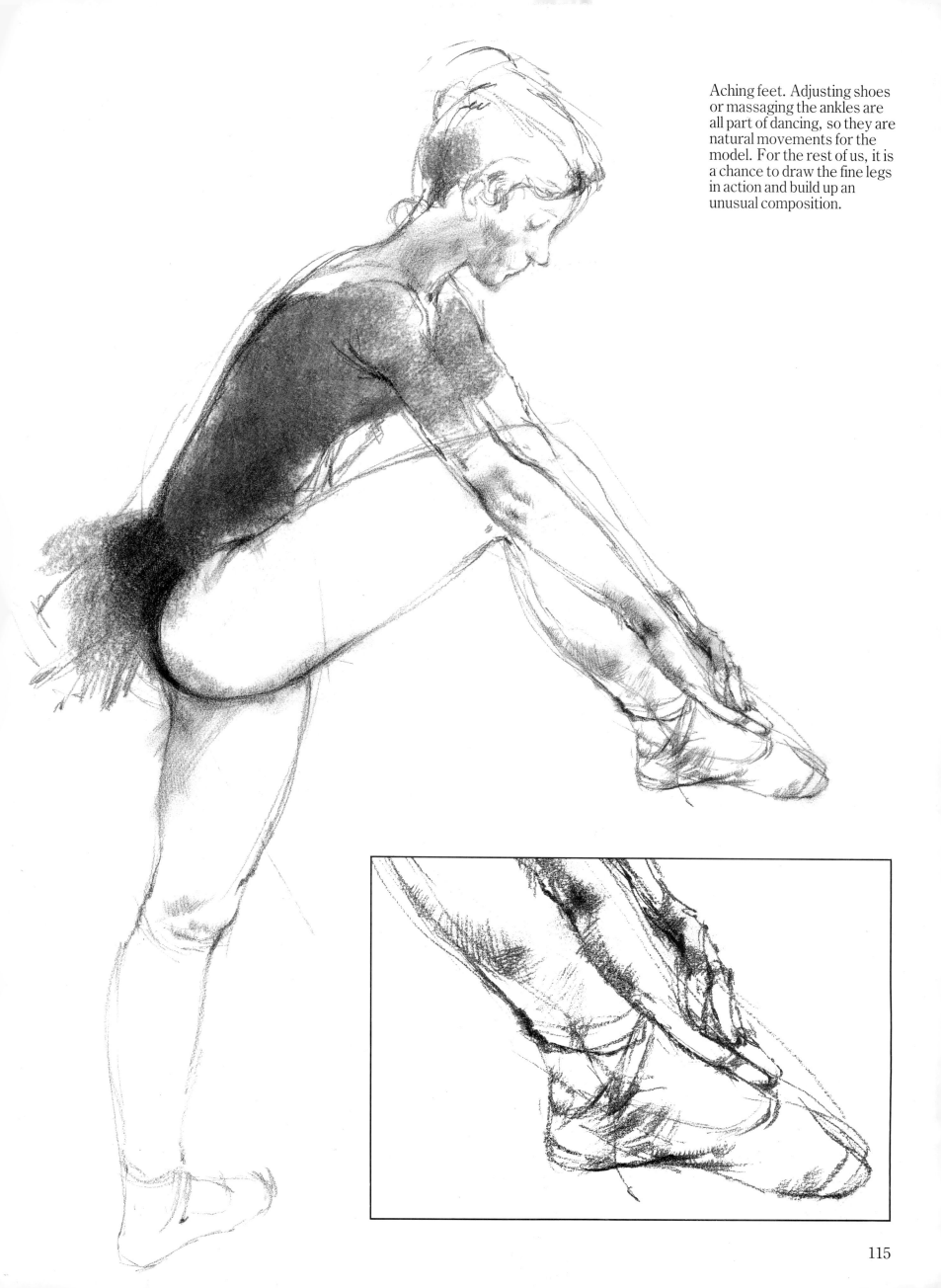

Aching feet. Adjusting shoes or massaging the ankles are all part of dancing, so they are natural movements for the model. For the rest of us, it is a chance to draw the fine legs in action and build up an unusual composition.

The Life Class

I hope that this book will inspire you to produce more drawings and that you will glean a few ideas for poses and techniques. I never tire of drawing. What makes it such an ideal medium for visual self-expression? It is quick, it makes you take a hard look at the subject, it makes you go straight to the point and it is the essential base for other art forms, be they sculpture, pottery, painting, or in my own case, illustration.